BLACK AND WHITE PHOTOGRAPHY

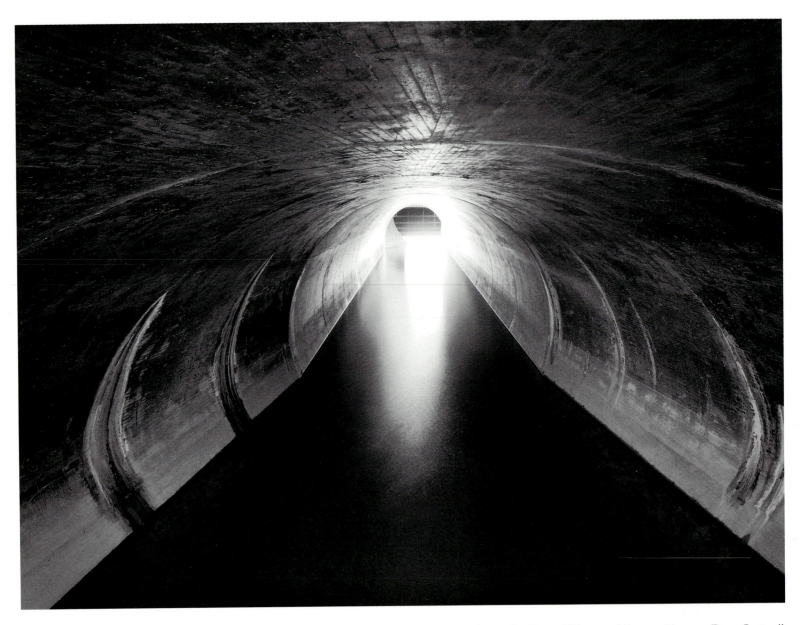

Hoover Dam at Night, Arizona/Nevada. From "Places of Power: Hoover Dam Series."

BLACK AND WHITE PHOTOGRAPHY

Glenn Rand

David Litschel
BROOKS INSTITUTE OF PHOTOGRAPHY

West Publishing Company

MINNEAPOLIS/ST. PAUL NEW YORK LOS ANGELES SAN FRANCISCO

Copyright © 1994 by WEST PUBLISHING COMPANY
610 Opperman Drive
P.O. Box 64526
Saint Paul, MN 55164-0526

Printed in the United States of America

01 00 99 98 97 96 95 94 8 7 6 5 4 3 2 1 0

Library of Congress Cataloging-in-Publication Data

Rand, Glenn M.
 Black and white photography / Glenn M. Rand, David R. Litschel.
 p. cm.
 Includes index.
 ISBN 0-314-02460-3 (soft)
 1. Photography. I. Litschel, David. II. Title.
TR146.R35 1994
771——dc20 93-14290
 CIP

Copyeditor: Cheryl Drivdahl
Composition: Parkwood Composition
Text Design: K. M. Weber
Page Layout: K. M. Weber
Cover Design: Pollock Design Group
Art: Visual Graphic Systems: Edward Rose and Ian Craft

WEST'S COMMITMENT TO THE ENVIRONMENT

In 1906, West Publishing Company began recycling materials left over from the production of books. This began a tradition of efficient and responsible use of resources. Today, up to 95 percent of our legal books and 70 percent of our college and school texts are printed on recycled, acid-free stock. West also recycles nearly 22 million pounds of scrap paper annually—the equivalent of 181,717 trees. Since the 1960s, West has devised ways to capture and recycle waste inks, solvents, oils, and vapors created in the printing process. We also recycle plastics of all kinds, wood, glass, corrugated cardboard, and batteries, and have eliminated the use of styrofoam book packaging. We at West are proud of the longevity and the scope of our commitment to the environment.

Production, prepress, printing, and binding by West Publishing Company.

to Margie, Michael, and Nathanael

CONTENTS

PREFACE

An important part of learning and perfecting black-and-white photography is the role of the teacher. John Sexton, master teacher and black-and-white photographer, once spoke of the way his teachers, primarily Ansel Adams, have influenced how he teaches others. "The single most important thing that Ansel shared with me was an excitement for photography," Sexton said. "By inspiring me he made learning photography automatic; he created a sponge for learning photography. He turned on the switch with excitement, then he provided the information needed to succeed." Sexton added, "The teacher has to be there to create an interest and then be there with the technical support."

A second point made by Sexton was that "the teacher can share successes and failures. A Chinese proverb says, Learn from the mistakes of others; you don't have time to make them all yourself." Sexton went on to say that teachers are indispensable because they can relate a lifetime of mistakes and successes, allowing learning at a faster rate.

Last, Sexton credited Adams with helping him understand the step beyond just making pictures. Sexton tells his students, "You must strive for perfection and tolerate excellence."

This book also recognizes the important role played by the teacher. It depends on the teacher to be there, to excite, to guide, and to share as well as to provide technical information to the students. A text can only assist the teacher, who must direct, demonstrate, evaluate, correct, "debug," support, and monitor the learning process.

Because books are only a part of photographic education, this one presents general materials supported by prevailing techniques used by teachers of black-and-white photography. This text does not try to teach all facets of photography or demonstrate the authors' particular methods or biases. Some chapters discuss several methods that give high-quality results, but we try to avoid showing a preference, leaving the discussion of application to the teacher.

Some things can be taught by the teacher better than they can be explained in writing. Each teacher of photography will have particular methods of teaching various aspects of the subject. Thus, to concentrate on any specific approach to photography might lead to conflict with another valid approach. This principle has guided us in the creation of the chapters in this book.

We also realize that the most individual portion of photography is the personal-aesthetic approach to making pictures. This is subjective at best, and we feel that the student photographer with the assistance of the teacher must come to an understanding of his or her own personal approach and not mimic any text approach.

To present the student with aesthetic choices, we have gathered together a variety of approaches to using black-and-white photography from a number of well-known photographers and teachers. All aspects of this book's production have involved the creation of a "catalog" for students to use to see how the medium can be employed.

In defining the scope of the book, we chose to limit the materials presented to black-and-white silver halide technology. The con-

cern was not to fend off a future that now includes color photography and electronic imaging techniques, but to present material that is readily accessible to the vast majority of students of photography. For, even as we move into a changing technological mix, the use of the basic tools of black-and-white photography will remain valid.

We have included in this book many features specifically designed to assist in the learning process. Because photography is a visual medium, illustrations, photographs, and tables appear on the pages where they are discussed. This allows the student to visually coordinate the illustrations and the supporting text.

At the beginning of each chapter is a group of brief statements that can help the student understand the type and level of materials that will be presented. Safety and environmental logos are inserted at key spots in the text to alert students to these concerns. In the appendices of the book there is a complete list of the contributing photographers. A time line places the development of photography within the broader cultural, historical, and artistic developments of the last two centuries. Last, at the end of the book is an extensive glossary.

In the writing of this text, we have been assisted by many. These included Robert Jucha and Laura Evans for editorial and production assistance, and Cheryl Drivdahl for copyediting. Many reviewers gave needed input at various stages of the writing process. These included Dorothy Potter Barnett, Lansing Community College; Don Bruening, Daytona Beach Community College; Wilfredo Q. Castaño, De Anza College; Vernon Cheek, Purdue University; Darryl J. Curran, California State University, Fullerton; Jere DeWaters, University of Maine; George DeWolfe, Colorado Mountain College; Robert Fichter, Florida State University; John F. Foster, Victor Valley College; Gerald Lang, Penn State University; Fran Lattanzio, Indiana State University; Victor Lisnyczyj, Onondaga Community College; Kirby M. Milton, Lansing Community College; Rand Molnar, Brooks Institute of Photography; Kim Mosley, St. Louis Community College at Florissant Valley; Mark Murray, Association of Texas Photography Instructors; Tom Patton, University of Missouri, St. Louis; Kevin Salemme, Merrimack College; J. Seeley, Wesleyan University; M. K. Simqu, Ringling School of Art and Design; Luther Smith, Texas Christian University; Sean Wilkinson, University of Dayton; and Richard D. Zakia, Rochester Institute of Technology, New York. And the fine photographers who are listed in the catalog section shared their images. Most important were the many teachers and students who over the years have helped us learn how to teach.

BLACK AND WHITE PHOTOGRAPHY

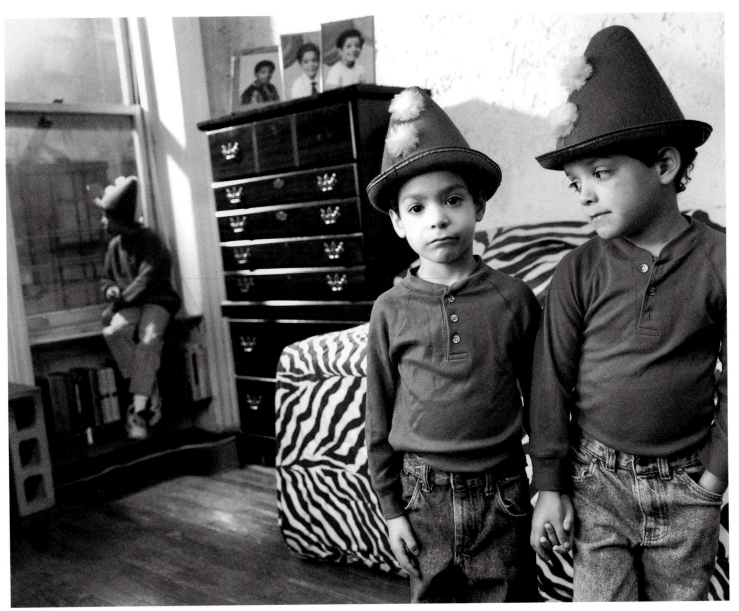

AIDS Orphans
Mary Ellen Mark/Library

CAMERAS

Modern cameras make photography in the 1990s much different than the process used by the pioneers of the medium. Gone are the days of cumbersome cameras requiring a pack mule to be mobile. Today, cameras are lightweight and in most cases can be handheld and hand operated. Five common types of cameras are available, along with equipment and techniques to support and operate them:

- Viewfinders are the most popular modern cameras and have great use today.

- A modification of the viewfinder camera is the rangefinder.

- The single-lens reflex camera is the popular choice of most serious amateurs and many professionals using the 35mm film format.

- The view camera's size and controls allow the photographer to make pictures of uncompromising quality.

- The twin-lens reflex camera brings to the photographer a larger film size and a different operating style.

- The camera must be supported to provide stability and allow for composing.

- A cable release is often used with a camera support to minimize camera motion.

Margot
© 1983 Nancy M. Stuart

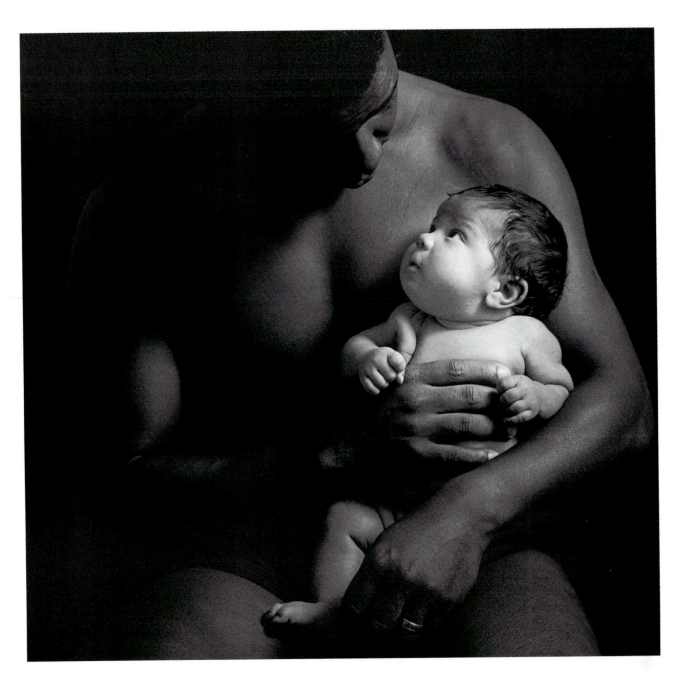

Today, people find it difficult imagining a world without photographs. Photography—which is the process of using light to create an image on a sensitized surface such as film—has been in existence since 1839. Surprisingly, cameras were around and in common use more than 300 years before that time. How were these cameras used without film?

The knowledge that light rays form an image when passed through a tiny pinholelike opening was well documented in history. Light rays pass through the pinhole and are represented in linear perspective, which is a technique for showing depth and distance by using parallel lines that converge. During the Renaissance, linear perspective was adopted by visual artists as the most desired method of illustrating reality. The **camera obscura** (Latin for *darkened room*) became the first basic camera design. This was a darkened room having a small hole on an outside wall. Light rays passing through the hole would project a lifelike image upside-down on the opposite wall.

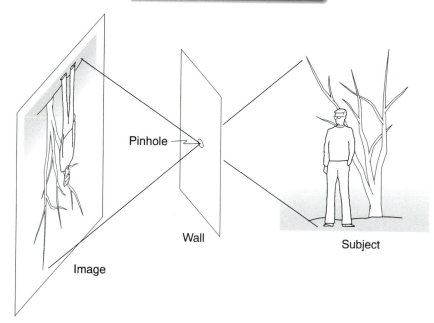

Light Coming through a Pinhole

Pinhole

Wall

Subject

Image

Lady Bird Grove in Fog
Nick Dekker

Reducing the camera obscura from a room-sized object to a small box allowed artists to use this device to record the world by tracing the projected image onto paper. Camera obscuras were fitted with a lens which gathered and focused the light to create brighter images. Lenses of various focal lengths—wide-angle, telephoto, and normal—were devised. A mirror was placed at a 45-degree angle behind the lens to project the image that passed through the lens up to a piece of ground, or frosted, glass, thus making these early camera obscuras single-lens reflex modules. The artist laid a piece of tracing paper over the frosted glass and traced the image, which was now right-side-up.

The transformation of the camera obscura to the types of cameras seen today came about when light-sensitive materials replaced tracing paper as a method of recording the image. A wide selection of cameras are available to choose from today. Camera types are generally categorized by the film size and the viewing system they utilize. For example, a 35mm single-lens reflex camera uses 35mm film and a single lens to reflect the image. The main film formats are small (35mm film), medium (120, 220, and two 70mm films), and large (4×5-inch film).

No matter what camera is purchased, the most important resource in understanding its correct use is its operation manual. Information contained in this manual is model specific and often unavailable elsewhere.

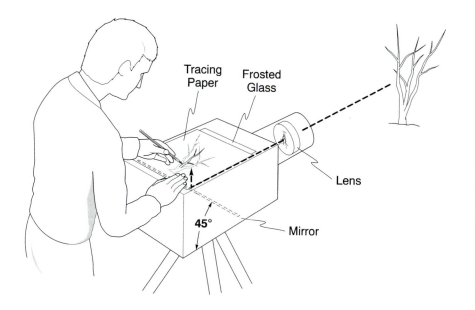

Single-Lens Reflex Camera Obscura
Artists were able to sketch from nature using a camera obscura image.

Tracing Paper

Frosted Glass

Lens

45°

Mirror

Viewfinder Camera

VIEWFINDER CAMERA

The most popular camera is the **viewfinder camera.** It has a separate viewing window that is located above and usually to the side of the taking lens. The taking lens is the lens that focuses the image on the film. The viewing window allows the subject to be framed roughly as it will be recorded on film. This type of camera does not allow the photographer to preview the focus in the viewfinder. Less expensive, lower-quality models have a fixed-focus lens, whereas many more expensive, higher-grade versions are autofocus. Most models are "point-and-shoot" cameras that are designed for snapshot photography. Although a variety of film sizes are available, the overwhelming majority of these cameras are manufactured in 35mm format.

Several manufacturers produce film boxes that contain a lens-and-shutter system allowing them to function as a camera. This one-time-use camera system has its roots in the Kodak camera introduced by George Eastman in 1888. The film box camera is an example of the viewfinder camera in its simplest form.

Roundup, State Line Camp, Idaho
© 1992 Adam Jahiel

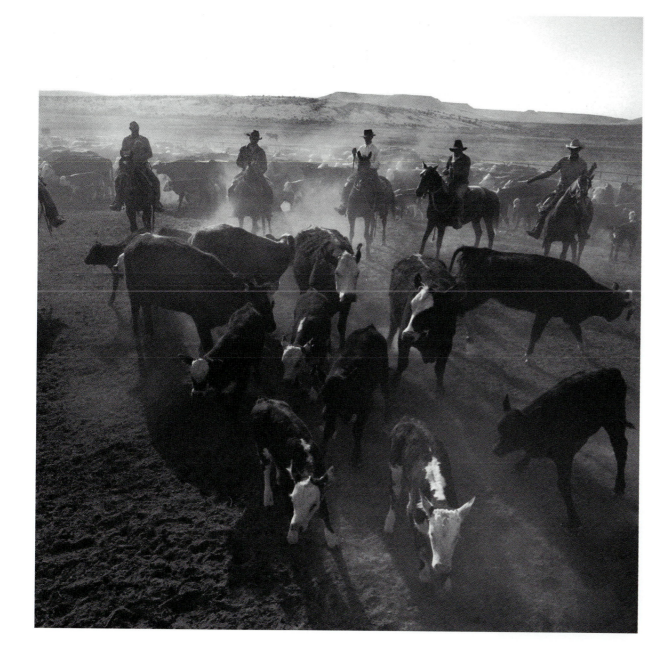

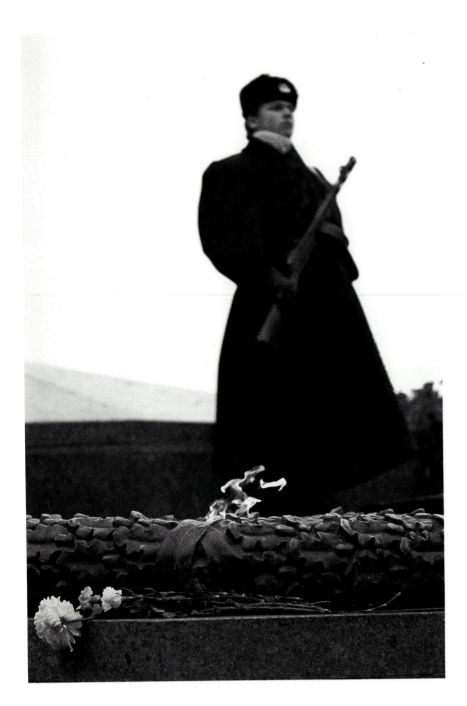

Odessa, Ukraine
David Litschel

RANGEFINDER CAMERA

Very similar in design to the viewfinder camera, the rangefinder incorporates a **rangefinder focusing system** within the viewfinder. Rangefinders use two focusing lens-and-reflector sets—lenses with either mirrors or prisms—which are placed in the camera body near the viewfinder. The images from the two lenses show a scene from two slightly different viewpoints, as do human eyes in binocular vision. The lens-reflectors are separated and the focusing mechanism uses the triangle formed by viewing binocularly to determine distance. When the images coincide, the focusing distance is set. When adjusting the focus, the photographer rotates the lens focus control and aligns a split image of the scene in the viewfinder. Rangefinder cameras are manufactured most commonly in 35mm format; however, many excellent medium-format cameras are also available.

The advantages of the rangefinder are many. It is lightweight and portable. It tends to be simpler in design than other cameras and it also possesses fewer moving parts, making it more trouble free and giving some advantages in slower-speed handheld shots. The viewfinder is bright and allows focusing in darker environments. The in-lens shutter allows for quiet and unobtrusive operation. The subject can be seen throughout the shooting procedure; it is not blacked out during shutter operation. Some models have interchangeable lenses, and viewfinders that delineate the limits of each lens's angle of view.

The depth of field cannot be previewed through the rangefinder viewing window. The depth of field can be determined by using the depth-of-field scale on the lens of some models.

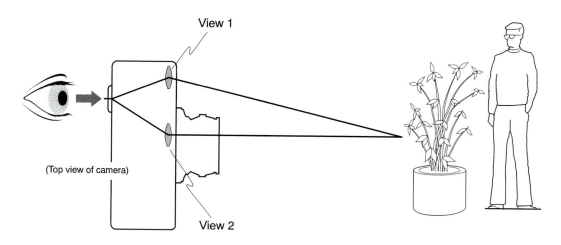

View 1

(Top view of camera)

View 2

The eye sees two views from the rangefinder
— view 1 and view 2 —
superimposed on each other in the viewfinder.
When the camera is focused correctly, these two views overlap perfectly.

In Focus

Out of Focus

Parallax Error

Viewfinder Sees **Lens Sees**

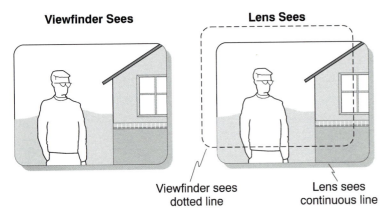

Viewfinder sees
dotted line

Lens sees
continuous line

Example shows typical parallax error with
viewfinder/rangefinder type camera

With both viewfinder and rangefinder cameras comes the problem of **parallax error.** Parallax error occurs in all cameras that do not allow the photographer to view the subject through the camera's taking lens. It is the difference between what will be recorded on film and what the photographer sees through the viewfinder. It occurs at close subject-to-camera distances—approximately 3 feet and closer.

Single-Lens Reflex Camera

Single-Lens Reflex Camera

The **single-lens reflex camera** is often referred to as an SLR. It is the overwhelming choice of most serious photographers who use handheld cameras. SLRs are manufactured in several size formats, though the vast majority are produced to use 35mm film. Because of its wide use, the SLR has been the target of many advances in camera technology in the past decade.

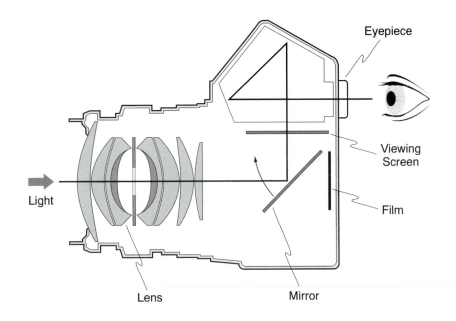

Eyepiece

Viewing
Screen

Light

Film

Lens

Mirror

The SLR contains one lens that acts as both the viewing lens and the taking lens. This design allows light coming into the camera to strike a mirror placed at a 45-degree angle directly in front of the film plane, and project the light to a viewing screen above the mirror. The image on the viewing screen is then corrected for lateral reversal by a pentaprism that is placed over the viewing screen. The photographer looks into this pentaprism from the rear of the camera, to focus and view through the SLR.

The SLR's ease of use is based on the single lens used to focus and expose the film. The photographer focuses on the subject through the pentaprism, selects an f-stop and a shutter speed, and cocks the shutter using a lever or knob that will usually advance the film at the same time. He or she cradles the camera firmly using two hands, and gently presses the shutter release button.

Report Card Ritual
© 1990 Claudia Siewert Liberatore

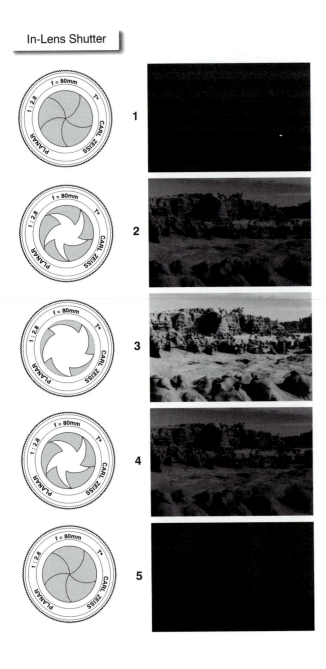

In-Lens Shutter

To enable the single lens to act as both the viewing and the taking system, the mirror must be removed from in front of the film plane to allow light to strike the film at the time of exposure. This is accomplished by hinging the mirror and having it flip up against the viewing screen during exposure. This function causes the viewfinder of all SLRs to go black for the time the shutter is open. Most models will automatically return the mirror to its position at a 45-degree angle, immediately following exposure. Some models require a recocking of the shutter to accomplish this task.

Either an in-lens shutter, called a "between-the-lens" or **leaf shutter,** or a focal plane shutter may be used in the SLR design. An in-lens shutter is the same as the shutter used in most viewfinder cameras. The shutter is made up of an iris which opens to expose the film. Most SLRs have a **focal plane shutter.** This shutter is located behind the mirror and just in front of the film plane of the camera. It utilizes two curtains that move across the film plane. While the shutter is operating, the leading and trailing cur-

tains chase each other across the film plane, allowing a slit opening between them to let light strike the film. Overall exposure of the film is achieved by this slit passing across the entire image surface of the film. The slit opening changes size with the shutter speed selected.

Focal plane shutters have the disadvantage of limiting the speed that can be used for flash photography. The very short duration of electronic flash and the fast speed with which the slit crosses over the film restrict the high end of synchronization. Typically, SLRs with focal plane shutters will synchronize at $\frac{1}{60}$, $\frac{1}{125}$, or $\frac{1}{250}$ second. The operation manual for each camera will specify the limits of the shutter speed of the focal-plane shutter. Any attempts to shoot at faster shutter speeds than the flash synchronization speed will result in a partial exposure. Lower shutter speeds are not restricted. This limitation does not apply for an in-lens shutter, which will synchronize at any speed.

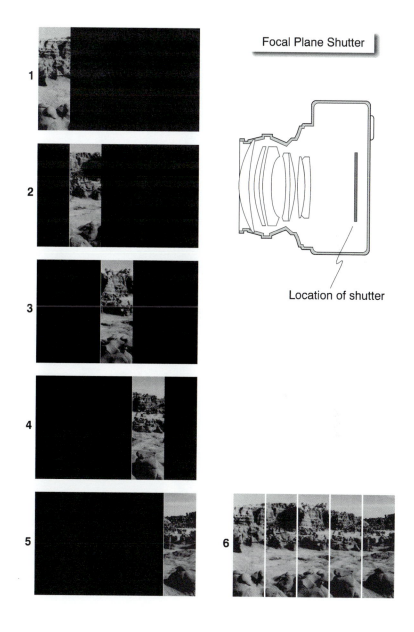

Focal Plane Shutter

Location of shutter

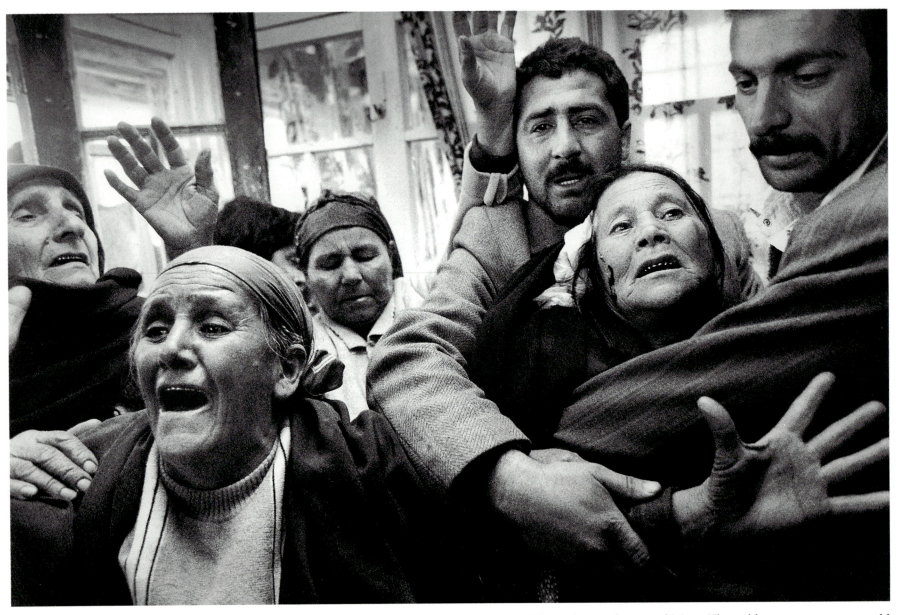

Victims of Hate. Azeri relatives of Maris Khatveldinov, a twenty-year-old villager killed by a sniper while feeding his cows, scream in anguish as they mourn over his body.
© Carol Guzy/Washington Post

SLRs have a wide selection of interchangeable lenses. Models with a focal plane shutter have the shutter in the camera body, thereby reducing the cost of the lens compared with that for SLRs with in-lens shutters. Many newer camera models have autofocus lenses. Some of these cameras will offer the option of manual focus or autofocus or both.

Many SLRs have light meters built into them. These are reflective-type meters and can prove quite convenient. They can range in design from a simple, center-weighted meter to meters that sample light readings across the entire image at the film plane and use this information to calculate exposure settings based on choices that have been predetermined by the photographer. Some SLRs incorporate one of three types of meters: reflective center-weighted meters, computer-assisted sampling meters, and spot meters that read a very small area of the scene, usually around 5 degrees.

Additional features abound for SLR cameras. The range of models extends from a very basic, all-manual SLR to a computer-driven, autofocus, autoexposure, autowind camera that reflects the greatest advances in the state of the art of camera design. These features add to both the cost of the cameras and their convenience.

Today, many SLRs include motor drives to advance the film automatically and recock the shutter. Some include motor drives as an integral part of the camera; some offer them added on as optional equipment. A choice of motor drive speed is available with top-of-the-line models. The selection of motor drive depends on your photographic needs. Sports photographers and others capturing fast-moving events will find it indispensable. Some photographers simply choose it for its convenience.

Most contemporary SLRs use an autoaperture lens. This means that when the lens is mounted on the camera, its aperture is wide open whenever the photographer looks through the viewfinder. No matter what f-stop the photographer has selected, the lens remains at its widest aperture for viewing and focusing. This feature permits

Three In–Camera Meter Configurations

Camera Viewfinder

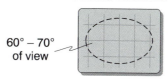

60° – 70°
of view

1. A center weighted metering system reads 60° – 70° of the image to make a light reading.

Areas of light and dark

2. The computer-assisted and sampling system is pre-programmed to identify various situations of light and dark in multiple sampling areas of the view.

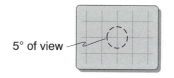

5° of view

3. The spot meter reads the light in 5° of the viewing screen.

During viewing, the aperture is not physically set in the lens because of the automatic lens feature.

The lens remains open at its maximum aperture to allow ample light to enter the camera for focusing.

When the depth-of-field preview button is depressed, the aperture is physically set in the lens.

The lens closes to f/11 to allow for a visual preview of the depth of field.

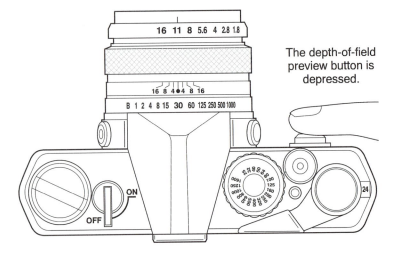

The depth-of-field preview button is depressed.

the maximum amount of light to enter the camera for easy focusing of the subject. When the shutter release button is depressed, the lens then stops down to the preset aperture as the picture is being taken. After exposure, the lens resets itself back in the full-aperture position for subsequent viewing and focusing.

The depth-of-field preview button, an option on some SLRs, enables the photographer to stop down the lens to the preselected f-stop and override the autoaperture viewing system. This permits the photographer to view the scene with the aperture that will be used to take the picture. By depressing this button, the photographer can accurately previsualize the picture's depth of field.

Self-timing devices are included on many SLRs. The self-timer may be a mechanically or electronically driven mechanism contained within the camera's body. Its purpose is to allow a time delay before the automatic release of the camera's shutter. This time delay lets the photographer be included within the picture.

Higher-quality SLRs have interchangeable focusing screens. The screens may be replaced by removing the camera lens and using a special tool to release the frame holding the viewing screen in place. These special-purpose screens help the photographer accomplish specific photographic tasks. For instance, a grid screen would be used for architecture photography and whenever a sense of true vertical or horizontal is needed. A bright screen is available to intensify the viewfinder image as much as four to eight times.

In the most advanced SLRs, a selection of shooting modes is provided. The most common modes are manual, aperture priority, shutter priority, and program. In the manual mode, all f-stops and shutter speeds are selected by the photographer. This exposure combination may be based on the light meter reading from the camera, from an external light meter, or from some other source. Manual mode allows the photographer the greatest degree of control over the exposure.

With aperture priority, the photographer selects the aperture, and the camera uses its own meter information to select automati-

cally the accompanying shutter speed. This mode is selected when the depth of field is a primary concern for a particular visual effect.

Shutter priority allows the photographer to choose the shutter speed that is required to achieve the desired visual effect on film. For example, with a slow shutter speed, the visual goal may be to blur the image of a moving object; with a fast shutter speed, the goal may be to stop the action of a subject. Once the photographer has chosen the shutter speed, the camera will use information from its light meter to set the appropriate aperture.

The program mode is the fully automatic mode of the camera. With the camera in program mode, the camera's meter will provide information to the camera regarding exposure. The camera will then automatically select an f-stop-and-shutter speed combination to match the meter requirements. The degree of control a photographer has in this mode is less than in the other three. In recognition of this situation, some camera manufacturers have offered specialty program modes that give the photographer a greater control over the program's exposure selection. One of these specialty program modes will always select the fastest shutter speed possible for the lighting situation. To accomplish this, it will always set the aperture as wide as possible. This mode is useful when the photographer is using a long–focal length, or telephoto, lens and a fast speed is essential to eliminate camera shake.

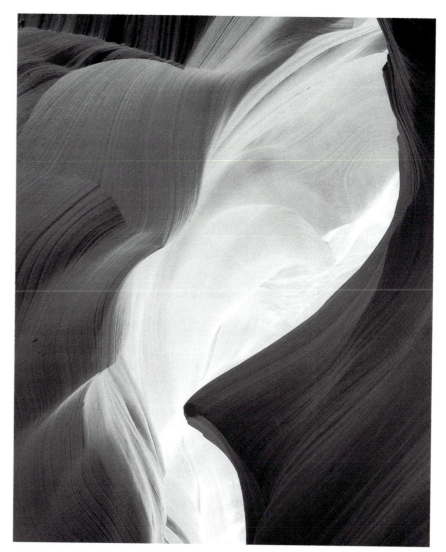

Antelope Canyon
© Nick Dekker

2-1/4 Single-Lens Reflex

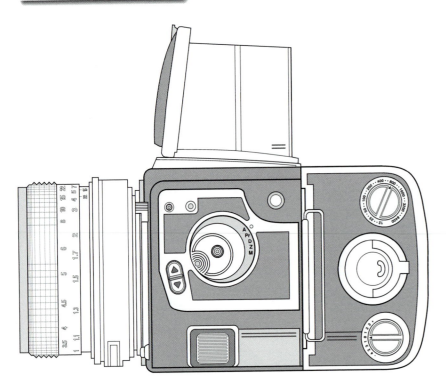

This type of camera allows for through-the-lens viewing and yields a larger image on film than 35mm resulting in a high quality image and the ability to reproduce a large print while maintaining that quality.

Several well-known brands of SLR cameras are not small but medium format, utilizing a 120 or 220 film size. These cameras may have in-lens shutters or focal plane shutters. They will generally have a different, and larger, appearance than 35mm SLRs. For the most part, all the technological advances and options offered on 35mm SLRs will be available with these cameras. A few options are obtainable that are not found on 35mm cameras. One of these is interchangeable film backs. If the camera is designed for changing backs, to switch film, make a format change, or switch to Polaroid film, levers on the back of the camera allow for the removal of one unit and its replacement. This allows the photographer to quickly change rolls of film in midroll. The use of a Polaroid film back is a standard procedure for medium-format photography, whereas it is highly unusual in 35mm photography. The Polaroid image is often employed to preview exposure and composition. Photographers who choose to use the 120 or 220 SLR will benefit from the larger film size that can result in higher-quality final prints.

The SLR is designed to allow for effective picture taking while the camera is handheld. However, provisions are made on most SLRs to place them on a tripod when necessary. For the highest image quality, a tripod should be used whenever practicable. With the potential for vibrations from the mirror inside the camera and for motion induced by the photographer's hand with longer lenses, the tripod adds significantly to the quality of SLR images.

TWIN-LENS REFLEX CAMERA

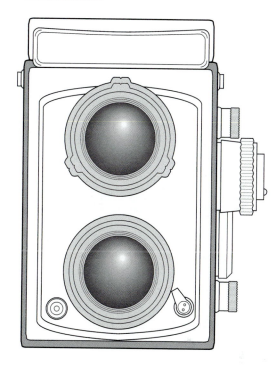

Twin-Lens Reflex Camera

Unlike other cameras, the **twin-lens reflex,** or TLR, has a two-lens configuration. One of the lenses is for viewing and focusing, and the other is for recording the image on film.

The standard design of the TLR places the viewing lens above the taking lens. A fixed mirror on a 45-degree angle is located behind behind the viewing lens, and it directs the image from the lens up to a viewing screen made of ground glass, on top of the camera. Typically, this viewing screen is shaded by a protective enclosure that pops up when the camera is opened. This shade allows for easier viewing of the projected image. The most common TLRs accept medium-format (120 and 220) roll film.

Being lightweight and portable, a TLR can be used on or off a tripod. Its design, with the top viewing chamber, allows waist-level operation. The viewing screen is large enough to allow for ease of composition. The larger size of the film used in TLRs yields a good-size negative helpful in producing quality enlargements. The use of roll film offers the convenience of multiple exposures without the constant changing of film holders.

A major concern with the TLR camera, as with the rangefinder, is parallax error. Also, the majority of TLRs receive an image on the viewing screen that is right-side-up but laterally reversed. This makes it difficult to follow moving subjects. Viewfinder prisms that will correct this situation are available as options on some models.

Herman Miller facility: Architect Frank O. Gehry and Associates, Inc.
Nick Merrick, Hedrich-Blessing

VIEW CAMERA

A view camera uses the lens to focus the image on a ground glass. A film holder is put into the camera between the lens and the ground glass for exposure. The large-format view cameras will be discussed in chapter 12.

CAMERA SUPPORT

Sharp images require a steady camera. A group of photojournalists were asked to shoot as slow as they could without bracing themselves on fixed objects. When the results were seen, it was determined that few of these professionals could get sharp images at shutter speeds slower than 1/60 second. Many photographers think they can discover a magic method to hold still at 1/8 or 1/15 second. Magic is not the answer: the way to do this is to put the camera on something. **Tripods** are commonly used to hold cameras steady for longer exposures. In the absence of a tripod some photographers use a shutter speed equal to 1 divided by the focal length of the lens as a minimum speed setting.

But even when shooting at higher speeds, the photographer has good reason to use a tripod. Framing and composing require fine adjustments while the camera is held steady. A tripod's design allows the photographer to look through the camera to see and study the composition of the picture. Because the camera is not moving, the photographer has control that allows refined visual judgments.

A tripod is perhaps the most underrated piece of photographic equipment. Too often, one is purchased as an afterthought. This means that little consideration is given to the real need. Tripods are designed for specific sizes of cameras, and selecting the appropriate one will make it more usable. A tripod designed for a large-format camera may be steady enough for a 35mm but too heavy to carry easily. The opposite is also true where the support for a 35mm is forced into use for a larger camera without providing the required steady base.

A photographic tripod has three basic parts: the legs, the head, and the column. The legs need to be strong enough to support the camera. When fully extended and locked, they should not bow or shake.

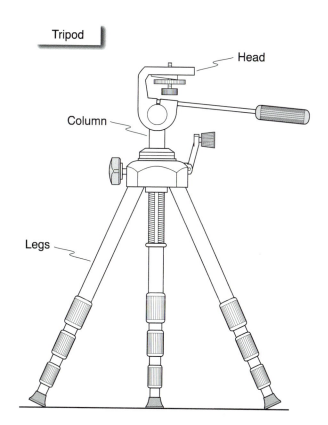

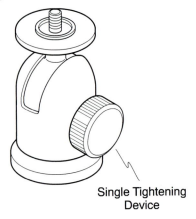

Ball Head

Single Tightening
Device

The head needs to have the types of movements required by the photographer. Most have the capability of rotating about three axes: one vertical, for panning, and two horizontal, for tilt and yaw. In some head designs, a ball is used to give these movements with one tightening device.

The column holds the head to the legs and allows the photographer to adjust the vertical height of the head in relation to the legs. Caution should be taken when using long column extensions, since the column is the least stable part of the tripod.

SHUTTER RELEASE DEVICES

It is also beneficial to have a shutter release device for use with a tripod. This allows the photographer to activate the shutter while adding the least motion to the camera. Three types of releases are readily available: cable releases, which come in lengths of about 6 inches to 3 feet; bulb-type air pressure releases of longer lengths; and electronic releases for remote operation.

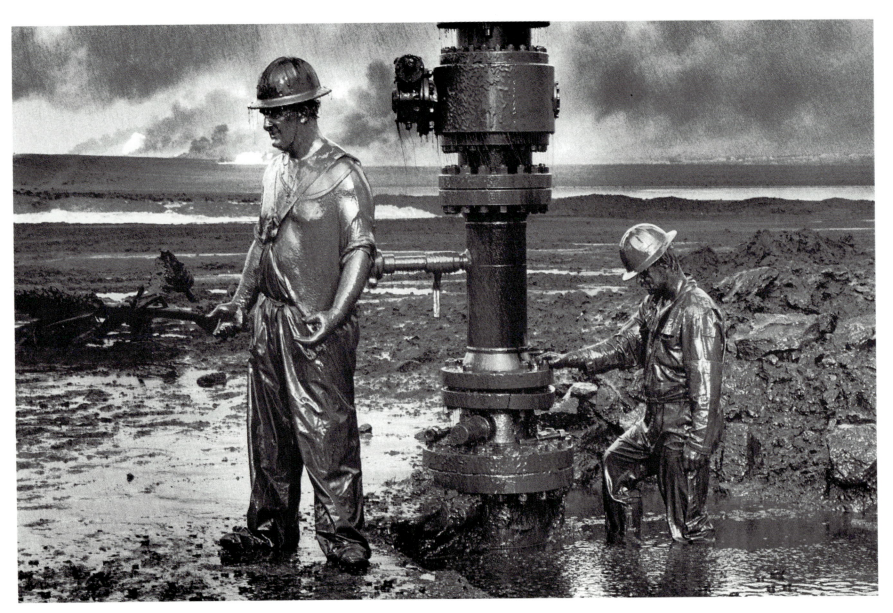

Kuwait
Sebastiao Salgado/Magnum Photos, Inc.

THE LENS

The lens gathers light, directs it into the camera, and focuses it on the film for a sharp image. Modern lenses are designed and constructed for specific functions. Several concepts make them effective:

- Focal length is the distance between the center of a lens and the film plane when the lens is focused at infinity.

- F-stops, or aperture openings, are the click stops for adjusting the opening of the diaphragm in a modern lens. They control the amount of light entering the camera and determine how much of the image is in sharp focus.

- Aperture is designated by f-numbers, which are used all over the world.

- Lens speed identifies the maximum amount of light that a lens will allow into the camera.

- The inverse square law defines the reduction in light intensity that occurs when a lens is moved farther from the film plane.

- Depth of field is the distance between the closest and the farthest area of sharp focus in an image. It is controlled by aperture and image magnification.

- Perspective is the relative size of objects in a photograph. It is controlled by camera-to-subject distance.

Random Light Rays Striking a Camera

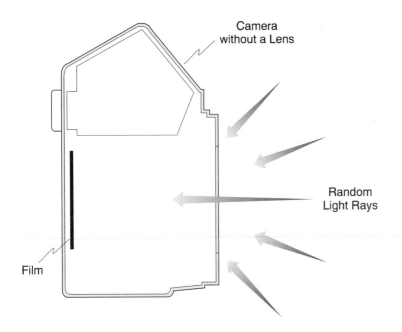

Camera
without a Lens

Random
Light Rays

Film

Light rays reflect off objects, travel in a random manner, and strike the camera from all angles. If they were to enter the camera through an open shutter without a lens, they would expose the film without creating an image.

The simplest cameras, such as the first camera obscura, use a pinhole to collect and focus the light rays. The size of the pinhole will vary relative to the distance the light has to travel from the pinhole to the film's surface. Pinhole cameras are capable of recording surprisingly acceptable images because the pinhole is very selective about the quality and quantity of light rays it allows to enter the camera. Of all the light rays in an environment, only those traveling the straightest path will ever strike the film.

Pinhole cameras have an extremely limited range of exposure speeds and are not efficient gatherers of light, which means they require very long exposure times. To shorten exposure times, cameras use lenses. Basic lens design has been around for centuries; as the camera obscuras developed, they were fitted with simple lenses. A lens forms an image by gathering light rays and focusing them on the film. The size and the curvature of the front lens element of the camera lens allows the lens to accept more light than does a basic pinhole. This results in shorter exposure times and therefore more camera flexibility.

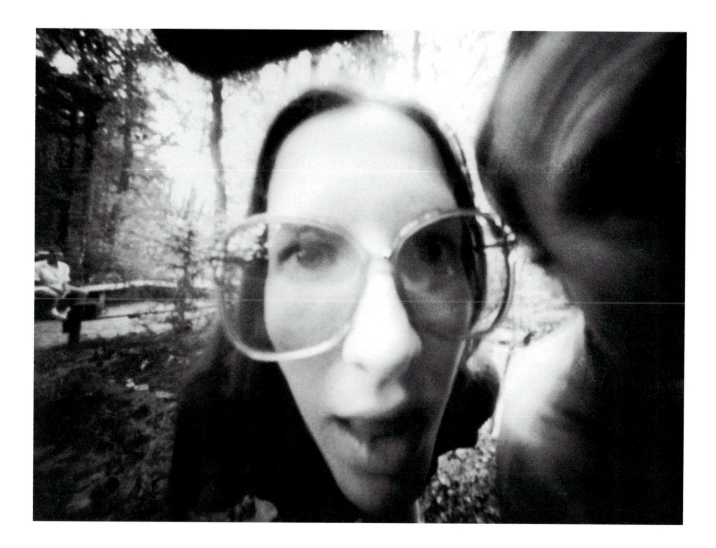

Untitled
Jerry Stratton

Points of Focus and Circles of Confusion

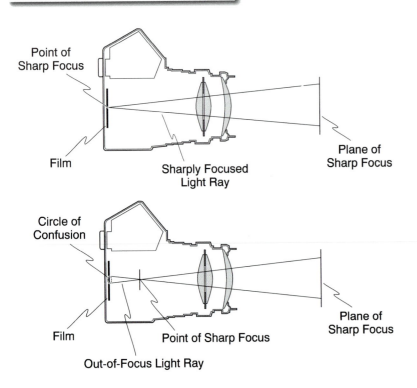

Point of
Sharp Focus

Film

Sharply Focused
Light Ray

Plane of
Sharp Focus

Circle of
Confusion

Film

Point of Sharp Focus

Out-of-Focus Light Ray

Plane of
Sharp Focus

The simplest lenses consist of one piece of glass, referred to as a lens element. Contemporary lens design is significantly more complex. Today, lenses are computer designed and use multiple elements of specific shapes and functions. These lenses minimize traditional lens problems with image definition, brightness, shape, and color.

All lenses are designed to focus light from one **plane of sharp focus** in front of the camera. The light that strikes the film in the camera from the plane of sharp focus will be recorded as points of focused light. Any light that enters the lens from areas in front of or behind that plane of sharp focus will be recorded on the film not as points of light but rather as tiny circles of light, called circles of confusion. If these circles of confusion are large, the image will appear to be out of focus. If they are small enough—$1/100$ inch or smaller—they will be seen not as circles but as points of sharp focus, even though the image is not actually in focus.

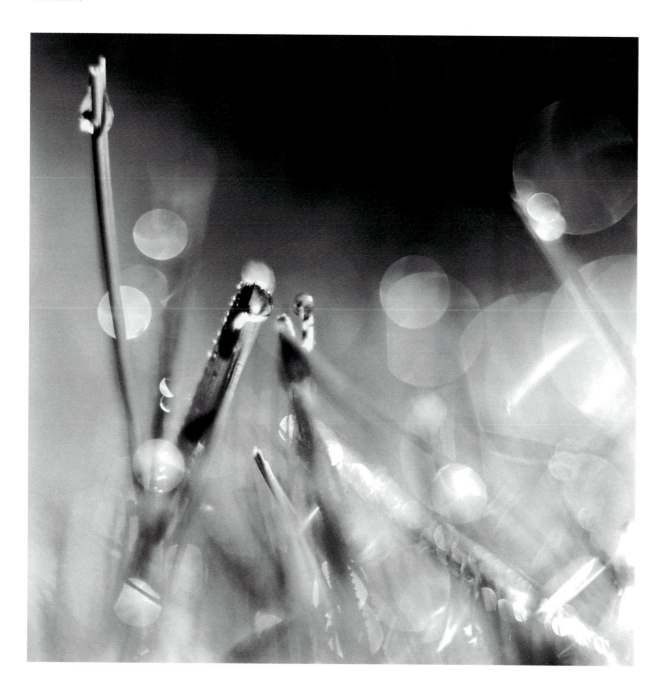

Dewdrop Series
© Dorothy Potter Barnett

Focal Lengths of Three Different Lenses

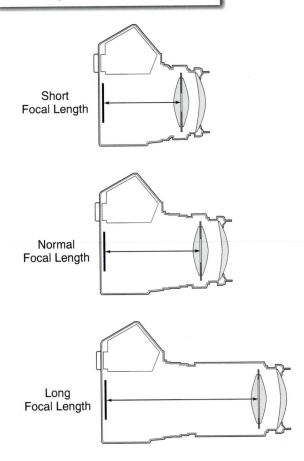

Short
Focal Length

Normal
Focal Length

Long
Focal Length

FOCAL LENGTH

Photographers talk about lenses according to the visual effect they have on the final image. **Wide-angle lenses** produce a wider angle of view in sharp focus than humans can perceive. **Normal lenses** represent a 45–55-degree angle of view, which is similar to the angle of crisp human vision. And **telephoto lenses** view a smaller angle than can the human eye.

The standard means of classifying lenses uses their focal length. **Focal length** is simply the distance from the center of a lens to the film plane when the lens is focused at infinity. If lenses were only single-lens designs, then the actual distance to the film would be the effective focal length. For reasons of size, weight, or camera operation, lenses are constructed to have a focal length longer or shorter than this actual physical dimension.

Photographers use the terms *short*, *long*, and *normal* to describe lenses with different focal lengths. A wide-angle lens has a shorter focal length than normal, and a telephoto lens has a longer focal length than normal. The focal length of a normal lens depends on the size of the image the camera produces.

By definition, a normal lens has a focal length equal to the diagonal measurement of the image area. A change in film size or film proportion will require a corresponding change in the focal length of the normal lens. Larger film or larger image sizes require a longer focal length to produce normal coverage; smaller film or smaller image sizes necessitate a shorter focal length to produce normal coverage.

Normal Lens Designation

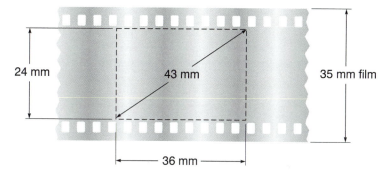

24 mm

43 mm

35 mm film

36 mm

The diagonal measurement (in this case 43 mm) of the image area is the normal lens size for any camera with any size film.

Manufacturers produce a range of focal lengths that would be considered normal for any film size. For example, the size of a 35mm film image is 24×36mm, and the diagonal measurement of this rectangular image is 43mm. Most normal lenses for this 35mm film format are 50mm, and the manufacturer's range for normal is from 40 mm to 58mm.

NORMAL FOCAL LENGTH LENSES	POPULAR FILM SIZES
35mm (half-frame)	21–28mm
35mm (full-frame)	40–58mm
2-¼ × 2-¼	80–85mm
2-¼ × 2-¾	90mm
2-¼ × 3-¼	100–110mm
4×5	135–165mm
5×7	210mm
8×10	300mm

The term zoom applies to a lens that is capable of changing focal lengths. For example, an 80–200 zoom can change to any focal length in between 80mm and 200mm. Zooms add the convenience of carrying one lens, to the advantage of having many focal lengths.

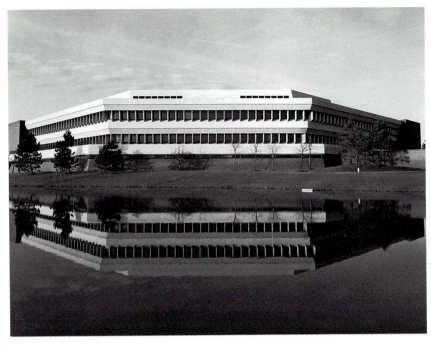

A. O. Building
Ike Lea

F-STOPS

Modern lenses have a mechanical iris, called a **diaphragm,** to control the amount of light passing through the lens and striking the film. This diaphragm sets the size of the aperture. To add consistency, most have click stops for adjusting the opening in the lens. These lens openings are called **f-stops** or aperture openings. Photographers use the phrases "opening up" to mean providing more light and "stopping down" to mean providing less light.

F-stops have two functions:

1. To control the amount of light entering the camera.
2. To control how much of the area of the photograph is in sharp focus. This is referred to as the depth of field.

Sterling Green, Senior Pro Rodeo Saddle Bronc Rider
© 1992 Adam Jahiel

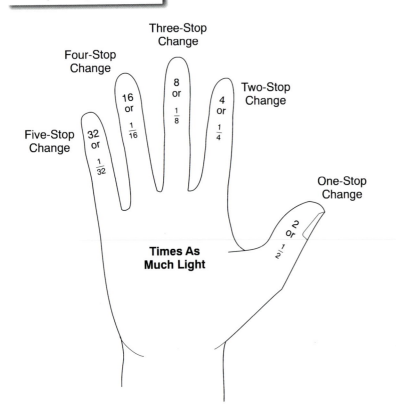

F-stop Changes and Light

Three-Stop
Change

Four-Stop
Change

8
or
1/8

16
or
1/16

Two-Stop
Change

4
or
1/4

Five-Stop
Change

32
or
1/32

One-Stop
Change

Times As
Much Light

2
or
1/2

APERTURE

A change of one f-stop results in a doubling or halving of the light entering the camera; a change of two f-stops causes four times more light or one-fourth the amount of light to enter; a change of three f-stops admits eight times or one-eighth as much light; and so on.

These f-stops or aperture openings have been assigned a numbering system that is standard throughout the world. The system consists of **f-numbers,** which are derived by dividing the focal length of the lens by the diameter of the aperture opening. For example, the f-number of a 50mm lens with an aperture opening that has a diameter of 25mm equals 50mm divided by 25mm, or f/2. The diameter of the aperture opening at f/2 is one-half of the focal length; at f/4, one fourth; and at f/8, one eighth. The formula is f = Focal Length ÷ Diameter. The same f-number set on lenses with different focal lengths will let the same amount of light strike the film, allowing for consistent control of exposure.

To be able to list all the whole f-numbers, it is only necessary to know two consecutive f-stop numbers, because every other whole f-number doubles and halves. For example, f/5.6 and f/8 are two adjacent whole f-numbers. To find all the other whole f-numbers, simply start doubling and halving f/5.6 and f/8. Doubling f/8 gives f/16, and halving it f/4; doing the same with f/5.6 yields f/11 (not all the numbers are neatly halved and doubled) and f/2.8. Putting all these numbers together creates an f-stop scale: f/2.8, f/4, f/5.6, f/8, f/11, f/16, and f/22. The smallest aperture opening will be the largest f-number, and the largest aperture opening will be the smallest f-number. The number f/22 signifies that each opening is one twenty-second of the entire focal length, and f/4 that each is one fourth of the focal length.

F-numbers, Focal Lengths, and Lens Diameters

$$\text{F-number} = \frac{\text{Focal Length}}{\text{Diameter}}$$

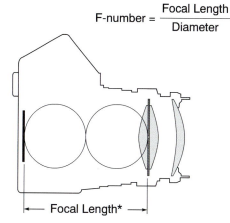

← Focal Length* →

With **f/2**, the diameter goes into the focal length two times.

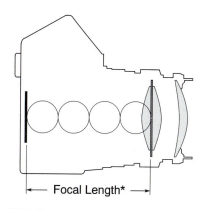

← Focal Length* →

With **f/4**, the diameter goes into the focal length four times.

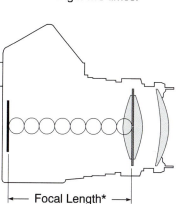

← Focal Length* →

With **f/8**, the diameter goes into the focal length eight times.

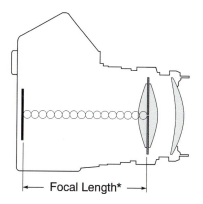

← Focal Length* →

With **f/16**, the diameter goes into the focal length sixteen times.

* Distance from center of lens to film

Common Full F-numbers and Aperture Openings

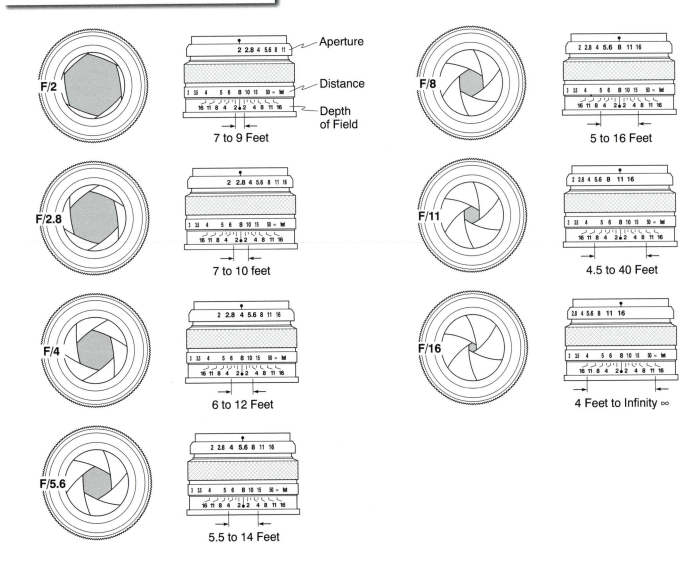

F/2 — Aperture — Distance — Depth of Field
7 to 9 Feet

F/2.8
7 to 10 feet

F/4
6 to 12 Feet

F/5.6
5.5 to 14 Feet

F/8
5 to 16 Feet

F/11
4.5 to 40 Feet

F/16
4 Feet to Infinity ∞

Because the f-number is a fraction of the focal length of the lens, the same f-number will designate a different-sized opening on lenses with larger and smaller focal lengths. The number f/2 will indicate a 25mm diameter on a 50mm lens, a 50mm diameter on a 100mm lens, and a 200mm diameter on a 400mm lens. This disparity in aperture size makes perfect sense when you consider the fall-off of light in lenses with a longer focal length.

LENS SPEED

Lens speed is a rating of the lens's ability to let light into the camera; the larger the maximum aperture opening, and thus the lower the f-number, the faster the lens. Lens speed and focal length are both important considerations when selecting a lens. Manufacturers produce lenses of the same focal length with different lens speeds. A 50mm f/2 lens and a 50mm f/1.4 lens are two examples. The advantage of a lens with a fast lens speed (a large maximum aperture) is the ability to take pictures in dim light, at faster shutter speeds, and with a brighter image when focusing. Telephoto lenses with very fast lens speeds have the ability, when used wide open, to create an extremely soft, out-of-focus background for isolating a sharp foreground subject. For view cameras, a faster lens speed may offer the additional advantage of a larger circle of illumination.

F-stops and Focal Lengths

f/4

Short Focal Length
(Wide Angle)

f/4

Normal Focal Length

f/4

Long Focal Length
(Telephoto)

Untitled
© 1982 Sam Wang

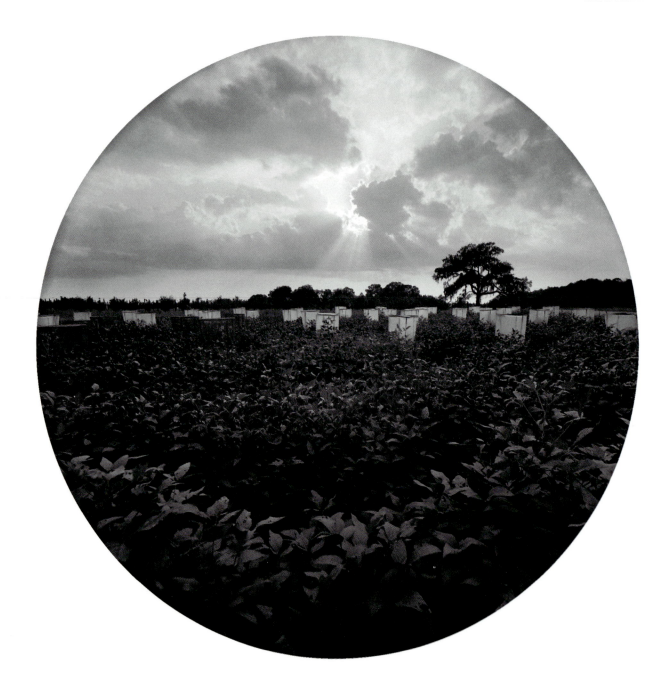

Inverse Square Law

The falloff of light that can occur in cameras is defined by the **inverse square law.** This law simply states that all light will be reduced to the inverse square of the change in distance. For example, if the distance from the center of the lens to the film is doubled, the light striking the film is one-fourth as strong.

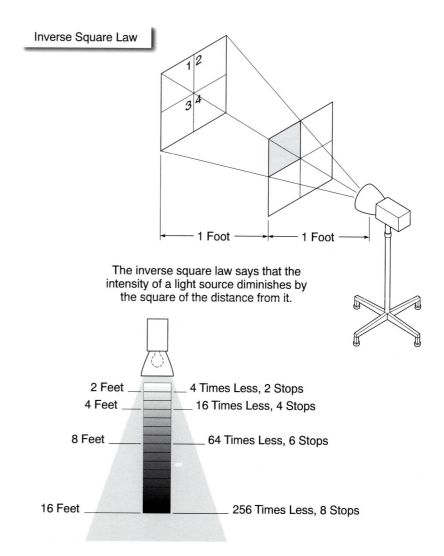

Inverse Square Law

The inverse square law says that the intensity of a light source diminishes by the square of the distance from it.

2 Feet — 4 Times Less, 2 Stops
4 Feet — 16 Times Less, 4 Stops
8 Feet — 64 Times Less, 6 Stops
16 Feet — 256 Times Less, 8 Stops

The illumination that eminates from a lamp and falls on a card diminishes in intensity by four times (two stops) if the card is moved twice the distance away.

Aperture and Scattered Light Rays

Wide Aperture Small Aperture

DEPTH OF FIELD

The **depth of field** is the distance from the closest area of sharp focus to the farthest area of sharp focus in an image.

Controlling Depth of Field

Depth of field is controlled by aperture and image magnification.

APERTURE. The wider the diameter of the aperture opening, the shorter the depth of field, and the smaller the f-stop opening, the longer the depth of field. Aperture diameter and depth of field are inversely related. That is, a doubling of the diameter of the aperture opening (a halving of the f-number) will nearly halve the depth of field. A larger f-stop opening allows more random scattered light rays to enter the lens and record on film, and a smaller f-stop opening allows fewer of these angular light rays to strike the film. The random scattered light rays are recorded not as points of focused light on film but as circles of confusion. A wider aperture opening will always produce more circles of confusion than will a smaller opening on the same lens.

IMAGE MAGNIFICATION. **Image magnification** is the size of a subject on film relative to its actual size. A change in image magnification can be achieved in several ways: by changing the focal length of the camera lens and by changing the camera-to-subject distance and by doing both. Image magnification and focal length are directly related to each other, and depth of field is inversely related to both. For example, with a camera-to-subject distance constant, a doubling of lens focal length will equal a doubling of image magnification and nearly a halving of depth of field.

A change in the image magnification enlarges or reduces the size of the circles of confusion recorded in the image. An increase in the magnification increases the size of the circles of confusion that are just smaller than a human can perceive visually. This changes these areas, which were once seen as points of sharp focus, to out-of-focus areas, resulting in less focus in the photograph, and less depth of field.

Making print enlargements from film will also increase the image magnification and will decrease the depth of field as the enlargement size increases. Some photographers stop down an additional f-stop or two when exposing the film, to compensate for these phenomena.

Untitled
© Nick Dekker

Madras, India
David Litschel

Determining Depth of Field

The most direct way to determine depth of field is to view it through a lens stopped down to the working aperture—the one the photograph will be taken at. This is effective with view cameras and other cameras having nonautomatic lenses, but not always possible with cameras having automatic lenses.

Most current 35mm SLR cameras have automatic lenses. These remain at the widest aperture opening, known as the **maximum aperture,** no matter what the f-stop control is set to. This feature is incorporated into cameras to facilitate focusing by allowing the maximum amount of light to enter the camera during viewing. The lens will stop down to the aperture set on the f-stop control, once the shutter release has been depressed and the mirror has moved up out of the way of the shutter (in SLRs) and the picture is taken.

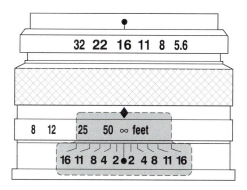

Automatic lenses prevent the photographer from stopping down to see the depth of field, unless the camera is also equipped with a depth-of-field preview button. Not all cameras have this feature; those that do, allow the photographer to view the scene at the working aperture and to see the depth of field. The disadvantage of the depth-of-field preview is that the image appears dark when small apertures are selected. It works very well for apertures close to the lens's maximum aperture.

A second manner to predict the depth of field is to use the depth-of-field scale engraved on the lens barrel of some cameras. This scale visually aligns the selected f-number with the distances on the focusing scale that would be in focus at that f-stop.

Manufacturers provide photographers with a third method to determine depth of field. Some instruction manuals contain tables that list the depth of field at various f-stops and subject-to-camera distances for the lens in use.

Hyperfocal Focusing

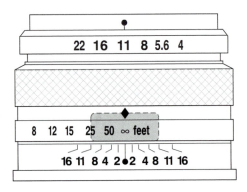

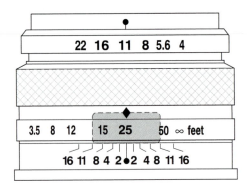

Focusing For Maximum Depth of Field

Many photographers utilize the axiom that at normal subject-to-camera distances, focusing one third of the way into the scene will yield a depth of field that comes forward toward the camera one third and recedes to the background two thirds. This is somewhat of a simplification; it works in most normal situations, and at worst is a good starting point for understanding the placement of focus for controlling depth of field.

Another technique that maximizes the depth of field in normal shooting situations is hyperfocal focusing. **Hyperfocal focusing** can be achieved by using the engraved depth-of-field scale on the camera lens barrel to shift focus to the hyperfocal distance.

The **hyperfocal distance** is the nearest point to the camera that is considered acceptably sharp when the lens is focused on infinity. It is the front end of the depth of field. When focus is shifted from infinity to the hyperfocal distance, the depth of field extends from a distance midway between the hyperfocal distance and infinity. This expands the image's area of foreground focus and lengthens the depth of field.

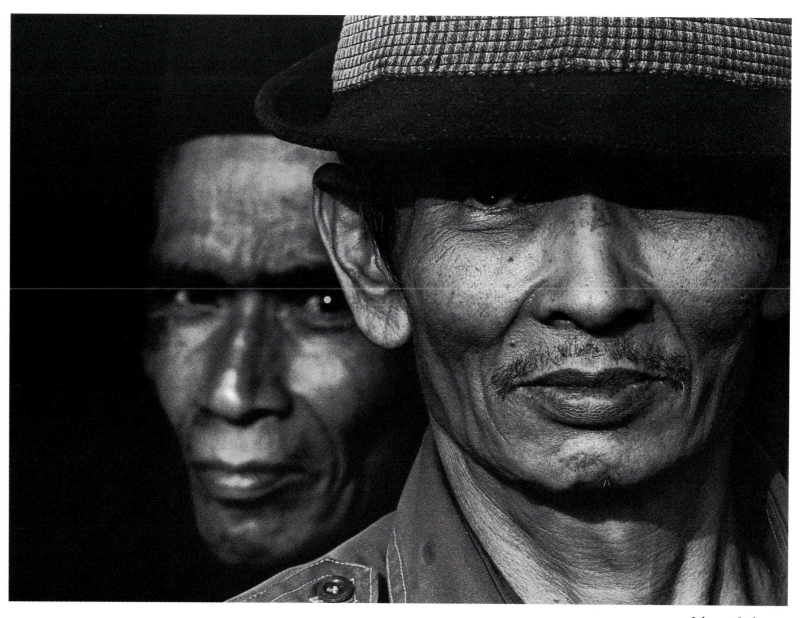

Jakarta, Indonesia
Paul Liebhardt

Using Depth of Field

The control of depth of field can have a dramatic visual effect on photographs. A minimal depth of field might be used to isolate a subject against a visually busy background by reducing the background to a soft, nonrecognizable backdrop. A maximum depth of field can communicate visual information related to texture, density, and deep space.

Selective focus is a visual tool many photographers use to make editorial statements with their images. It allows a sharp, in-focus image to be placed against a soft, out-of-focus—but still recognizable—foreground or background. This control of depth of field sets up a relationship between subjects within the photograph that the photographer orchestrates to achieve visual goals.

PERSPECTIVE

Perspective is the size relationship of objects to one another within space. In a photograph, it is controlled by camera-to-subject distance, not by focal length. Increasing the size of an image through the use of a telephoto lens does not change the size relationship of objects within that frame unless the camera-to-subject distance changes also. Using a wide-angle lens and a telephoto lens at the same camera-to-subject distance results in two very different photographs—but close examination will reveal that the difference is not one of a change in perspective. For example, if a foreground object is twice as large as a background object in the telephoto shot, that same relationship will hold true in the wide-angle shot.

Wide-Angle Distortion

Wide-angle distortion is the stretching of three-dimensional objects placed near the edges of the area to be included in the photograph. It is caused by off-axis light rays striking the film on oblique angles instead of on the lens axis. ("Off-axis" light rays are those not perpendicular to the film).

Wide-angle distortion can be used to establish a deep sense of space and a change in our normal perspective. It is enhanced by using lenses with a short focal length at close subject-to-camera distances. The distortion will be accentuated if the camera is not level with the subject.

Telephoto Effect

The **telephoto effect** is often described by photographers as the "stacking up of space" in a photograph. This effect can be used to flatten out the depth in a photograph. It is obtained by using lenses with a long focal length at far camera-to-subject distances.

Dream Reader, The Hunters
© 1992 J. Seeley

FILM

Cameras were in use long before the development of photography. It was the introduction of light-sensitive materials that made photography as we know it possible.

■ Films are exposed when light energy touches their emulsion. They react to light differently depending on their design.

■ Several concerns must be taken into account when choosing a film. The most important issue for many photographers is the speed of the film. The apparent graininess of the photograph varies with the type of film; a photographer may choose a particular type of film in order to maximize or minimize graininess. Contrast, resolving power, latitude, color sensitivity, acutance, shelf life, and processing ease also affect the choice of a film.

■ Films are constructed of an emulsion, a support, adhesives, and coatings.

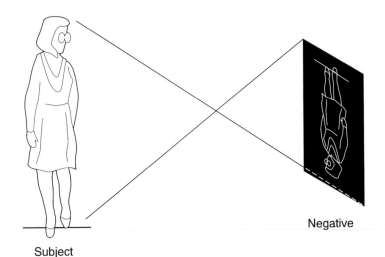

Subject and Negative

Negative

Subject

The creation of light sensitive material changed the camera from a tool of the painter to a tool of a new technology: photography. Today's film uses the same basic process established by William Henry Fox Talbot in 1839. This negative-to-print process uses separate sensitized materials in the camera, for the negative, and for the final print.

Black-and-white photography is based on the use of a **negative.** There are many steps between the taking of the picture and the seeing of the print. The image is projected on a light-sensitive surface that records it with all tones reversed. What is light in the scene is dark or opaque in this "negative" step. Film is the light-sensitive material that actually is exposed in the camera to create the negative.

FILM EXPOSURE

Film exposure happens when light energy strikes a film's emulsion. The **emulsion** is a coating of sensitized particles made up of silver and halogen ions. These ions are called **silver halides.** As the light strikes the emulsion, the silver halides change to form a latent image. A **latent image** is an image captured within the emulsion but not visible without chemical action. To form the latent image, a film requires a specific amount of light. If sufficient light energy is present, the latent image will form; if this critical amount of light is not present, no image will form. The color of the light will also affect the creation of the latent image.

FILM CHOICES

With today's technology, film is created to meet the specific needs of photographers. Photographers using black-and-white film have a great choice of types to take advantage of particular situations. Each film is designed to deal with specific sets of light conditions. Photographers can choose film based on its speed or sensitivity, its graininess, and its ability to be flexible in exposure and/or process, among other considerations. The choice of film will help determine the exposure and the quality of the final print.

Speed

The speed of a film affects many other aspects of the film's function. Film speed is referred to by an **International Standards Organization (ISO)** or **American Standards Association (ASA)** number. Both ratings are commonly used in North America, whereas the **Deutsches Industrie Norm (DIN)** system is common in Europe. These are standard speeds associated with the sensitivity of film.

The ISO/ASA speeds of films are arranged by relative sensitivity, with a higher number meaning the film is more sensitive to light. The speeds are calculated by defining the amount of light that will produce a desired density on the film and have specific characteristics.

The speeds are also set up on the primary photography concept of a **2:1 factor.** If a film's ISO/ASA rating is twice that of another, then the first film is twice as sensitive to light. This holds regardless of the numbers involved. Consequently, a film with a speed of ISO/ASA 200 is twice as sensitive as a film of ISO/ASA 100, and a film with a speed of ISO/ASA 400 is four times as sensitive.

In Egypt's Bahariya Oasis an old woman wears the marks of southern Saharan beauty: a qatah, or gold nose pendant, and a chin tatoo.
Paul Liebhardt

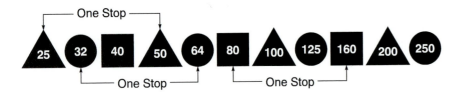

ISO numbers double and halve every third one.
Doubling or halving equals a change of one stop.

The film's ISO/ASAs are organized into three steps, with each succeeding step being one third more sensitive than the previous step. They are whole numbers that double or halve every third step. This gives a progression of 8, 10, 12, *16*, 20, 25, *32*, 40, 50, 64, and so on. For one set of steps, the doubled numbers are approximately the same as the denominators of the standard shutter speeds, which are 1/8 second, 1/15 second, 1/30 second, 1/60 second, and so on.

Graininess

One major concern of many photographers is the appearance of **graininess.** Actually, it is not possible to see the grains of silver in most photographs. What is seen is the pattern created by grains that clump together or shadows created in the film.

The speed and the grain are related. The photochemical reaction involved in exposing film requires more light intensity to activate smaller-surfaced silver crystals. The more light available, the finer the grains of silver that can be used to form the latent image. This means that for a given type of silver halide molecule, slower (lower ISO/ASA) films, which need more light, have a finer grain. Conversely, faster films have a larger grain structure.

Other Basic Characteristics

Though speed and grain are the major concerns in most film choices, consider several other basic film characteristics. **Contrast** relates to the amount of tonal steps between the lightest and darkest parts of the photograph. The **resolving power** indicates the film's ability to record fine detail. **Latitude** describes the ability of the film to handle over- and underexposure and over- and under-development. **Color sensitivity** is a measure of how much of the visible spectrum the film records. Panchromatic films are sensitive to all visible colors of light; orthochromatic films are not sensitive to red light; and specialized films such as infrared films are designed to record heat as well as the high end of the visible spectrum. **Acutance** is the film's ability to produce edge sharpness.

Another difference in film is its designation as either amateur or professional. Manufacturers label films in these ways for two reasons. First is the aging tolerance of the films. All films age and change the way they react to light as they are affected by time, heat, and other environmental elements. A manufacturer will plan a certain amount of "shelf life" into a film. This includes the length of time the film is projected to sit on the store shelf, the length of time it will be warehoused, and the length of time it will spend in shipping. Professional films are manufactured with closer tolerances (they produce better-quality images but also age more quickly than nonprofessional films) and need to be refrigerated while stored. The second reason for labeling films as either amateur or professional is that several films that are defined as professional require either special or exacting processing. The manufacturers assume that these demands will stop the amateur from choosing these films.

Two women mix bread by hand in a village near Turohansk, Siberia.
Thia Konig

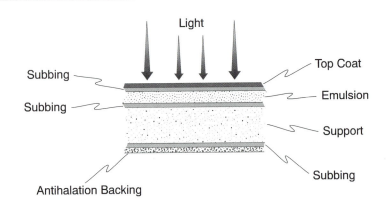

Cross Section of Film

Light

Subbing

Subbing

Antihalation Backing

Top Coat

Emulsion

Support

Subbing

FILM CONSTRUCTION

To understand what the film is able to accomplish, it is helpful to understand how films are constructed. Several parts of the film determine the way a film functions and its overall effectiveness. These are the emulsion, and the support, adhesives, and coatings.

Emulsion

The most important part of the film is the emulsion. Though the emulsion needs the other parts of the film in order to function properly, the major concern is how it reacts to light and how the action of the light on it is then transformed into a negative.

The two major parts of the emulsion are the light-sensitive silver halides and the gelatin.

SILVER HALIDES. The most important part of the emulsion is the **silver halides,** which are photochemically altered by light. These are ions of silver combined with ions of one of the five halogens (fluorine, chlorine, bromine, iodine, and astatine). When light or other electromagnetic radiation or both strike the emulsion, the silver halide crystals are altered to form a latent image. The exposed-but-latent image will not be visible until the film has been processed.

In common photographic film emulsions, three halogens are used. These are the elements chlorine, bromine, and iodine. The simplest construction has halogens replace the nitrate radical of silver nitrate when mixed in solution. This creates the ionic structure needed in the photographic process. When light strikes the silver halide crystals, the ionic electronic charge in each crystal is altered. This change allows the alkaline developer to identify the exposed silver halide crystals and to reduce them chemically into metallic silver.

Where is my son?
© 1993 Erhard Pfeiffer

In a pure form, the silver halide crystals are sensitive to blue and ultraviolet light—shorter—wave electromagnetic radiation. This means that without alterations, the emulsion would not react to all visible light. To facilitate a film's ability to react to all light, **sensitizing dyes** are used to absorb different spectral energy. Sensitizing dyes are designed to absorb spectral energies that do not normally activate the silver crystal; the dyes allow those energies to expose the film. The dyes also have a secondary effect of increasing the speed of the film.

Another configuration is to layer two emulsions that are sensitive to two different ranges of light, to create the ability to work with a longer range of light. This multilevel emulsion allows a film to be created to meet specific needs of a photographer. The most common film of this type is constructed with a slow and short-range emulsion on the bottom, and a faster and longer-range emulsion on top. The bottom emulsion is designed to work in the highlight areas of the scene, and the top emulsion is designed for the shadow areas.

The first consideration is building an emulsion is the way the grains of silver halide are formed and the resulting crystals on the film. The type of grain will determine many characteristics of the film. Two basic types of grain are used in film. Some types look like pebbles, and the others resemble flat tablets. Regardless of the type of grain, the larger the surface area of the grain facing the exposure, the faster the film. With a pebble-type grain, the size of the grain determines the speed. With **tabular grains,** the way the grain lies on the film also influences the way the emulsion functions. Tabular grains must be coated perpendicular to the direction of light for maximum effect.

The second consideration is the thickness of the emulsion. The thinner the emulsion, the finer the image structure in the film. Tabular grains tend to allow for thinner emulsion and a higher speed for the size of the grain. Because of their shape, tabular grains have more surface area than pebble grains. The increased surface area means that developing will be more critical.

GELATIN. **Gelatin** contains the light-active silver halides. Specially formulated gelatin is used for three reasons. First, it has little effect on the light as it exposes the film, because of the fineness of the gelatin particle. The gelatin used in photographic film is specially produced to give a fine, even texture with a light-transmission property that allows for good acutance and resolution.

Second, the gelatin must suspend the silver halides and allow for the chemicals in the process to work properly. Specially prepared gelatin uniformly distributes the silver halides throughout the emulsion. The chemical neutrality of this gelatin also allows the silver halides to be processed without interference. With the exception of a few impurities—some of which help the emulsion to function—the gelatin provides a clean support for the light-sensitive silver halides, without causing problems.

Third, gelatin can be softened during processing, by developing solutions. This allows the processing chemicals to react evenly with the silver halides.

Alan
© 1986 Nancy M. Stuart

Mind of Darkness—2
Nam Boong Cho

Support, Adhesives, and Coatings

For a film emulsion to work properly, several materials and coatings go into the construction of the film. The most obvious of these is the **film support,** or film base. In early photography, glass was used for this support—and for some applications, glass is still used. Most modern films, however, are made with a flexible polyester or acetate base.

The nature of the support material requires the use of special adhesives to hold the emulsion to the support. These adhesives are known as **subbing.** They are also used to hold the other elements of the film to each other.

One major problem created with some support material is that light can bounce and reflect within it. This causes either fogging of the film in some situations, or softening of bright areas of the picture. The highlight softening is called **halation.** To combat this effect, a light-absorption layer is coated on the rear surface of the film to keep light from reflecting back. This is the **antihalation backing.** Though it will reduce internal reflections caused by light passing through the film, it does little to reduce minor fogging along the film's edge. Both the antihalation backing and sensitizing dyes are removed in normal processing.

A **top coat** is commonly used for two reasons. One, it is applied as a protective coating for the softer emulsion. Two, with the development of finer and thinner emulsions, it is also used to add texture to the front surface of the film, to allow for retouching.

City Palms
Linda Wang

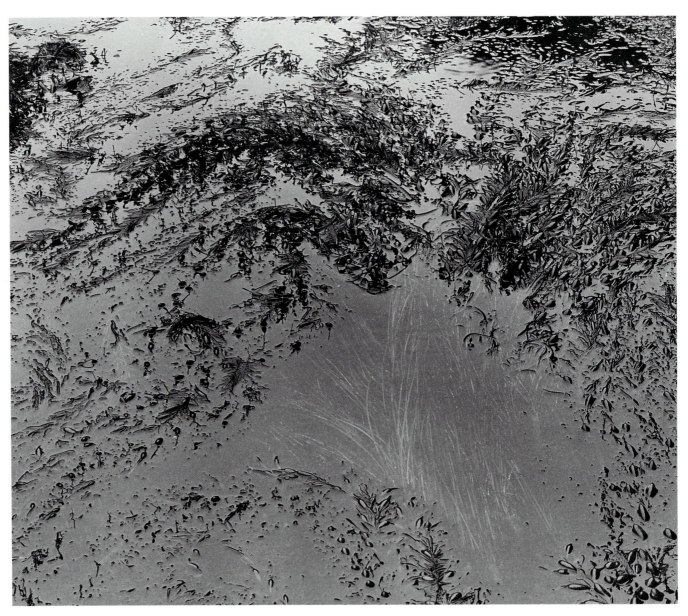

Low Tide Point Lobos #4
Glenn Rand

EXPOSURE

Making a good photograph starts with good exposure on the film. Several effective techniques and tools are used to control exposure:

- Understanding and using the sun as a standard for exposure, called basic daylight exposure, is the basis of nonmetered photography.

- Understanding middle gray is the key to understanding metered exposure.

- The two types of light meters are reflective and incident. Many styles are available for the photographer, including through-the-lens, handheld, and spot meters.

- Reflected-light metering reads subject tones (the light reflected off the subject).

- Incident-light metering reads the light that falls on the subject and gives results similar to those from a reflected-light meter pointed at an 18 percent gray card.

- Three methods for metering reflected light are average, average value, and substitution. Average metering uses a simple system for reading the mix of light, middle, and dark tones in a subject and producing a camera setting based on all the light coming from the subject. Average value metering has been developed for situations where the lighting does not approximate 18 percent gray or the range of light is beyond the normal range of exposure. The substitution metering technique is used to eliminate problems caused by subject tone.

- The ability to calculate equivalent exposures to control either shutter speed or depth of field is an important tool for the photographer.

- Reciprocity effects vary greatly among films.

Militia raise their hats and cheer against background of gunfire smoke in a re-enactment of the Battle of Groton Heights in Connecticut.
© Anacleto Rapping

The proper **exposure** of the negative is the key to making an excellent photograph. Until the negative is exposed, no other part of the photographic process can take place. For this reason, taking the time to make a good exposure will greatly improve the rest of the photographic process.

Several approaches can be used to make correct exposures. These include methods that do not require a light meter and several that do. They also include considering equivalent exposures, reciprocity effects, and solarization.

NONMETERED EXPOSURE

Most modern cameras have built-in light meters to help with exposure. But acceptable exposures can be made without using a light-metering device. The key to using a nonmetered exposure system is to be able to judge the intensity of the light. Many great photographers have spent their lifetime understanding light intensity. The use of the sun as the dominant source of light in photography simplified this a great deal.

The sun is the key to nonmetered exposure. Two characteristics make the sun usable. First, the sun is a constant source. Second, in most situations, the light from the sun can only be decreased by atmospheric conditions. This means that the sun can be used as a standard measure for the light employed in making photographs.

The amount of light on a sunny day will give a basic exposure equal to a lens setting of f/16 at a speed setting of 1 divided by the ISO (f/16 at 1/ISO). This means that if the film in the camera is ISO 125, then on a clear, sunny day, the exposure will be f/16 at 1/125 second. This is often called the **sunny day rule.** It is also the key to the **basic daylight exposure (BDE) method.**

The BDE chart is a list of camera settings that can be used to predict correct nonmetered exposure. This chart is not a mysterious thing. If you look either at the inside of the box a film comes in or on the data sheet packaged with the film, you will often find an

exposure guide that gives BDE information for a few common lighting conditions; the settings on this guide are based on the intensity of sunlight. The BDE chart covers more situations. It gives comparisons to the sunny day rule in the number of stops of change required based on the type of light illuminating the scene. In this chart, the speed of the shutter is 1/ISO. Notice that only the first light situation requires less exposure than is needed on a sunny day, or stopping down.

BDE CHART

LIGHT CONDITION	EXPOSURE CHANGE	F/STOP
Bright sun off snow or sand	One stop less	f/22
Sunny day	Normal	f/16
Bright hazy sunlight	One stop more	f/11
Normal bright cloudy light	Two stops more	f/8
Heavy overcast or open shade	Three stops more	f/5.6
Neon and lighted signs bright or stage show spotlights	Five stops more	f/2.8
Major sporting events, bright streets in theater districts, fluorescent office lights, store windows at night, and ground fireworks	Six stops more	f/2
Brightly lit downtown streets	Seven stops more	f/1.4

Under normal sunny day conditions on a downtown city street, a photographer using BDE will encounter two basic lighting conditions: sunny day light on one side of the street, and open shade on the opposite side of the street. The experienced photographer will instinctively change the exposure setting on the camera by the three stops between these lighting conditions as she or he crosses the street. This readies the camera without the photographer having to take a meter reading.

BDE provides normal subject tones, that is, true tonality, without any metering influences.

Taipei, Taiwan
David Litschel

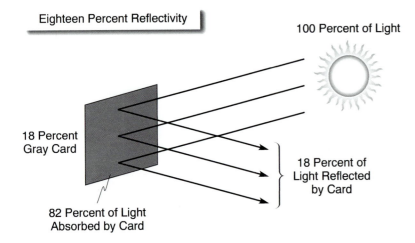

Eighteen Percent Reflectivity

100 Percent of Light

18 Percent
Gray Card

18 Percent of
Light Reflected
by Card

82 Percent of Light
Absorbed by Card

An eighteen percent gray card absorbs 82 percent
of the light striking it and reflects only 18 percent
of that light. We see it as middle gray.

METERED EXPOSURE

Middle gray is the basis of metered exposure. This is not the same thing as 50 percent black and 50 percent white; it is the tone that is perceived as being halfway between black and white. In black-and-white photography terms, **middle gray** is defined as the color or tone that reflects 18 percent of the light that falls on the subject. This means that if 100 units of light fall on the subject, only 18 units reflect from the subject. If the subject reflects 18 percent, it will be recorded as middle gray in a black-and-white photograph. The 18 percent reflectance level is the one metering systems use to calculate exposure. The meter will read all the light within its viewing area and use that to set the exposure of the film to record the overall reflectivity at 18 percent.

Most cameras have meters as a part of their operating system. Usually, the meter is designed to take an average reading from the scene. This means that the meter takes all the light reflected in a scene and calculates the exposure. The result will give the camera settings needed to produce an average negative or in the case of autoexposure cameras, will actually activate the setting of the camera.

The key to all metering systems is the way middle gray is used to produce the proper exposure. When this reflectance level is established, the exposure becomes a calculation of the length of time the shutter is open (shutter speed) and the amount of light passing through the lens (f-stop).

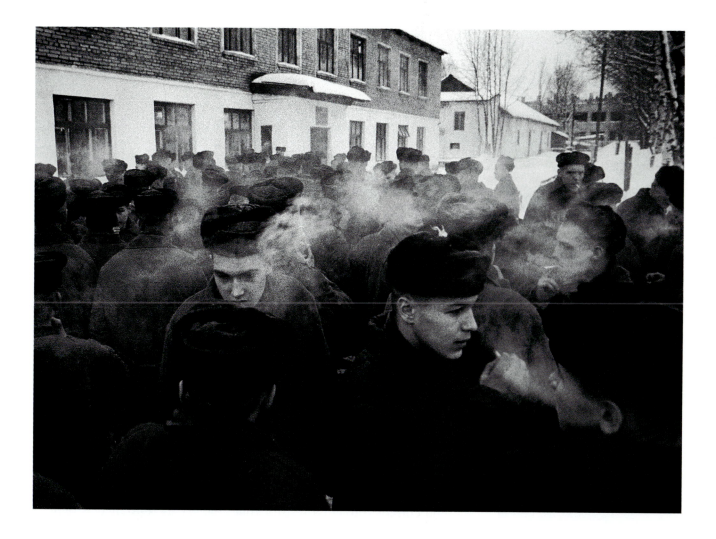

Photo taken at a prison for young prisoners north of Russia, 1989, from the series "Atonement."
Igor Gavrilov

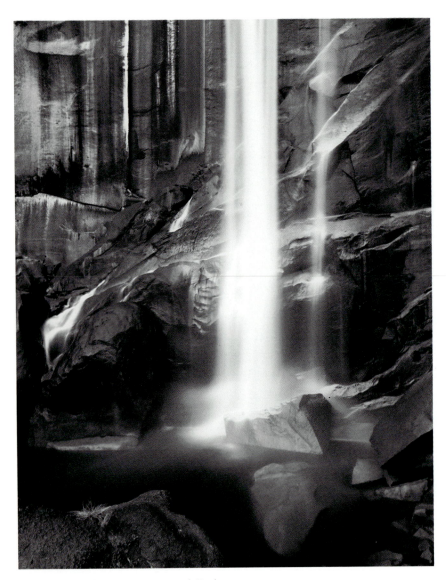

Vernal Fall, Yosemite National Park
D. A. Horchner

LIGHT METERS

Light metering systems **(light meters)** are used for the majority of photography.

Through-the-Lens and Hand-Held Meters

The **through-the-lens (TTL) meter** is the most common meter used in photography. Within highly integrated camera systems, a TTL meter is used with a small in-camera computer to produce **programmed exposures.** This allows the computer to take into account the amount of light coming through the lens, the film speed, the desired f-stop, and the lighting conditions (such as backlighting), and to set the camera to make the exposure.

Some cameras do not have a TTL and some specific photographic techniques do not work with a TTL; in these cases, handheld meters are used. These meters measure the amount of light falling on the subject or the amount of light reflecting off the subject or both.

The way the light is actually measured is not dependent on the type of light measured. Meters employ two basic methods to read the light. One method uses the energy from the light to produce an electrical charge and then measures that charge. Instruments that use this method are known as **photovoltaic meters.** Resistance-based meters such as **cadmium sulfide (CdS) meters** or **silicon diode meters** are more common. These use a battery to send current through a resistor that changes its resistance as light acts on it.

Both light-measuring systems, have advantages and disadvantages. Resistance meters require batteries, and lose their effectiveness in the cold or with low battery power. Photovoltaic meters tend to drift to lower power output as they remain exposed to strong light. Resistance meters tend to have a memory, which will cause a lag in their reading of actual light after a rapid decrease of light value. Using a constant current as opposed to converting light energy to a current allows the resistance meters to be better in low-light situations.

Incident- and Reflected-Light Meters

Meters are designed to read **reflected light, incident light,** or a combination. They are manufactured for use in continuous light (sun, tungsten, etc.) as well as for use with electronic flashlighting.

Within the group that read reflected light are **averaging meters,** which take a light reading over a large angle of coverage, and **spot meters,** which use lenses to read very small areas of the scene. Most continuous-light meters and several flash meters read reflected light. A special adaptation of the spot meter is the **large-format probe** which becomes a TTL meter for sheet film cameras. Large-format probes are available for both continuous-light and flashlight applications.

All **reflected-light meters** will read the light that reflects from a surface. If that surface reflects only a percentage of the light that falls on it, the meter will assume that amount of light is all the light present. Since light-meters are designed to calculate exposure based on an average reflectance of 18 percent, the subject reflectance will affect the exposure. An averaging meter is programmed to assume that the mix of light averages 18 percent for the entire scene. A spot meter reads the reflected light from a small portion of the scene and allows the exposure to be set based on the 18 percent concept for a very small portion of the scene.

Incident-light meters are used to read the light falling on the subject. Their design takes out the variability of the subject tone by using a diffusion dome to accept the light. This dome is pointed toward the camera from the scene, and the meter records the light available to make an exposure. Incident-light meters are also designed around the 18 percent reflectance concept. They are manufactured to give a reading equal to a reflected-light meter's measuring of an 18 percent gray card. The most common studio and flash meters are incident-light meters.

Advancements in meter technology have allowed several manufacturers to build meters that function in all these ways. The photographer can find a meter that reads average reflectance, spot

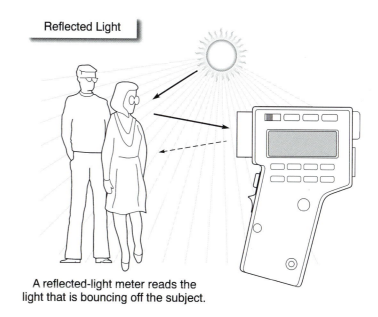

Reflected Light

A reflected-light meter reads the light that is bouncing off the subject.

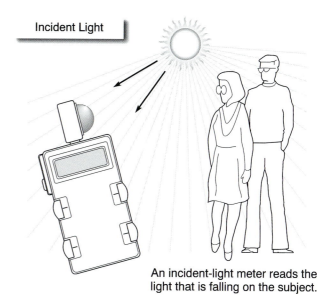

Incident Light

An incident-light meter reads the light that is falling on the subject.

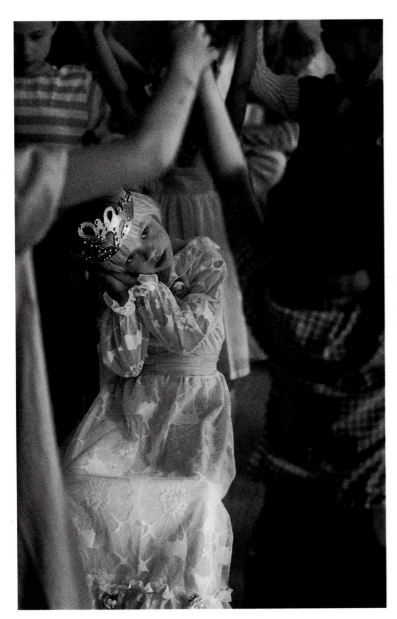

The Sleeping Beauty, 1987, Helsinki
Leena Saraste

reflectances, and incident light, and can be plugged into a probe. These meters work for both flashlight and continuous light.

REFLECTED-LIGHT METERING

Averaging Meters

In the averaging meter, calculations for exposure are based on producing a negative that will have an overall average tonal value of middle gray. The average scene contains about the same amounts of light tones as dark tones. If these are mixed with the larger group of middle tones present in the scene, then the scene will have an overall middle gray value. The metering device is used to read the mix of light, middle, and dark tones, and produce a setting for the camera based on all the light coming from the subject.

For the most part, this simple system works. Most scenes are made up of a mixture of tones that are close to the mix designed into the metering systems. The meter in the camera or working with the camera gives a good reading and produces acceptable camera settings for most amateur purposes. This is why most cameras use this method of determining exposure settings.

Problems with an averaging meter come about only when the mix is out of the bounds of the design of the system or when the lighting within the scene is not normal. For example, if a photograph is taken of a large expanse of sand, the metering system will not know that the camera is pointed at a scene made up of a large amount of light-toned material. The metering system will assume that the designed mix is present, and the camera settings will be stopped down to produce an overall middle gray. With normal processing, the negative will be underexposed. In effect, the sand will be recorded as middle gray, the middle tones in the scene will become dark, and the dark tones will become unexposed and will reproduce as black.

The opposite will be true if a photograph is made with a large expanse of black. When an averaging meter reads a large amount of black in the mix of values, it sets itself to overexpose. The black will be exposed as though it were a middle gray, a lighter tone than actually present. This type of mixture of tones will produce an overexposed negative with normal development.

If the subject to be photographed falls into an abnormal mix or lighting situation, the BDE can be a check to see if the metering system is giving a reasonable setting.

Average Value Metering

A method that can be used to get correct exposure in some situations is **average value metering.** This method can find the average value for the light intensities of the scene, and use that information to make the exposure. It can easily address the effects of abnormal light or of lightness mixes that are outside the balance of the metering system. If the meter reads only snow, it will give an exposure calculation to render the snow 18 percent, which is darker than the actual subject. Likewise, if the subject is very dark, the meter will give settings to make it the same 18 percent, which is lighter than the actual subject.

To avoid having the meter "faked out" (fooled) by light conditions or subject tone, the photographer can determine his or her own average for the scene. This means the averaging effect is in the control of the photographer and not just the meter. To find the average value, the photographer needs to determine two critical areas of the photograph: the highlight detail and the shadow detail. The photographer decides at what point in the picture detail is required in the shadows and in the highlights. These two areas of the picture then become the measure for making the exposure.

In a normal situation, thirty-two times more light reflects off the highlight detail areas in the picture than off the shadow detail

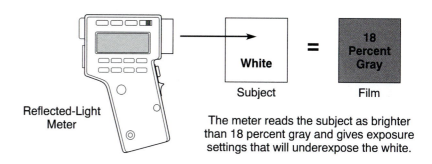

Subject Tonality and Reflected-Light Metering

Reflected-Light Meter

White
Subject

= 18 Percent Gray
Film

The meter reads the subject as brighter than 18 percent gray and gives exposure settings that will underexpose the white.

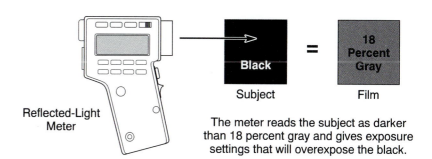

Reflected-Light Meter

Black
Subject

= 18 Percent Gray
Film

The meter reads the subject as darker than 18 percent gray and gives exposure settings that will overexpose the black.

The Five-Stop Range

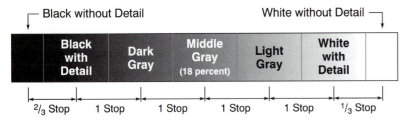

In the five-stop range each value is one stop away from
the adjacent value except at the two extremes.

areas. This is a statement not of how much shadow is in the picture but of how much light is reflected off the shadow areas. In a scene that has a large amount of shadow area, an average meter might overexpose the negative trying to make the large dark area 18 percent gray. With the average value method, the reflectivity of the large dark area becomes just part of the exposure calculation.

The average value method uses two elements in producing the exposure setting. First, the meter will try to set any portion of the picture it reads at 18 percent gray. Second, the light intensity reflecting from the highlight details and shadow details normally has an exposure range of from 8:1 to 32:1 (three to five stops). That is, the highlights are reflecting from eight to thirty-two times more light than the shadows. This does not include black and very dark areas of the picture or white and very light areas of the picture.

After the photographer has established what areas in the picture will have critical shadow and highlight details, the metering can be done. The metering is accomplished by bringing the light meter or the camera in close to the subject to read the light off only each area identified as critical. Care must be taken not to change the light reading by casting a shadow or reflecting more light into the subject area being metered. When both the shadow detail areas and the highlight detail areas have been metered, the average value reading is found by determining the center point between the highlight and shadow readings. This average of the highlight and shadow readings is used as the exposure setting because the meter is trying to move both readings to 18 percent gray.

For example, assume that the shadow reading is f/4 at 1/125 second. In the same scene, the highlight reading is f/16 at 1/125 second. At the middle setting, f/8 at 1/125 second, the exposure will be affected by the lighting on the subject regardless of the amount of highlight or shadow tone within the scene.

The average value method works well within the limits of the film. If the difference between the highlight and the shadow is greater than five stops or less than three stops, the exposure can be

Dunes
Glenn Rand

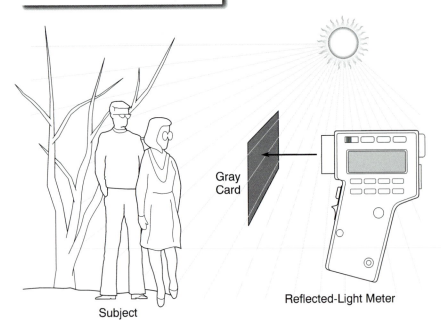

Use of the 18 Percent Gray Card

Gray Card

Reflected-Light Meter

Subject

The gray card can be used to take an accurate substitution reading. It must be in the same illumination as the subject and have no glare or shadows cast on it.

corrected by manipulating the contrast during the development of the film. Outside the five-stop range limit, the average value method cannot be used owing to the exposure limit (the latitude) of the film.

Substitution Metering

When it is important to avoid being misled by light or subject imbalances, many photographers use **substitution metering.** This method employs an object other than the subject to read the reflectance of the light falling on the scene. If this substitute's reflective percentage is known, then the settings will be based on the amount of light that is reflected from it. In this way, an object of known reflectivity is used to keep the scene's lightness or darkness from disturbing the exposure.

The concept of 18 percent reflectance once again makes this process successful. Several manufacturers produce materials of 18 percent reflectance. These items are marketed as 18 percent gray cards. (An 18 percent reflective gray card is on the inside of the back cover of this book.) Often the use of a gray card is called midtone metering.

To use a gray card properly, the photographer places it into the scene at a point of critical light or detail so that it does not itself create glare or shade. Then, a meter reading is taken from the card so that only light reflecting from the card is affecting the metering system. With a TTL metering system, the camera is brought in close enough that the card fills the viewfinder. Since the exposure systems that are programmed into a metering system are at 18 percent reflectance, and this is the value of the card, the reading from the card gives an exposure setting that will accurately reproduce the tone of the card as well as other tones in the photograph. Once the exposure setting is established, the gray card is removed from the scene and the picture is taken. Even though the meter

reading may vary from the gray card value once the gray card is removed, the camera settings should remain as established by the use of the gray card.

Materials other than 18 percent gray cards can be used for substitution metering. This type of metering is sometimes called key tone metering. Any object of known reflective value can be used. Common items such as the palm of the hand, a clear blue north sky, or green grass can be chosen. If a reflected-light metering system is aimed at the area of the sky opposite the sun—which would be the north sky at midday—then the light coming from that portion of the sky is approximately 18 percent of the light coming from the sun. This method works only with a clear sky. As haze and clouds obstruct the sky and sun, the ability to use this system becomes less effective. The palm of the hand is a handy item to use for substitution metering. A comparison meter reading of a gray card and the palm will indicate the compensation required when using the palm. For example, a palm reflects about 30–40 percent of the light falling on it. Thus, it reflects about twice as much light as the 18 percent photographers would like to use. This means that if the palm is used for metering, the exposure settings on the camera need to be opened up one stop from those given by the metering systems reading the palm. In this instance, if the palm reads f/8 at $\frac{1}{125}$ second then the camera should be set at f/56 at $\frac{1}{125}$ second. A clear sky, grass, or other materials can be used by metering a gray card and then the material to determine the stop difference, and then using the stop difference as a substitution constant.

Runners
© Stacy H. Geiken, 1993

INCIDENT-LIGHT METERING METHODS

Incident-light meters give readings similar to those of a reflected-light meter pointed at an 18 percent gray card. They do not differentiate light from the primary source and light from reflections or other sources, and they are not influenced by subject tonality. They use all the light falling on the meter as the measure for exposure.

To maximize the effect of an incident-light meter, the meter should be held at the critical point in the scene and pointed toward the camera position. This means that the meter's dome will receive the same light as the critical area of the picture. What is important is that the light dome be in the same light as the scene. Therefore, when a landscape is photographed, the meter need not be taken to the actual scene, provided it is placed in light that is the same as that in the picture. For instance, open sun on the meter at the camera location is the same as open sun in the scene being photographed. The significant concern in using the meter this way is to have its dome pointed in the direction from the scene toward the camera.

Incident-light meters can also be used for an average value–type exposure system. This system is similar to the average value method for reflected-light meters, but uses the light values in the highlight and shadow areas to calculate the exposure setting. In this method, the incident-light meter is pointed at the camera from the brightest portion of the scene as well as from the darkest area of critical importance. The midpoint exposure setting is then used.

I. R. Sansevieria
© Dorothy Potter Barnett

EQUIVALENT EXPOSURES

Photographers do not always find the conditions that will meet their expectations for the final picture. The light intensity might be less than that required for a fast shutter speed at an established f-stop, or more depth of field may be needed. In making the picture, the one thing that must be kept constant is exposure.

When the way the picture is conceived and the calculated exposure settings do not meet the major expectation of either depth of field or speed, then an equivalent, or reciprocal, exposure can be used. **Equivalent exposures** utilize the 2:1 factor concept of photography. Since the f-stops and shutter speeds (speed stops) are organized in multiples of two or one-half, an easy conversion is possible. For each change in f-stop or shutter speed, an equal but opposite change must be made in the other. For every f-stop the photographer opens up the speed is changed by increasing one speed stop, moving to a higher shutter speed. If a photographer has to change f/4 at 125 to a faster speed, the exposure will be f/2.8 at 250 or f/2 at 500. All three are in the same equivalent exposure set, though they will each have different effects in the photograph. In this way, the photographer can choose speed or depth of field for its visual impact on the picture.

Equivalent Exposures

——————————— F-numbers ———————————

F/64	F/45	F/32	F/22	F/16	F/11	F/8	F/5.6	F/4	F/2.8	F/2	F/1.4	F/1
1	$\frac{1}{2}$	$\frac{1}{4}$	$\frac{1}{8}$	$\frac{1}{15}$	$\frac{1}{30}$	$\frac{1}{60}$	$\frac{1}{125}$	$\frac{1}{250}$	$\frac{1}{500}$	$\frac{1}{1000}$	$\frac{1}{2000}$	$\frac{1}{4000}$

——————————— Seconds ———————————

All of these exposure combinations should give an equal
and correct exposure to the film.

Horse Series
© 1992 Gerald Lang

LAW OF RECIPROCITY

F-stops, shutter speeds, and film speeds are based on a 2:1 ratio. This is the reciprocal relationship of photography. It is assumed that this relationship holds over the exposure range of film. This assumption is called the **law of reciprocity.**

When film is exposed for lengths of time that are longer or shorter than would be normal and expected, the reciprocal relationship fails. In effect, the emulsion loses sensitivity to light. The emulsion requires more light to achieve exposure in low light levels. As the exposure time increases or decreases beyond the point of **reciprocity failure,** doubling or halving does not double or halve the exposure. Compounding the effect is the need to compensate development to lessen the contrast based on the increased exposure time. This is not a straight or linear exposure-development compensation; it is a geometric function. Because each emulsion is manufactured differently, reciprocity failure will vary a great deal from film to film.

Jerusalem
Paul Liebhardt

FILM PROCESSING

Processing changes a film's latent image to a negative and allows the photographer to print the image. A few basic guidelines and five processing steps are involved in producing usable negatives and storing them for future printing:

- Good-quality photographs are the result of consistent processing chemicals, techniques, timing, and temperatures.

- The first step in film processing is developing. This step requires a darkroom or a developing tank, developing chemicals, accurate timing, controlled temperatures, consistent agitation, effective loading, and judicious use of replenisher.

- The second step in film processing is stopping. This step neutralizes the developer and halts the developing action.

- The third step in film processing is fixing. This step eliminates the undeveloped silver halides and makes the image permanent.

- The fourth step in film processing is washing. This step removes all the remaining chemicals from the film.

- The fifth and last step in film processing is drying. This step removes the water from the film and allows the emulsion to become firm and durable.

- Once a film is processed, it must be stored in a clean, dry, dust-free environment.

When light energy alters silver halides in a film's emulsion, a latent image is formed. This image cannot be seen without a chemical change in the emulsion. Developing the film transforms the emulsion with its latent image to a negative.

Film processing will have a great effect on the final outcome of the photograph. The photographer has to approach it consistently to make photography predictable and usable. The processing of film follows a few basic guidelines and five separate steps. The order of these steps is developing, stopping, fixing, washing, and drying.

THE BASICS

Consistent control is the most important part of film processing. The photographer must control the developing so that any choices or changes in any aspect of photography, such as exposure, have an expected result in the negative. This can only be done if the film is developed under consistent conditions in the same manner each time. Since making a photograph includes both exposure and processing, if the processing is inconsistent, then the results will be inconsistent and will lead to poor-quality photography. The time of each step, the temperature of the chemicals, and the processing agitation will all affect the quality of the negatives.

Being consistent requires paying attention to the strength and freshness of the chemicals being used.

Commercially prepared chemicals used in the processing of film are sold in two forms: dry powders and concentrated solutions. Rarely are they used in either of these forms. From these purchased chemicals, the photographer prepares **stock solutions,** which are at storage strength (less concentrated than the packaged mix but too strong to use with film). The stock solutions are further diluted to prepare the actual **working solutions,** which are used in film processing.

The chemicals used in film processing are affected by the order in which they are used and by cross contamination. Cross contamination refers to the effect of amounts of one step's chemicals getting into an adjacent step's mixture. The chemicals are formulated to accept a small amount of cross contamination in the correct order of the process. For this reason, if a small amount of developer is on the film, it will not adversely alter the operation of the stop bath. A small amount of stop bath will have an insignificant effect on the fixer. But the reverse is harmful to the processing. If chemicals contaminate those in prior steps—for example, if stop bath contaminates developer—the effectiveness of the solution from that earlier step can be radically altered. Care must be taken not to have "back" contamination occur.

Molly and Her Mother
© Nancy M. Stuart

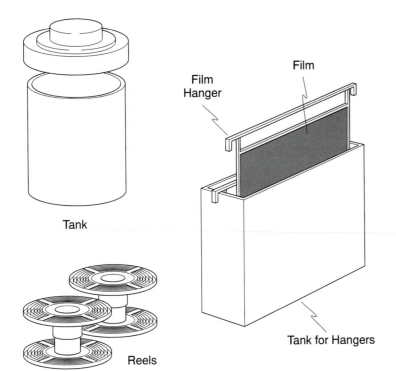

Tanks, Reels, and Hangers

Tank

Reels

Film Hanger

Film

Tank for Hangers

DEVELOPING

Development of the latent image is the first step in film processing. Developing **reduces** silver halide crystals that have been exposed to light; in other words, it breaks them down into their components, silver and halide. **Alkaline developers** are used to change the light-struck silver halides to **metallic silver.** The chemical reaction changes the exposed halide crystals and adjacent crystals.

Since both the exposed crystals and those nearby will change to metallic silver, the amount of development is important. Too much or too little development will produce a poor negative, making printing difficult or impossible.

Development is the most important step in film processing. Time, temperature, and agitation control the amount of development. These variables must be closely monitored.

This step requires a way to keep the film in the dark during processing; chemicals; a timing device; a method to control temperature; replenisher (when applicable); and controlled loading and agitation techniques.

Darkrooms and Developing Tanks

The developing process must take place in total darkness. Until the film has been developed and the unexposed silver halides have been removed, the film continues with the same sensitivity to light as it had in the camera.

Two techniques can be used to keep the film in the dark for developing. The photographer can develop the film in a darkroom with no light of any kind in or entering the room; open-tank and tray development must take place in a totally dark space such as this. Or the film can be loaded into a specially designed container that allows the processing chemicals to be poured in and removed without the container being opened to light.

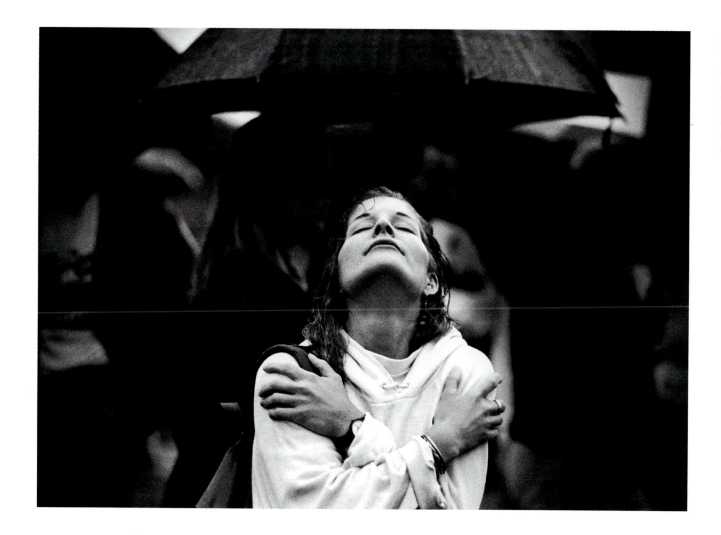

Remembering. Anna Bartolomeo listens as names of those who died of AIDS are read at the opening of the AIDS Quilt in Washington, D.C. Her husband, Edward Mardvich, died from the disease.
© Carol Guzy/Washington Post

Untitled
Sami Suojanen

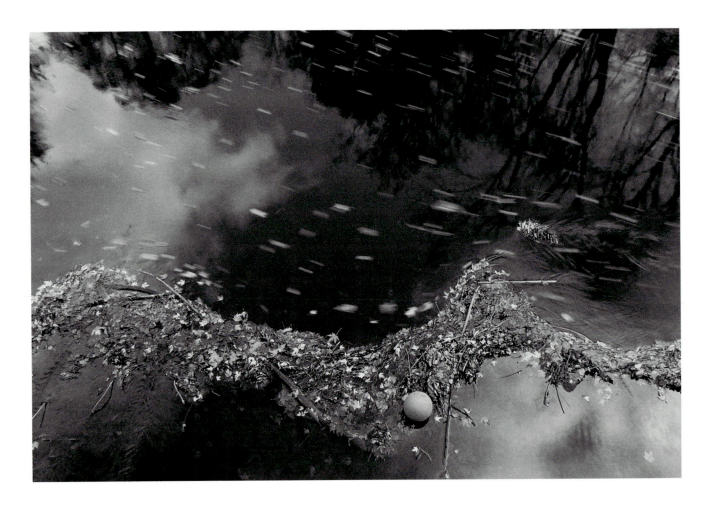

The use of lighttight containers is the most common way of developing film. These containers are known as **daylight tanks** and are designed in varying configurations and sizes to accommodate different film formats. They are constructed with three main parts. First is a receptacle that holds the film and the chemicals. The amount of chemical in the tank must completely cover the film.

Second is a device to keep the film's emulsion from touching any surface or other film while it is in the development process. For roll film, spools or aprons are used, and for sheet film, hangers or slotted racks provide the separation.

The third part of a daylight tank is a lid that has a built-in light trap to allow the chemicals to be poured into and out of the container without opening the lid.

Developing chemicals need to reach the emulsion and will need to be moved and changed throughout the developing process. If the film's emulsion is in contact with anything during the process, the gelatin will stick and will not allow the chemicals to act on the area of contact. Because chemicals will be unable to reach the film or to change it in the touching area, development either will not happen in that area or will not be completed. If a loading error keeps the chemicals from getting to all parts of the emulsion, the negatives will have large irregular areas of undeveloped silver, which look either tan or clear depending on the effect of the fixer.

Chemicals

The chemicals used in photography will age and change their strength. Contact with air and age will have a major effect on the strength of both stock and working solutions, and the strength and freshness of mixed solutions will affect the development process. Bottles used for storing stock solutions should be marked to show the type of solution and the date the contents were mixed, and should use airtight stoppers.

CAUTION: Though most chemicals used in photography are weak, they can cause different types of health problems. The most common problem is **contact dermatitis,** a skin condition caused by exposure to chemicals (not just photographic chemicals). Contact dermatitis is similar in appearance to psoriasis, and it can be serious. Care in preparing the chemicals and the use of rubber gloves will eliminate most possible inflammation. When dry powders are used, a slight problem with inhaling the powder also exists.

Safety should be a concern for every photographer. If problems with health exist, the photographer needs to see a health professional to discover what precaution or medication can remedy the problems.

ENVIRONMENTAL NOTE: Another set of concerns the photographer must take into account are local requirements for the proper disposal of the chemicals used in the developing process. Though many solutions can be reused, they will eventually fatigue and need to be discarded. Some of the solutions used may have high concentrations of heavy metals. Many community sewer systems will not allow the disposal of these materials. Also, septic systems can be damaged by some of the chemicals. Local environmental control agencies should be contacted for information on proper disposal.

The chemical process of development is determined by the strength of the developer. Both age and the mixing of the developer affect strength. The chemical reaction that reduces silver halides to metal causes the chemicals used in developing to oxidize (react to oxygen) and change their effectiveness with time. Though many developing chemicals weaken with excessive storage, some actually get much stronger. In particular, hydroquinone developers, which are quite common, get much more active as they age. Developers must be mixed and used within the limits of the manufacturer's recommendations.

Kentucky #58, 1983
Barry Andersen

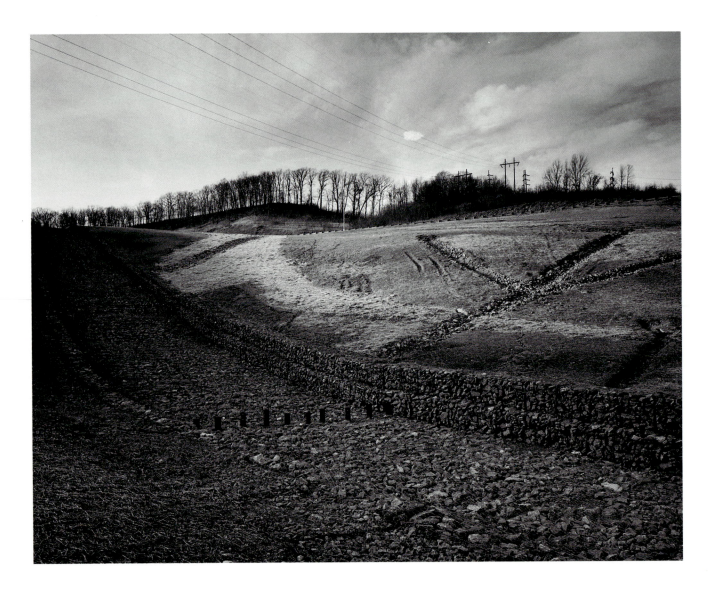

Timing

The easiest development variable to understand is time. The longer the film is in the developer, the more development takes place. But the film does not develop at the same rate throughout the developing time. The early stages of development are the most important. In the early stages of development, the chemical reaction works on all the silver halides that have received the minimum amount of light needed to expose the film. The primary development in shadow detail areas of the negative happens in the early portion of the process. The highlight areas of the picture fill in as the film receives increased development. This means that both underdevelopment and overdevelopment have more effect on highlights in the picture and less effect on shadow areas. For these reasons, even penetration of the developer into the emulsion will influence the quality of the process.

As the solutions work on the emulsion, the gelatin first softens to allow penetration by the active developing agent. A water **presoak,** or wetting, is often used to soften the emulsion so that the chemical developing solutions can evenly penetrate. Presoaking is generally recommended with shorter developing times and especially those near or under 5 minutes. With normal developing times of 8 minutes or longer, the use of a presoak depends on the preferences of the photographer.

Temperature

Increases in temperature speed up the developing process. The temperature combined with time and agitation are the basis for correct development. Manufacturers recommend development times based on the temperature of the developer. To keep development consistent when increasing temperature, developing time must be decreased. Some developer-film combinations are created to work at high temperatures and short times. Care must be taken to control the temperature to within the film's usable range.

Time and Temperature

———— Tri-X Pan Film ————

Small tank (agitation at 30 second intervals) • Developer D-76, 1:1 dilution

Temperature (°F)	Time (minutes)
65°	11
68°	10
70°	9.5
72°	9
75°	8

Note: The listing above is for Tri-X Pan film with D-76 developer diluted 1:1 only. Specific time/temperature combinations for other films or film/developer combinations are available from the manufacturers.

Santa Barbara Mission
© 1993 Erhard Pfeiffer

If the temperatures of the various steps of film processing vary greatly, problems can arise. A large, rapid temperature change from one step to the next will cause emulsion wrinkling and realignment. This is called **reticulation.** Temperatures should be held to within plus or minus 4 degrees Fahrenheit (approximately 2 degrees centigrade) from one step to the next. This is most important between developer and stop bath and between stop bath and fixer. It is less important during the washing stages, although reticulation can also occur if the water temperature changes during the washing step.

Loading and Agitation Techniques

Another critical concern in the development portion of film processing is the use of controlled and consistent technique. This includes the way the chemicals are put into the trays or tanks and the agitation of the tank or film. For some films, the length of time it takes to change the chemicals used in the process can have a great effect. The agitation cleans spent developer from the surface of the film and replaces it with fresh chemical. Not all films require the same type of agitation. Some require vigorous agitation, whereas others need smoother agitation patterns. Over- or under-agitation will influence the contrast, graininess, and evenness of the negative image.

Replenisher

ENVIRONMENTAL NOTE: Many developers can be reused with the addition of replenisher to return strength to the depleted chemicals in them. The **replenisher** is a concentrated solution of the developer. At times, however, either the processing sequence or the developer type does not make replenishment possible. In this case, the developer should be disposed of according to directions or in accordance with local ordinances. Awareness of the

problems created by the disposal of chemical waste is growing. Even though the strength of the chemicals used in developing is weak, limitations may be placed on the disposal of spent chemicals.

STOPPING

The second step in film processing requires stopping the effect of the developer. Since time is critical in the development of the negative, stopping the effectiveness of the developer at the proper moment is very important. The use of **stop bath** halts the developer action. The developing agents in film processing are alkaline and are neutralized by adding an acid to the developing tray or tank. But the stopping action does not happen until the developer is either neutralized or completely removed from the surface of the film.

The development and stopping reactions take place on the film's surface. The development reaction continues with the chemical remaining in the emulsion even though all other developer has been emptied from the tray or tank or is being poured out. For this reason, in daylight tank development, the developer is emptied from the tank and the tank is filled with an acid stop bath. In open-tank or tray development, the film is moved from the developer to the stop bath. Some photographers believe that water can be used as a stop, but it only reduces the developer effect and does not stop the reaction.

The strength of the acid will determine the effectiveness of the stopping action on the development of the film. Stop bath is generally mixed by placing 1–1½ ounces of 28 percent acetic acid in a quart of water. Stop bath is also available with an indicator in it that changes color when exhausted.

After the stop bath has been used, it can be saved and reused without replenishment. If it is being reused, its **pH** (acidity) should be tested to ensure the strength of the solution: the pH of the stop bath should be between 3 and 5.5 for it to be effective. When **indicator stop bath** is used, the solution changes color if it will not work effectively.

Jan Simpson, librarian
Peter Glendinning

Once in the stop bath, the film requires agitation to ensure that the neutralizing effect of the acid on the alkaline developer reaches all parts of the emulsion. The length and form of agitation will not affect any quality of the negative. Because overagitation has no consequence, agitation should be constant to guarantee complete stopping of the development process.

FIXING

The third step in the process of making exposed film into negatives is the fixing of the film. Fixing makes the image permanent. After the developer changes the exposed silver halides into metallic silver, the undeveloped silver halides still remain in the emulsion. The **fixer** is designed to remove the undeveloped silver halides to eliminate any potential of their interfering with the use of the negative. It dissolves the undeveloped silver halides and washes them out of the emulsion. At this point in film processing, examination will show clearly that the image is visible, no longer latent.

Sodium thiosulfate or **ammonium thiosulfate** is the prime ingredient in fixer. The thiosulfate dissolves the undeveloped silver halides. Fixer for film often is a **hardening fixer.** Added to the thiosulfate is a hardening agent that will make the emulsion more durable. The most common chemicals used as a hardener are potassium alum and formaldehyde.

In the fixing step, the same concerns are present as in the developing step. These are time, temperature, and agitation. As in the earlier steps, it is important to use the chemical long enough for it to accomplish its task—in this case, the fixing of the image. Unlike stop bath, fixer can have a bad effect if the film stays in it too long. Overfixing can reduce the shadow detail of the picture and cause graininess. Underfixing can result in the film fogging as it ages, which creates problems in printing. The actual time required to fix a film will vary depending on the strength of the fixing solution and the type of film. Manufacturers of fixers as well as those making film give recommendations for the proper fixing time.

Many photographers use large containers of working solution of fixer. When doing so, a simple method for determining the proper length of time for fixing is to use an undeveloped piece of the same film being processed, and to fix it in an open beaker and observe the time it takes to clear. The film in the breaker will be undergoing the same changes by having the silver halides removed from it. The time required for effective fixing will be two or three times the amount of time it takes for the film in the beaker to clear. With this method, the photographer uses a time that takes into account the strength and temperature of the fixer. The photographer can also be alerted to weak fixer and allow for increased time for complete fixing.

The dyes used to sensitize some modern films are also removed in the fixing. If these types of films are used, the presence of any dye—normally a pink color—on the film indicates potential incomplete fixing.

Just like the stop bath, the fixer can be saved and used for more than one processing run.

Agitation is as important in the fixing of the negatives as it was in the development. It makes sure that fresh chemical moves into contact with the emulsion to help with the fixing process. A good practice is to use the same agitation pattern in the fixing step as was employed in the development step.

City Palms
Linda Wang

Taipei, Taiwan
David Litschel

WASHING

The purpose of the wash is to remove any residual processing chemicals from the film. It can be done in two ways. One is to use only a water bath. The critical issues in this method are the rate of exchange of the water in the bath and the time the film stays in the bath. For effective film washing, the water should completely change five times each minute. To accomplish this, the photographer can either use flowing water or dump and exchange the water.

ENVIRONMENTAL NOTE: Washing with just a water exchange or running water will take about 30 minutes. This time can be shortened and the effective washing of the fixer from the film increased by the use of a **washing agent.** Washing agents are known as **hypo-clearing solutions** or **hypo eliminators.** These chemicals change the properties of the chemicals remaining in the film to allow them to be washed out more effectively. They couple with the sodium thiosulfate or ammonium thiosulfate of the fixer to create a compound that is more soluble and will more easily wash out with water. If a washing agent is used following the manufacturer's directions, the washing time can be reduced to 6 minutes with a water exchange rate of five times each minute, resulting in a significant savings of water and time.

If the washing step does not remove the residual chemicals, problems will affect the long-term qualities of the negatives. With time, fixer that remains in the film can cause the silver image in the emulsion to deteriorate.

DRYING

Once the film is developed, stopped, fixed, and washed, the negatives need to be dried. When the emulsion is kept in liquids, it is swollen and soft. Though the hardener in the fixer makes the emulsion more durable, the negatives are not easily used without damage until they are dry.

For the film to dry properly, it should be prepared with a wetting agent. A **wetting agent** is a substance that creates a sheeting action of the water on the film. Like wetting agents used to make glassware dry without spotting, it reduces the surface tension of the water, allowing it to drain evenly from the film. Proper mixture of the wetting agent will eliminate water marks or streaks on the film and will speed drying. If the agent is not properly mixed—if it is either too strong or too weak—it will not work effectively. **Photoflo** (a registered product of Eastman Kodak Company) is the most common wetting agent and has come to be synonymous with this process.

The wetting agent will be the last solution used in film processing. Pure or deionized water should be used to prepare the wetting agent. Any grit or dirt in the water will dry to the surface of the emulsion, causing later printing problems.

Though most photographers use only a wetting agent to help in the drying process, others use a squeegeeing technique to remove excess water after the film has been washed and Photofloed. Squeegeeing the film has both a negative and a positive side. On the negative side, any grit on the film or squeegee can scratch the film backing or emulsion. This is a reason many photographers do not recommend squeegeeing. On the positive side, squeegeeing evens out the water on the film and eliminates streaking.

Squeegeeing is performed in three main ways. The first way is to use a chamois. This is a small piece of very soft leather. It is soaked in water to soften it, wrung out, folded over the film, and then drawn over the length of the film with even, light pressure. The second way is to use a lint-free material to wipe the film base side of the negatives. The third way is to draw a soft clamping device across the film. This device is made of sponge or soft rubber. To avoid scratching, rubber squeegees should be held in hot water or warm Photoflo prior to use. This softens the rubber blades.

The actual drying needs to take place in a dust-free space. The emulsion of the film is soft and tacky after the wash. This means that if dust comes in contact with it, the dust can become bonded to the negative.

The best drying conditions are found in specially constructed drying chambers. These have a system to allow clean air to flow through them. Some drying equipment has heaters to promote the drying process. If heat is used, it should be controlled so that excessive heat does not damage the film. If the equipment includes a fan or a part that moves air, filters on the air supply are recommended.

The film needs to be completely dry; residual moisture in the emulsion can be problematic. A clue to this condition is if the negative seems dry but is cooler than room temperature.

 Review of Film Processing

 Developing

 Stopping

 Fixing

 Washing
- Hypo-clearing
- Washing
- Photo-flo

 Drying

 Perform only in the dark

May be performed in the light

STORING

Once the film is dry, it should be immediately put into clean storage. Many items can be used for storage: envelopes, sleeves, or negative pages. This procedure needs to be done in a clean, dust-free environment. If dust or lint attaches to the film during storage, problems can arise during printing. Regardless of the method selected, each negative or strip of negatives should be stored so that its emulsion and backing surfaces are not exposed or in contact with other film.

Sinead O'Connor, 1990
© Herb Ritts, Courtesy Fahey/Klein Gallery, Los Angeles

PRINTING

After the film has been exposed and processed, the photographer needs to make a print to see and evaluate the quality of the picture. An understanding of the basic photographic printing process, which is similar to the processing for making negatives, helps in attaining desired results. Specialized equipment and processes are involved in making contact sheets, proof prints, and first prints:

- The print darkroom has two parts: the wet and dry areas. Each area needs specific equipment.

- Print processing uses several chemicals and follows six basic steps: developing, stopping, fixing and inspection, hypo clearing, final washing, and drying.

- The papers used in print processing may be graded or multicontrast.

- Before making full-size prints, a photographer prints a contact sheet, or a sheet filled with prints the same size as the negatives. The photographer examines this sheet to select images that will be made into final prints.

- To gain information about print quality, a photographer makes proof prints, or enlarged images of contact prints that will be made into final prints.

- Dodging and burning are two techniques that may be used to make local corrections in a print.

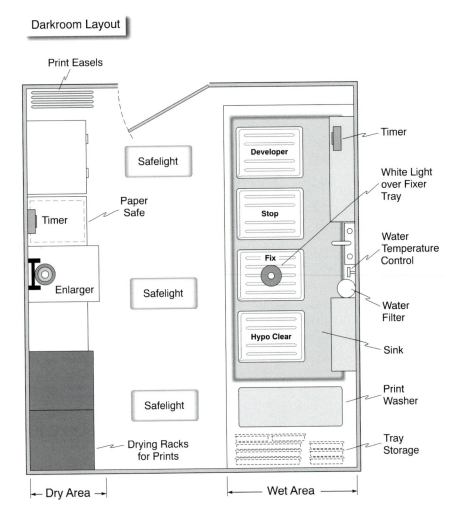

Darkroom Layout

Print Easels

Safelight

Timer

Paper Safe

Enlarger

Safelight

Safelight

Drying Racks for Prints

← Dry Area →

Developer

Stop

Fix

Hypo Clear

Timer

White Light over Fixer Tray

Water Temperature Control

Water Filter

Sink

Print Washer

Tray Storage

Wet Area

Once a film has been successfully processed, contact prints and enlarged prints can be printed from the negatives. Making a print is very similar to making a negative. The differences lie in the speed of the light-sensitive materials and chemistry used, the backing of the emulsion, and the method of exposure and processing. The concept and steps in making prints function the same as those in making negatives.

To process prints, it is necessary to have a darkroom facility with special equipment, printing chemistry, and photographic printing paper.

THE DARKROOM

CAUTION: Although the term **darkroom** implies a lightless environment, for most printing needs, the room will be illuminated by a **safelight,** which is a lamp that has a filter to screen out rays that would expose photographic paper. The walls of this room need not be black or even dark, with the exception of the area around the enlarger. The walls around the enlarger should be painted black to absorb any stray light rays coming from the enlarger during its use. It will be advantageous to have the rest of the room painted white to allow for better illumination from the dim safelight and for a safer working environment.

Care must be taken to make the room as lighttight as possible. Although the emulsion of photographic paper has a slower sensitivity than that of film, the entry of unwanted light must still be blocked.

The darkroom design should incorporate a basic division of space into a dry area and a wet area.

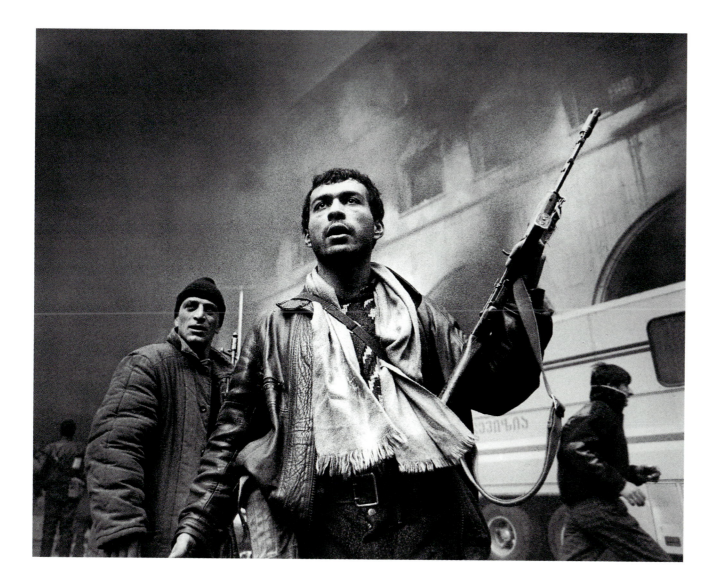

Tbilisi. Rebel forces fighting to oust Georgian president Zviad Gamsakhurdia.
© Carol Guzy/Washington Post

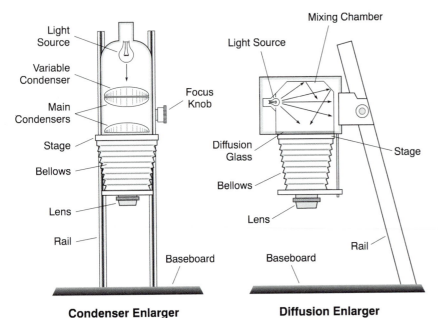

Condenser Enlarger

The condenser enlarger uses a set of lenses above the negative to create a set of parallel light rays.

Diffusion Enlarger

The diffusion enlarger uses a material or light source that creates a diffuse light directly above the negative.

The Dry Area

Within the dry area are pieces of equipment that will be harmed if they get wet. For this reason, the two areas of the darkroom are separate. The dry area houses the enlarger, which projects the negative to make a print. The enlarger needs to match the film format size for the photographer's camera equipment. To use the enlarger requires several other pieces of equipment: enlarging lenses and film holders to fit each film format, an enlarging timer, a printing easel, tools made for dodging and burning, multicontrast filters for using multicontrast paper, and a grain focuser. The dry area also contains equipment that is not part of the enlarging of prints. The three main pieces of equipment that are needed beyond the enlarger are a contact-printing device, called a proofing frame, a safelight, and a paper safe to store unexposed paper.

ENLARGER AND ENLARGING EQUIPMENT. The **enlarger** is actually a type of camera that is designed and used to project images. This machine acts in a manner opposite that of a picture-taking camera; it makes a larger image from a smaller negative. Its design incorporates a light source that projects illumination through the negative and out of the enlarger. It is commonly but not only used in a vertical position for space considerations. A baseboard offers a flat, level space to place a printing easel and provides support for the enlarger. A column allows positioning of the enlarger head above the baseboard, and a rail or track on the column allows for the raising and lowering of the enlarger head. The head is the primary component of the enlarger. It contains the light source, the condensers or diffusing device, the stage, the bellows, and the lens. (See chapter 10 for further discussion of condenser and diffusion enlargers.) The stage, the part that holds the negative carrier, needs to be parallel to the baseboard and the easel. The bellows allow the lens to focus the image on the paper.

Once the light passes through the negative, it is projected onto the printing paper. A lens is used to focus the light on the paper. The normal focal length enlarging lens for any film size can be determined by taking a diagonal measurement of the image size.

FILM SIZE	ENLARGING LENS SIZE
35mm	50mm
2-¼ inches	75–80mm
6×7cm	90–105mm
4×5 inches	135–165mm

The negative carrier holds the film steady and flat, allowing the enlarger to remain in focus while the paper is exposed. These carriers are designed specifically for the film size and format. For example, 120 film is commonly used for 6×4.5 cm, 6×6 cm, 6×7 cm, 6×8 cm and 6×9 cm formats. Each format will have a negative carrier which will be used for making enlargements.

Enlarging timers come in many styles. Although some workers have been known to time enlarging exposures by counting or using a metronome, these methods are not recommended because of the difficulty of achieving consistent results. The purchase of a good timing device is strongly recommended. Most of the timers on the market are solid-state digital timers that are adjustable down to 0.1 second. These are extremely accurate when dealing with cumulative time. The timer will have a time-focus switch that allows the enlarger to override it and to be turned on for focus purposes. Once the enlarger is focused, the switch can be returned to the time position. A button on the timer can then be pushed to activate the enlarger light for the set exposure time.

A **printing easel** holds the paper flat and allows it to be positioned under the enlarger. Easels come in many forms. Speed easels are designed to accept one standard size of paper with no adjustment. Bladed easels allow the image to be centered on a sheet of paper and the borders to be adjusted. Specialty easels allow for the making of borderless prints, business cards, and so on.

Amelia's Gift, from the Niche Series
Beth Linn

Dodging and burning tools, although available commercially, are best constructed from scratch as the need arises. Dodging tools are used to block the light striking the paper in order selectively to lighten a print. Burning tools are used to add light in order to darken local areas in a print. (The use of these tools is discussed at length later in this chapter.)

Multicontrast filters are necessary to change the print contrast when using multicontrast paper. These filters are available in two forms: ones that fit under the lens in a filter drawer that is provided with the filter set, and others that are larger sheets of acetate that fit above the negative carrier and below the light source of the enlarger. For optimum results, the manufacturer of the paper should match that of the filters. (Multicontrast filters are also discussed in depth later in this chapter.)

Grain focusers and **grain magnifiers** are needed to obtain the maximum sharpness of focus on a print. They enlarge the grain enough to allow focusing on individual grains of the film. This device is a necessity when enlarging many contemporary fine-grain films.

PROOFING FRAME. A **proofing frame** holds negatives against the printing paper so that a contact print can be made. Proofing frames for contact printing can be as simple as a ¼-inch-thick piece of plate glass or as elaborate as a hinged device that separates each strip of film when printing.

SAFELIGHT. Safelight illumination will allow the printing and processing of paper to be done in a low-level yellow light that absorbs blue light because most photographic papers are sensitive to blue light. Be sure to establish a distance of at least 4 feet from a safelight to any working surface.

A simple test may be conducted to determine the safety of a safelight. Lay a piece of unexposed photo paper emulsion-side-up on one of the working surfaces, and place a coin on the paper. Allow the paper to be exposed to the safelight for 5–10 minutes. Develop the paper. If any hint of the coin appears, the safelight is not functioning properly.

PAPER SAFE. **Paper safes** are commercially produced lighttight boxes used to hold unexposed photographic paper. They protect photographic paper from white light when room lights are on, and provide the convenience of making the paper more easily accessible in the safelit darkroom by eliminating the awkward opening and closing of the manufacturer's packaging.

The Wet Area

The wet area of the darkroom is used to process film and paper. Within this area will be the equipment for all aspects of chemical use, mixing, and storage. This will include processing chemicals and storage bottles; mixing graduates and a mixing paddle; processing trays; tongs or rubber gloves for processing, and other safety equipment; a safelight; a white light for inspecting wet prints; a print washer; a squeegee and squeegee board; and some means for drying prints.

Chemicals for both film and paper processing should be mixed ahead of time and stored in clearly labeled and dated lighttight bottles. For mixing the chemicals, graduated cylinders are better than beakers. A graduated cylinder has parallel sides and finer calibrations than a beaker. Plastic graduates are most sensible for use and durability. Mixing paddles are used to stir the chemicals into solution when mixing both stock and working solutions.

Trays for print processing are made in the common sizes of photographic paper. Though a print can be processed in a tray the same size as the paper, it is better for handling and quality to use a tray larger than the print. Ribbing on the bottom of the tray helps the photographer pick the wet print off the bottom. Flat-bottom trays are also available for special uses though not recommended for general printing.

⊘ CAUTION: Safety in the darkroom is important. Some of the equipment used for handling prints is helpful in remaining safe. Print tongs are designed to allow the movement of a print through the trays of chemical solutions without the photographer ever having to come into contact with those chemicals. If they are not chosen, then rubber gloves should be used. The best gloves are thin, latex surgical gloves available at most pharmacies in boxes of fifty to one hundred. They are used for one printing session and then disposed of. Failure to use either the tongs or the gloves could result in skin reactions to the chemicals, such as contact dermatitis. Other safety equipment such as eyewash and first aid kits should be located in a convenient and accessible area. Local regulations may dictate the types of safety equipment needed in the darkroom.

The design of safelights allows a photographer to see in the darkroom while making black-and-white prints. Their construction lets light pass through a filter so that it will not expose black-and-white photographic paper. Photographic papers are sensitive to blue and green light, so amber or red filters can be used in safelights for black-and-white printing.

A white light can be positioned above the sink in the vicinity of the fixer tray. This light is used to inspect the print.

What's in a Picture?
Jerry Stratton

The simplest method to wash prints with a good exchange of water is to use a print siphon hose. Siphons are relatively inexpensive devices that sit on the edge of a print processing tray and convert it into a washing bath. Other print washers are available in a range of prices. Two concerns when shopping for washers should be the way they use water and the exchange rate of the water. This rate is usually given in gallons per minute.

After a print has been washed, the surface should have most of the water removed from it. This is normally accomplished through the use of a photographic squeegee, which is similar to the tool used to clean windows. The squeegee is run across the print while the print is lying on a smooth, flat surface such as a piece of Plexiglas or glass. By applying a slight pressure when pulling across the print's surface, the photographer forces water off the print.

Two types of paper construction change the way print drying takes place. The emulsion of resin-coated (RC) paper is bound in a liquid-permeable plastic. Fiber-based paper has a gelatin emulsion on a paper base. When **resin-coated (RC) paper** is used, it is greatly simplified since the normal drying time is short—approximately 10 minutes. Therefore, a basic setup such as a clothesline and clothespins will work well. When **fiber-based paper** is used, a print dryer should be employed for single-weight paper, and either a print dryer or air drying for double-weight papers. Air drying is the recommended method for the best-quality print surface.

Many photographers use nylon or fiberglass window screening stretched over a frame to create an efficient air-drying rack for RC and fiber-based papers alike. RC papers are dried face-up and fiber-based papers are dried face-down.

CHEMICALS AND PROCESSING STEPS

Wet print processing consists of a minimum of three chemical steps, inspection, a wash, and drying for RC paper, and a minimum of six chemical steps, inspection, a wash, and drying with fiber-based paper.

To prepare for processing in either case, first mix stock solutions of the chemicals in buckets or graduates according to the manufacturers' times and temperatures, and pour into bottles for storage. Clearly label these bottles to show what chemical is in them and when it was prepared. Following the mixing directions and labeling will benefit consistency and safety. It is best to mix powdered chemicals that must be prepared at high temperatures the day before printing, to allow them to cool.

When you are ready to print, mix working solutions of the chemicals you will need, following the manufacturers' directions, and pour each working solution into a processing tray. The number of trays that will be required in a printing session is determined by the type of paper to be used. Four trays will be needed for RC paper, and six for fiber-based paper:

RC PAPERS		FIBER-BASED PAPERS	
Tray 1	Developer	Tray 1	Developer
Tray 2	Stop bath	Tray 2	Stop bath
Tray 3	Fixer	Tray 3	Fixer*
Tray 4	Inspection	Tray 4	Inspection
	Final wash	Tray 5	Water rinse
	Drying	Tray 6	Hypo clear or hypo eliminator
			Holding bath*
			Final wash
			Drying

*For archival print processing—which produces a print that will be saved for a long period of time—many photographers include a second fixing bath, and may include a water holding bath after the hypo clear.

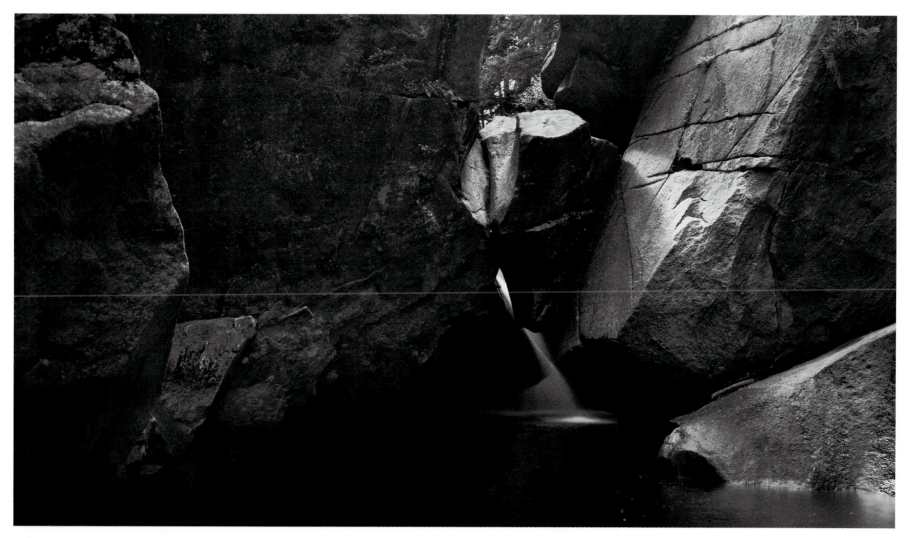

Indian Leap, Lost River, Woodstock, New Hampshire
Stephen Beck

The Tehans
© 1986 Nancy M. Stuart

Developing

The initial step in any print processing is developing. Print developer is generally a commercially prepared liquid or powder that is mixed with water to make a quantity of stock solution. To use the developer, a small amount of working solution is mixed by diluting the stock solution with water according to the manufacturer's instructions and placing it in the first print processing tray. The dilution of the developer may vary from product to product, but any variation in it will not cause a change in contrast of the print, though it could cause a change in print color.

Print development is a completion process. The developing agent reacts with exposed silver halides in the emulsion of the paper and reduces them to black metallic silver. The main developing agents used in general-purpose print developers are hydroquinone and metol.

It is important to have enough working solution to cover the paper completely as it develops. Print development time will vary from photographer to photographer, but should be in the range of 1-1/2–3 minutes, with the lower end of the range for RC papers. The prints should be agitated constantly in the developer. This is easily done by rocking the tray so that the developer moves in all directions. The last 10 seconds of the developing time is used to drain the print to prevent contamination of the next chemical, the stop bath. Print developer temperature is not as critical as film developer temperature, but should never go below 65 degrees Fahrenheit (18 degrees centigrade). Normally, the range is 65–75 degrees Fahrenheit (18–24 degrees centigrade).

A tray containing 1 quart of working solution of print developer is good for approximately ten to fifteen 8x10-inch prints. The developer should be replaced with each batch of ten to fifteen prints to maintain the best print quality. It is better to establish consistent limits on the number of prints you produce with your diluted print developer than to push it beyond the limit at the risk of sacrificing print quality.

Stopping

Print developer is alkaline, and stop bath is acidic. The acidity of the stop bath neutralizes the developer and stops developing action. The same stop bath used for film processing can be used in printing. Stop bath is generally mixed by placing 1–1-1/2 ounces of 28 percent acetic acid in a quart of water. It is also available with an indicator in it that changes color when the acid is exhausted. Indicator stop bath is diluted to a working solution in the same way as nonindicator stop bath. The indicator adds a measure of safety and convenience.

The stop bath step takes from 20–30 seconds with constant agitation. The last 10 seconds are spent draining the print before placing it in the fixer. Temperature is less critical than with developer, but the temperature of the stop bath should be as close as practical to that of the developer.

Stop bath can be reused if not exhausted. To check for exhausted stop bath, feel the liquid. It should feel "squeaky" between the fingers; if it feels somewhat "slippery," as does the developer, it is exhausted. Indicator stop bath is yellow when it is fresh and changes to a light purple when it exhausts. This color shift will be difficult to see under safelight conditions.

Fixing and Inspection

The fixer is made up of sodium thiosulfate or ammonium thiosulfate, which dissolves unused silver halides. This makes a print light safe.

Fixing time will depend on the type of paper. RC papers use very short fixing times—approximately 2 minutes—and fiber-based papers take up to 5 minutes depending on the level of processing desired. Archival processing requires longer fixing times and two fixing baths. Agitation should be constant for the first minute and on regular intervals throughout the remaining time. Temperature requirements are similar to those for stop bath.

The print can be inspected with white light after 1 minute in the fixer with fiber-based papers, sooner with RC papers. An inspection tray is handy to have for this purpose.

Fixer should be saved and reused. Check with the manufacturer for the maximum number of prints that can be fixed with each gallon. A product can be purchased that will allow a quick check of the fixer to see if it is exhausted.

ENVIRONMENTAL NOTE: Fixer contains the salts of silver, a heavy metal, and should not be poured down the drain. Consult your local environmental council for proper fixer disposal.

Hypo Clearing

Hypo-clearing agent and hypo eliminator contain chemicals that couple with the sodium thiosulfate or ammonium thiosulfate of the fixer to create a compound that will more easily wash out with water. Without one of these solutions, a print would have to be washed much longer in the final wash to remove residual fixer.

The time for the hypo-clearing step of the process varies from product to product, but it will be in the range of 1–2 minutes. Agitation should be at regular intervals throughout this time.

Hypo clear is not normally used with RC papers, since the fixer does not become such an integral part of the paper as with fiber-based papers.

Final Washing

The final wash is done with clear water. The print washing time differs with the type of paper in use. For RC papers, it is 2–5 minutes depending on the manufacturer. With fiber-based papers, it will vary based on whether hypo-clearing agent was used and the level of processing desired. The normal wash time for fiber-based paper when hypo-clearing agent was used in 5 minutes; without the use of hypo-clearing agent, it can be 20–30 minutes.

Drying

Prints can be dried in several ways. Commercially available print dryers use heat to dry them rapidly. Many photographers choose to purchase or construct drying frames and racks. The frames are similar to window frames; they are made of metal or wood, and window-screening material made of fiberglass or nylon is stretched across them. These frames can be covered with wet prints and stacked horizontally in racks designed to hold many of them while the prints dry. They are inexpensive and efficient, and their only drawback is the time it takes to dry prints.

RC prints are dried face-up to keep the screen from leaving any marks on the emulsion. If excess water is squeegeed off the RC prints, they will normally dry within 10 minutes. This is much faster than the time needed for any fiber-based print that is air dried. Only double-weight fiber-based papers should be air dried on racks. After squeegeeing the double-weight prints, place them face-down on the screen. This keeps them from curling. The time for air drying depends on humidity, but prints will easily dry overnight. Attempting to air dry single-weight paper will result in the print curling up as it dries.

Lindisfarne Castle, Northumber-
land, England
© Michael Kenna

PAPERS

Black-and-white photographic papers are manufactured to produce tonal ranges that meet the requirements of negatives of different density. **Paper grade** refers to the range of tones that can be printed on a paper. Papers are either graded, meaning that they are specifically designed for a certain tonal range in the negative, or **multicontrast,** meaning that they can be adjusted to many densities by the use of printing filters. The numbers assigned to the filters correspond to the ranges of graded papers.

Graded Papers

Graded paper is assigned a numbering system to indicate its contrast, or the range of light the paper can reproduce. The numbers generally run from 0, indicating the lowest-contrast paper and the widest range of values that can be reproduced, through the whole numbers 1, 2, 3, 4, and to 5, which represents the highest-contrast paper and the narrowest range. This numbering system is nonstandard and may differ somewhat from manufacturer to manufacturer. Some specialty papers, such as the silver-rich fine arts printing papers, which are a manufacturer's premium products, have a limited number of contrast grades available. In this instance, the photographer may find grades 2, 3, and 4 the only ones produced.

Lower-contrast papers (grade numbers 0, 1), referred to as **soft papers,** possess a longer exposure scale, so they are capable of recording more tonal variations and would be selected for use with a negative of longer density range. Higher-contrast papers (grade numbers 4, 5), referred to as **hard papers,** possess a shorter exposure scale and will work well for negatives with limited density range.

For printing negatives that represent the normal or average contrast range, a photographer will choose either grade 2 or grade 3, depending upon personal preference. If the same negative is printed on a grade 2 and a grade 3, the print on the grade 2 will be flatter, without as much difference between dark and light areas. The grade 2 paper has a longer exposure scale and possesses less contrast, thus giving a flatter print than the grade 3 paper.

The photographer should establish a standard that becomes the normal grade of paper that will be used on all her or his average negatives. Once this normal contrast grade is designated, then the photographer will use the grades below and above it for adjustments in print contrast based on the requirements of an individual negative. For example, a negative that is thinner than normal will need to be printed on paper with a higher-than-normal contrast grade. This paper will give the final image additional contrast that was lacking owing to the thin nature of the negative. If a negative has a long density range—if the difference between its highlight and shadow areas is greater than in a normal negative—then the photographer must choose a paper with a lower-than-normal contrast grade.

Graded papers may also be used intentionally to introduce high contrast in a print from a normal negative. To do this, one would pick a paper with a higher-than-normal contrast grade on which to print the normal negative.

The use of graded paper can result in lower minimum print contrast and higher maximum print contrast than may be possible by the use of multicontrast paper. The disadvantage of using graded paper has to do with the cost to maintain a full range of contrast options, meaning one must purchase a box of each grade, even though some grades will be used much more frequently than others. This problem can be avoided through the use of multicontrast paper.

U.S.–Mexican Border: New Mexico
Ken Baird

Multicontrast Paper

Light

Green-Sensitive

Blue-Sensitive

Emulsion

Multicontrast Papers

Multicontrast paper changes contrast grades through the use of colored filters placed under the lens or above the condenser, or dialed in on a color enlarger used to print black-and-white prints. Unlike graded paper, multicontrast comes in one form, and a single box is all a photographer needs to be able to print any contrast that is desired. The paper has two emulsion coatings, which respond to changes in the color of the light striking them, with a corresponding change in contrast. One of the emulsion levels is for higher-contrast printing and is sensitive to blue light, and the other is for lower contrast in the paper and is sensitive to green light.

The numbering system for the filters is similar to that of graded paper, but is more extensive in that it includes increments of half a contrast filter, thus giving the printer finer control. A typical set of filters is, starting from lowest contrast and going to highest contrast, 0, ½, 1, 1-½, 2, 2-½, 3, 3-½, 4, 4-½, 5. The normal-contrast filter—that is, the filter one would select to print all negatives in the normal contrast range—is a 2 or 2-½, depending on the manufacturer and personal preference. The filters themselves get more yellow as their number decreases below 2, and more magenta as the number increases above 2. This variation controls the mix of blue and green light striking the paper. Using multicontrast paper without a filter would be roughly equivalent to printing with a number 2 filter. Though multicontrast paper can work with no filtration, it is designed to be used with a filter in the enlarger at all times.

Contemporary multicontrast filters are designed to be changed without requiring adjustments in exposure time. When a test print made with a number 2 filter shows the need for more contrast, for example, any filter up to and including a number 3-½ filter may be put in the enlarger in place of the number 2 filter to increase the print contrast with no exposure change on the print. The following filters can replace a number 2 filter and yield an increase in print contrast with no change in exposure time: 2-½, 3, and 3½. If the problem is one of too much contrast on the print with the number 2 filter, then any filter down to and including a number 0 filter can be used in place of the number 2 to reduce contrast with no exposure change on the print. For changes to a very high contrast filter—4, 4-½, or 5—from filters below 4, a one-stop increase in exposure must be made to compensate for the increase in filter density.

Use of Multicontrast Filters

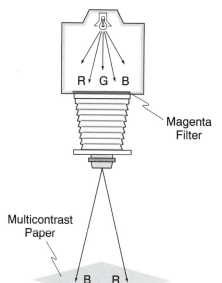

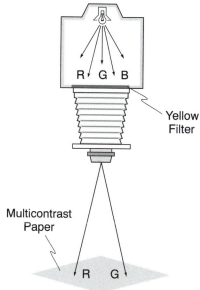

Magenta Filter

A magenta filter removes the green rays from white light. The remaining blue rays activate the blue-sensitive layer of a multicontrast paper's emulsion, giving higher contrast to the resulting print.

Yellow Filter

A yellow filter removes the blue rays from white light. The remaining green rays activate the green-sensitive layer of a multicontrast paper's emulsion, giving lower contrast to the resulting print.

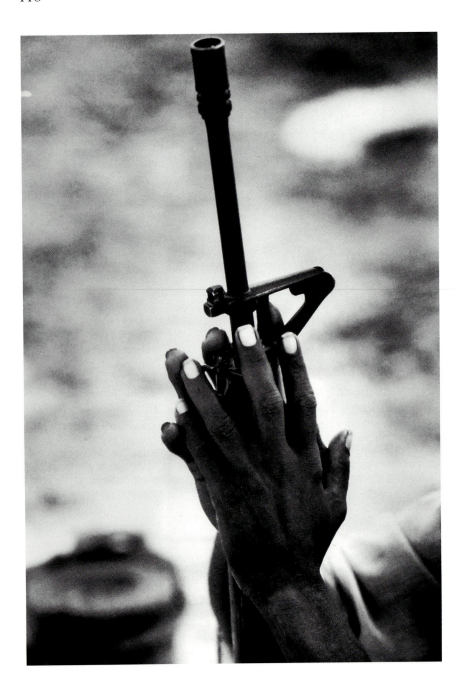

This stepless concept in filtration is both fast and convenient, but it would lose its elegance if test prints were made with no filter. Therefore, even though printing with no filter is roughly equivalent in contrast to printing with a number 2 filter, it would be a distinct disadvantage to have to recalculate the proper print exposure when adding a filter, if a test print done without a filter showed a need for increased or decreased contrast.

Multicontrast filters are available in mounts to allow their placement under the enlarger lenses or in acetate sheets that can be positioned in the enlarger head above the negative and below the lamp. The sheets are preferable, as they can be used without extreme attention to dust and scratches, which would deteriorate the image quality if placed under the lens. Sheets are available in sizes to fit most enlarger applications.

Somali Gunman
© Alexandra Avakian/Contact Press Images

CONTACT SHEETS

Contact sheets, sometimes referred to as proof sheets, are prints that are the same size as the negative. They are used to gain information about a number of negatives at the same time, without going through the lengthy process of enlarging, or projection printing, each one separately.

A contact sheet is made by laying the negatives emulsion down directly on the surface of the printing paper. The paper must be placed face-up with the emulsion facing the light source. A piece of glass is then positioned over the top of both negatives and paper. This puts the emulsion of the negatives in direct contact with the emulsion of the photographic paper. Light is passed through the glass and through the negatives, and records the images onto the light-sensitive paper. A contact frame or proof printer is designed for this purpose.

Though any light source can be used to print a contact sheet, the most readily available source in most darkrooms is the enlarger. To position the enlarger for contacting, raise the head until a circle or a rectangle (if an empty negative carrier is in the enlarger) of light is large enough to cover the paper onto which the negatives will be printed. The first time you do this, it is a good idea to mark the height of the enlarger to standardize it for all future contact printing. The light will expose the paper by passing through the negatives, which are held in "contact" with the paper by a piece of glass or a printing frame. Select an f-stop from the middle of those marked on the lens barrel—also note and reference this for future prints. Then, run a test strip by positioning a piece of cardboard over the sandwich of glass, negatives, and paper or printing frame and actuating the timer for an interval of time. A good starting point for choosing intervals is one second for thin negatives, two seconds for normal negatives, and three seconds for dense negatives. Use at least five intervals in order to get a good sample of exposure times. At the end of each interval of time, remove the cardboard to reveal more of the contact sandwich to light, and reactivate the timer. Continue this process until the whole set of

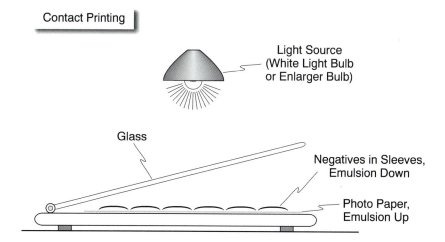

In a contact print sandwich, the pressure of the glass is necessary to remove air between the negatives and the paper.

Gaston Goumaz
© Stacy H. Geiken, 1993

negatives has been exposed onto the paper. After processing, the contact print will have a range of exposures from very light to very dark. This technique is also used to create test strips when enlarging.

On 35mm film, a clear film edge, sometimes called the **rebate edge,** is located around the sprocket holes. This is an area of the film that received no camera exposure and that possesses the minimum density of the film without exposure. This minimum density is referred to as **base plus fog.** Base is the density, or light-stopping ability of the actual film base—polyester, acetate, and so forth. **Fog** is the condition of any extraneous light striking the film and the resultant density on the film. In this case, it is any fog, however inconsequential, that occurred in the film's manufacturing process. Base plus fog has minimum light-stopping abilities, but more than the absence of film over the paper, and this difference is the key to judging the correct contact print exposure.

Choose the correct contact sheet exposure from the test strip by selecting the time that yields a just-noticeable difference between the clear film edge of the negative printed on paper and the black of the photographic paper with no film blocking the light striking it. Then, use that time to print the entire contact sheet.

A carefully printed contact sheet or proof sheet can reveal a good deal of information about the exposure and development of the negatives to be printed. If negatives on a properly printed contact sheet look like normal prints, then they are good negatives with proper exposure. Negatives that are too dark on the contact sheet are too thin in density as a result of underexposure, and those that are too light are too dense as a result of overexposure. Contact sheets that contain good shadow detail overall but lack highlight detail overall—because of overly bright highlight areas— indicate overdeveloped negatives. Contact sheets that show good shadow detail overall but are flat, without contrast, and lack highlight brightness are most likely the result of underdeveloped negatives.

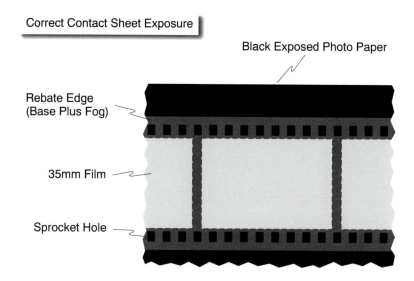

Correct Contact Sheet Exposure

Black Exposed Photo Paper

Rebate Edge
(Base Plus Fog)

35mm Film

Sprocket Hole

The contact sheet is printed until the exposed paper is black and the rebate edge is dark, dark gray—almost black, but a tone lighter than the photo paper.

Sliding Rocks, the Racetrack, Death Valley National Monument, CA, 1992
© Christopher Broughton

PROOF PRINTS

Proof prints, sometimes called work prints, are enlarged images that have been made for informational purposes without concern for print quality. Photographers use proof prints as an intermediate step before committing to final printing.

When the contact sheets are examined, the photographer must determine which images on them will be enlarged. Proof prints will help in making this decision. They should be large enough to clearly give information about both technical and design concerns. Unless a picture on the contact sheet obviously presents this information, the negative should be proof printed.

Two starting points can be used to make a proof print. One is to use the exposure time for the properly printed contact sheet. If this is done, care must be taken to keep the enlarger height, lens aperture setting, and timer setting the same as for the contact print.

The best way to establish exposure for proofing is to make a test strip for the print. This test strip is made in the same basic way as the test strip for the contact sheet. It is created by using a piece of cardboard to cover portions of the projected negative and to add increments of exposure to the paper. After the entire sheet has been exposed, it is processed, and the normal exposure is selected from the test strip.

The advantages to using the test strip method are that the image can be cropped—that is, the enlarger height can be moved from the position for contact printing to make the image larger or smaller on the paper—and that more control is available over exposing the individual negative.

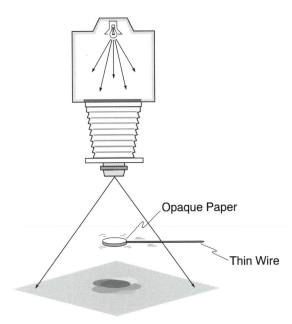

Dodging with a Dodging Wand

Opaque Paper

Thin Wire

DODGING AND BURNING

Even though great care is taken making the negative, some prints will need local corrections to make them match the photographer's expectations. This can be accomplished by controlling the amount of light reaching critical parts of the image during the printing process. This local control of light on the print is called dodging or burning.

Dodging tends to be more common than burning, but both are used to make local density changes in a print. **Dodging** reduces the light from the enlarger by placing something between the enlarger lens and the printing paper for a portion of the printing time. The longer the blockage of light, the lighter that part of the print.

Though many photographers use their hands to block the light while dodging, dodging wands tend to be more accurate. A dodging wand is constructed by attaching a piece of opaque paper to the end of a rigid, thin piece of wire. This allows the paper to block areas within the image without blocking a large amount of the light to other portions of the print. The shape of the opaque paper can be cut to approximate the area of the picture that needs to be lightened.

Regardless of the method used to block the light, the closer the blocking action is to the enlarging lens, the smoother the transition will be from the dodged portion of the print to the unaffected portion of the print. The advantage of being close to the enlarger lens is that the edge of the dodging material is softened by shadow characteristics of the light. Also, if a wand is used, the effect of the wire is greatly reduced.

Regardless of the height of the dodging material, it needs to be kept in motion slightly to further aid in the transition from the dodged portion of the print to the undodged portion. If the dodging material is placed on the surface of the paper and not kept in motion, it will leave a noticeable crisp shadow.

The reverse of dodging is **burning.** This means giving extra exposure to areas of the picture. It is normally achieved by using a card or piece of cardboard with at least one black side, and a small hole cut through it. The board is then held between the enlarger lens and the print so that the hole lets light strike only the areas of the print that require more exposure to increase density or to darken. Once again, the photographer will want to keep the board in motion to ensure smooth density transitions.

Dodging is normally a reduction of light and exposure and happens during the original exposure of the print. Burning is the addition of light and exposure and is done after the primary exposure of the print.

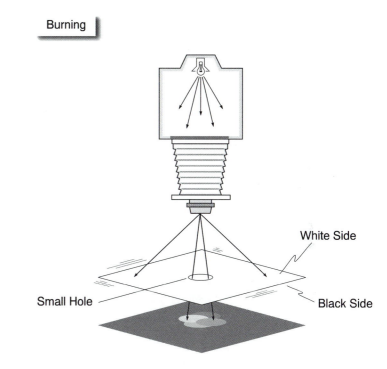

Christian Laettner for Gentlemen's Quarterly
© Gregory Heisler 1992

FINISHING

Once the final print is made, the work needs to be presented. Several methods are used to correct small imperfections and prepare the work for display.

- Photographers can correct small dust spots on a print by using spotting dyes.

- Negative retouching makes printing easier and allows better communication of the photographer's ideas.

- Different approaches to matting and mounting prints allow for creativity in display.

John Szarkowski
© 1991 Nancy M. Stuart

The presentation of a print is the last step in its production. Finishing is the process of making a print suitable for presentation as a finished photograph. It consists of spotting prints, retouching negatives, and mounting and matting final prints.

SPOTTING PRINTS

Spotting is a retouching process that uses photographic dyes to eliminate defects in negatives and prints. Few photographers retouch their own negatives, but most use retouching methods to correct flaws in their prints. It is essentially a means of camouflaging image defects. Hiding dust is its prime use, but it can also be employed to cover other small imperfections.

A fine-tipped brush should be used for spotting. Its size is not as important as its ability to make very tiny marks on the print.

Many manufacturers produce spotting dyes; the important thing to remember when selecting a dye is to match the image color with the dye color. Sometimes it will be necessary to mix dyes of two different colors—for example, black and brown—to arrive at a color match for the paper in use.

The most difficult part of spotting is matching the tonal value of the dye to the tonal value of the defective area of the print. To accomplish this, use of a dye palette is encouraged. Any white dish, piece of Plexiglas, or white artist's palette can be used as a palette. The dye is diluted with water to make a gray scale on the palette. This range of dye values can be allowed to dry on the palette. A damp brush will rejuvenate the dye when it is needed at a later date.

A piece of white border from a print with the same emulsion should be used when deciding which dye value to pick up for spotting the print. A few dots of dye color on the scrap of border can be compared against the area of concern in the print. This allows for careful consideration of the correct value of the dye before its application. Note repeated application of dye in the same area will result in a darkening of the spotted area's value. Once spotting dye is absorbed into the emulsion, it is difficult to remove, and for this reason, it is always better to begin with too light a dye rather than too dark.

Spotting is done by depositing a small amount of dye on the surface of the print at the defect. The brush is not used in a traditional sweeping motion; it is held perpendicular to the paper, and only the tip of the brush is used to place small dots of dye on the surface of the print. This technique is called stippling. It is better to carry a minimum amount of dye on the tip of the brush. If the brush is overloaded, the dye will puddle on the print. The loading of the brush, can be controlled by blotting or twisting the brush tip on an absorbent surface.

A folded soft paper towel or photo wipe should be placed on the print to rest the hand on when spotting—or an editing glove with the thumb and index finger removed can be worn. These practices keep smudges off the print. The toweling has the added advantage of giving a handy surface for absorbing areas where too much dye puddles on the print and for easily removing excess dye from the brush.

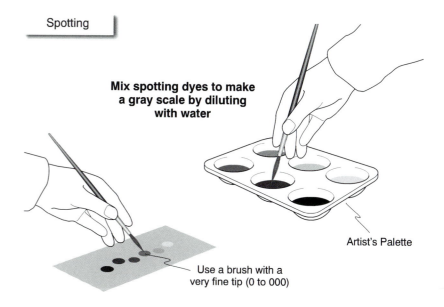

Spotting

Mix spotting dyes to make a gray scale by diluting with water

Artist's Palette

Use a brush with a very fine tip (0 to 000)

Test for close match with print tones on a scrap of trimmed photo paper

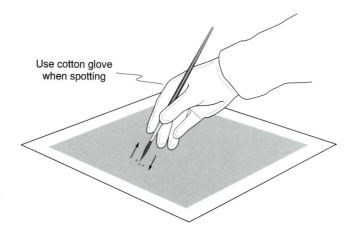

Use cotton glove when spotting

Use stippling action to spot photo; brushing action is not recommended

RETOUCHING NEGATIVES

Retouching negatives requires great skill, special tools and supplies, and a good amount of practice. Many books discuss this subject in depth. Basic negative retouching is limited to changing defects that are black on the print, to make them print white. This will allow these defects to then be spotted.

Defects on the print that are black—dust specks, lint, hairs, and so forth—are clear areas on the film. To remove them from the print, the negative is retouched to add density to the clear areas. The same spotting dyes used on the print can be applied for this purpose. The biggest challenge is the small size of the defect on film, and because of that, magnifying lenses or lens-light combinations are often used. Applying a dark value of the dye to the negative establishes density and creates an area that will print white. Once the print is made with the defect changed to white, traditional spotting methods can be used to remove the defect on the print.

Some brands of professional film in 120, 220, and 4 × 5-inch sizes have a retouching tooth built into the base side of the film. This tooth creates surface texture that can be used for retouching. These films in black-and-white can often be retouched with graphite retouching pencils.

Night Rodeo
© 1993 Adam Jahiel

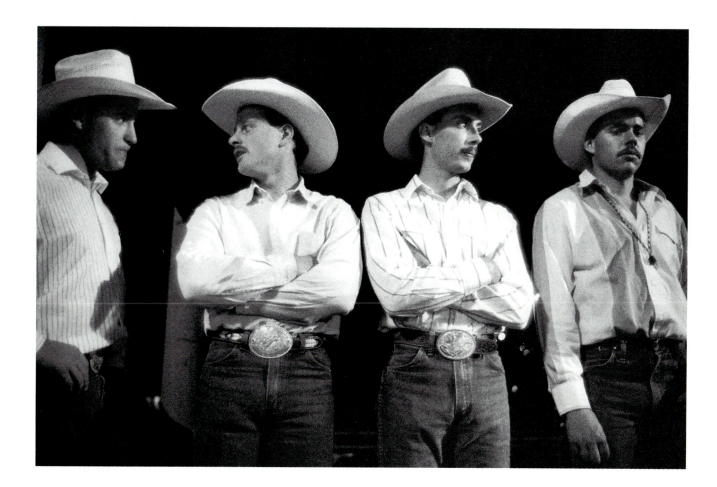

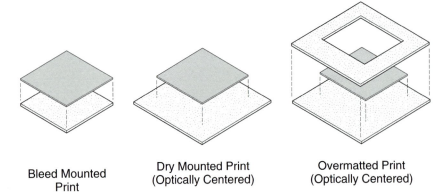

Various Types of Print Presentation Methods

Bleed Mounted
Print

Dry Mounted Print
(Optically Centered)

Overmatted Print
(Optically Centered)

PLACING PRINTS ON A PRESENTATION BOARD

Photographic images are presented in numerous ways. The most common way is mounted on a larger board that frames the print with borders. Larger prints may look better if the image "bleeds off" the board—that is, is exactly the same size as the board so that the board is not seen. In this case, the board's only purpose is to provide rigidity. Some prints are adhered to the surface of the board, whereas others use the board to create a window to the photographic image.

Mounting Boards

Mounting board, to which photos are attached for display, comes in various qualities, colors, and sizes. The quality of the mounting board should be a prime consideration. Prints that are going to be used in a portfolio, sold as art, or otherwise have a long life expectancy should be mounted on the highest-quality board. High-quality board has two requirements: it should have a neutral pH—this is referred to as acid-free mounting board; and it should be made of 100 percent cotton fiber—this is often called "rag" board. The cotton fiber avoids the problem with high sulfur content of most boards made from wood pulp, which is that eventually the board will cause the print to discolor and deteriorate. The most common example of **rag board** is museum board, which is either 100 percent rag content or pH buffered. All photographic projects do not necessarily call for this high-quality board. Lesser-quality, and less expensive, board would be the appropriate choice for most student assignments, and for mounting photographs that have a short life expectancy, such as RC prints.

Optical Centering

An optical illusion occurs if a print is absolutely centered on a board. This illusion makes the top border of the board appear larger than the bottom and gives too much visual weight to the top. **Optical centering** is a technique to overcome this illusion. It allows for more space at the bottom of the board, in a direct relation to the size of the print, and establishes a firm visual foundation for viewing the print.

The trimmed print is placed in the upper left-hand corner of the mounting board. The distance from the edge of the print to the end of the uncovered portion of the board is measured both horizontally (measurement A) and vertically (measurement B). Measurement A is then cut in half, and the resulting distance marked on the board as line x. Measurement B is cut in half and that distance is marked on the right-hand side as point a'. A line (line a/a') connects the lower left-hand corner of the print (point a) to the point where line a/a' intersects the right-hand edge of the mount board (point a'). The intersection of line a/a' with line x determines where the lower right-hand corner of the print will be placed, thereby optically centering the print.

Optical centering can be applied to any size prints. Commercial devices are available that will assist in optically centering small- and medium-size prints.

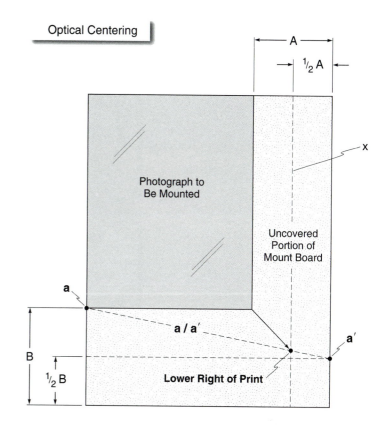

Untitled
G. Pasha Turley

He felt empty and without emotion. He could not remember when he had ceased to experience. He could only remember controlling his feelings. He had never allowed himself to love.

Dry Mounting

The most common method of presenting prints is through **dry mounting.** The most common dry mounting technique uses heat-sensitive tissue to adhere the print to the mounting board. This procedure involves some special equipment: a dry mounting press, a tacking iron, and some means for trimming the print and the board. The supplies required include the print to be mounted, dry mounting tissue with a melting temperature designed for the type of photographic paper being used, release papers and cover sheets, and the mounting board.

Two basic types of dry mounting tissue are available: a porous adhesive and a nonporous adhesive. The melting temperatures of these tissues differ very little. The main difference between the two is in their application. The porous adhesive tissue, which breathes, is the best choice for mounting nonporous materials. RC print paper is a nonporous material. This tissue is the most adaptable of the two and a good choice for general use on all materials. It is designed to work in the temperature range of 185–205 degrees Fahrenheit (85–96 degrees centigrade).

The nonporous tissue is designed for mounting porous materials. Fiber-based printing papers are porous. The use of this tissue is not recommended in areas of high humidity. This tissue should also not be used with RC paper, as doing so would join two nonporous materials, and could cause air pockets under the print because of the inability of either material to breathe. The temperature range of the nonporous tissue is 200–225 degrees Fahrenheit (93–107 degrees centigrade).

⊘ **CAUTION:** Do not put RC papers in dry mounting presses set at temperatures above 205 degrees Fahrenheit (96 degrees centigrade), as the print surface will melt.

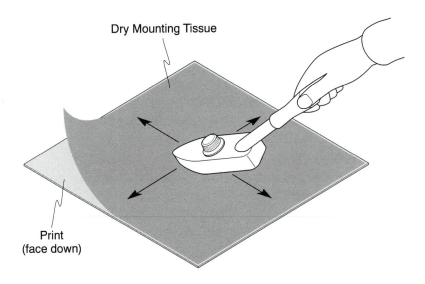

Tacking Dry Mounting Tissue onto a Print

Dry Mounting Tissue

Print
(face down)

The dry mount tacking iron is a small handheld iron with a temperature control. Its purpose is to tack the dry mounting tissue in place on the print before it is trimmed, and to tack the print and tissue onto the mounting board before they are put in the dry mounting press. The temperature control should be set on high for fiber-based papers and on medium high for RC papers.

Tacking the dry mounting tissue to the back of the print is the first step in the dry mounting process. This is done by aligning the sides of the tissue and the print, and using the tacking iron to make four marks on the tissue that form a cross. First, lay the print face-down on a smooth, heat-resistant surface, and center the tissue over the back of the print. Starting in the center of the tissue, pull the iron toward the middle of one side of the print. Remember, the tacking iron is a tool. Its job is to melt the tissue; you need not apply heavy pressure to it—this would only result in an unwanted embossing of the print. Starting in the center once more, pull the iron to the middle of another side of the print. Finish the tacking by pulling the iron from the center of the tissue to the middle of each of the remaining two sides of the print. When the tissue is completely tacked in place, the tacking marks should resemble a cross with its arms connecting the middles of all four sides. Do not attempt to tack a print in place using two strokes of the tacking iron running from edge to edge vertically and horizontally. This usually causes problems with air bubbles trapped under the print.

Once the tissue is tacked in place, the tissue and print are trimmed so that their sides are exactly equal, successfully hiding the tissue beneath the print. Trimming can be accomplished with a variety of tools, from elaborate paper cutters that clamp the paper in place while cutting, to something as simple as a utility knife and a straightedge.

Mounting boards absorb moisture from the air. In humid climates, it is advisable to dry the mounting board before attaching the print, by placing it in the dry mounting press for 1 minute at the same temperature you will use for mounting (100°C, or 212°F).

The trimmed print can now be optically centered on the mounting board. Take care to make marks for locating the print that are

easily covered up by the print or removed after mounting. Align the print in place on the board, and hold it in position. Cotton gloves are recommended to keep fingerprints and smudges off the print. While holding the print, raise one corner of it, leaving the dry mounting tissue against the board. Using the tacking iron, touch the corner of the dry mounting tissue to tack it in place. Follow the same procedure on the remaining three corners. Be careful not to move the tacking iron across the board when tacking the corners, as this could cause residue from the iron's surface to stick to the board. The print is now ready for dry mounting.

Carefully check the print for alignment on the board before placing it in the press. If it is necessary, the tacked print can be removed at this time and realigned; this will not be possible once it has been dry mounted.

Place the board with the tacked print face-up into the dry mounting press. Cover it with release tissue or a cover sheet or both.

Specialized release papers keep any residue from the dry mounting tissue from sticking to the dry mounting press and the print. They have a silicon coating that prevents the tissue from sticking to the surface. Many photographers also use some form of cover sheet. This is a thicker piece of paper or board that is placed between the dry mounting press's platen (heating element) and the print, to protect the print's surface from indentations caused by residue or dirt that may have accumulated on the platen.

Carefully close the press, and wait approximately 45 seconds. The exact time will depend on the thickness of the cover sheet and the type of board in use. If the dry mounting press temperature is set correctly for the paper in use, the print can be allowed to stay in the press indefinitely.

Upon removing the print from the press, place it face-down on a clean, flat surface and hold it in place until the heat dissipates. This will ensure that the board is flat, not buckled or bowed. A final light flexing of the board after it has cooled will attest to its successful dry mounting.

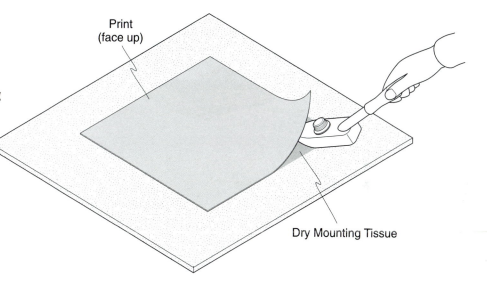

Tacking an Aligned Print onto a Mounting Board

Print (face up)

Dry Mounting Tissue

Hoopman
© Nick Vedros/Vedros & Associates 1990

Other Mounting Systems

Dry mounting, although popular, is not the only means of affixing photographs to mounting boards. Self-adhesive boards that have a peel-away layer that exposes the adhesive allow for a quick mounting of prints. This system is limited to bleed mounting of prints. With bleed mounting the photo extends to the edge of the board.

⊘ **CAUTION:** Spray adhesives are available to coat the back of a print for mounting. These have the disadvantages of the need for a well-ventilated area for application and of the environmental consequences of their aerosol packaging.

The newest and most sensible mounting system is the cold mounting process. Many commercial labs have changed over to this system, which eliminates the need to keep a dry mounting press on all day long and results in a great savings in electrical bills. The cold mounting system utilizes a specialized set of rollers, similar to the rollers of a printing press, to apply pressure-sensitive adhesive tissue between the print's back surface and the mounting board's front surface. This forms a permanent bond between the print and the board, without air bubbles. Cost is the disadvantage of this system for noncommercial enterprises.

Overmatting

When the photographer does not want to affix a print permanently to a board or a different look in presentation is desired, overmatting, or window matting, can be used. **Overmatting** involves cutting a window—which could be optically centered—in a **mat board,** hinging the window board over a support board holding the photograph. The mat board is the one in which the window has been cut.

Most overmats are cut using special mat cutters and have a beveled edge on the window opening. The window dimensions are measured and marked on the back side of the window mat board. The cutting is also done from the back side, on a soft surface, such as a piece of mounting board, to allow the blade of the knife to protrude through the entire board. Care should be taken to overcut the corners just enough to allow the easy removal of the cutout section. Keeping a fresh blade in the cutting tool is essential to getting crisp, evenly cut edges on the window.

Burnishing, or polishing, the edges will smooth out any unevenness from the cutting process. This can be done using a fingernail or the cap of a ballpoint pen. Special burnishers made of polished bone are available through specialty supply stores.

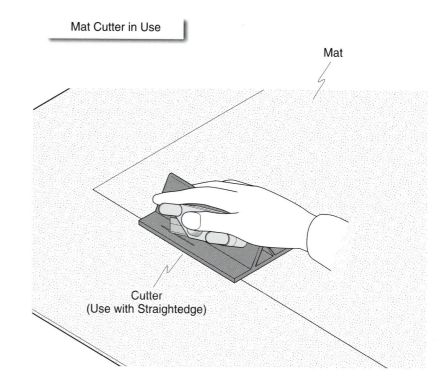

Mat Cutter in Use

Mat

Cutter
(Use with Straightedge)

Hinged Window Matting

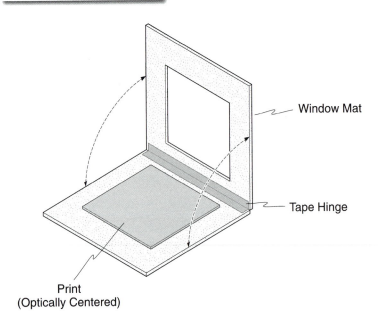

Window Mat

Tape Hinge

Print
(Optically Centered)

When prints are overmatted, the window mat is hinged to a support board of the same size. The hinge is made of tape. Special linen tapes are available for this purpose. The print can be dry mounted on the support board, or it can be mounted in a less permanent manner using photo corners or hung from the top of the support board with tape.

A nonpermanent mounting system like overmatting has its advantages. It gives the photographer the ability to remove a print from an overmat and replace it with another. Permanent mounting is particularly unnecessary if a print will be displayed in a frame or on a wall, under glass. The glass will serve to keep the print flat against the support board.

Prints can be kept flat by dry mounting a sheet of unexposed, processed printing paper to their back side. This provides a flat, durable print that has enough rigidity to be placed in an overmat that will not be framed with glass.

Harriet Doerr, author
Anacleto Rapping

Untitled
© 1986 Jerry Uelsmann

COMPOSITION AND COMMUNICATION

"A picture is worth a thousand words." Photographs use the visual elements of composition and design to communicate meaning to viewers. When photography's potential for communication is maximized, a thousand words may not be enough!

- Three basic principles of composition define the way image elements work together. These are balance, perspective, and juxtaposition.

- Six elements of design are the building blocks that allow the principles of design to function. These are shape, value, line, texture, volume, and space.

- Perception and symbolism are the major tools for determining meaning within photographs.

Abstraction, California
Robert G. Smith

Making photographs is much more than using a camera, developing the film, and printing the pictures. Photographs are powerful communication devices that can be used in many ways and in many cultures without translation. To make photographs that are truly successful at communicating, the photographer needs to use composition to arrange the subject and objects in the picture to effectively guide the viewer through the picture.

COMPOSITION

The major tools that photographers use to compose their images are the same as those used in other visual artistic endeavors. **Composition** is defined in several ways. One of the most useful is to describe overall principles that identify relationships within pictures, and the elements that are used as building blocks. These principles and elements are interrelated and do not function independent of each other.

Principles of Composition

The human perceptual system interprets the major principles of photographic composition. This system takes information from a photograph, restructures it, and communicates the reality the photographer saw at the time he or she made the picture. The mind's interpretation relates to the way the viewer has learned to see. For this reason, cultural differences mark the way people see and the effect of composition on photographs.

But for most individuals, three major principles are active in the composition of photographs. These are balance; the perception of space known as perspective; and the juxtaposition, or comparative positioning, of objects.

BALANCE. **Balance** is the way the parts of a picture work to stabilize the view. This effect may create equilibrium or disequilibrium. Balance allows the viewer to move through the image and see and use the information within the picture. Without balance, pictures become difficult to view.

Balance is universal in all photographs, regardless of the elements chosen in them. To understand it, the photographer needs to understand the way the mind defines the center point in a frame. A frame is the rectangle of the viewfinder in a camera or the edges of a picture. In geometric terms, the center can be defined as the point where the diagonals from the corners cross. This might be helpful in a mathematical sense, but the human eye tends to see the center of a frame slightly above the **geometric center,** or physical center. And in understanding balance, it is the **visual center** that determines the activity in the picture.

Motion and weight are the most important concepts involved in balance. As with many concepts in discussions of still photographs, both are only implied by visual elements.

Since a photograph is a still image, a moment frozen in time, **motion** is the effect of the elements within the picture on the motion of the eye. A frame contains two nonmotion-producing places. The first is the visual center, and the second is along the edge on the bottom of the frame. If the central subject or major structural elements are at either of these locations, the picture will tend to have a **static balance,** without apparent motion. This is neither good nor bad, just a choice. Static images tend to be quiet because they have little induced motion and are in equilibrium.

Location of Visual Center

Visual Center

Geometric Center

I have always wondered, are zebras white with black stripes, or black with white?
© Dorothy Potter Barnett

Visually, pictorial elements appear to move toward the visual center and the edges of the frame. The apparent motion increases as an element gets closer to the center or an edge until it is no longer visually separated from the center or edge. In the frame, certain areas create greater amounts of induced motion. Areas near but not touching the edges and the visual center are the most active, whereas areas midway between the center and the edges are more stationary. Areas above the visual center tend to induce more motion than those below the center. In western culture, because of the direction of reading, the area producing the most motion is slightly above the visual center in the right portion of the frame.

When pictorial elements of a picture are arranged to induce the feeling of counteracting motion, or motion in two or more different directions simultaneously, then the image stays in balance. Photographs that employ this method for balance are said to have **dynamic balance.**

Symmetrical balance is often talked about. This means that the frame has approximately the same size, number, and weight of elements on either side of the vertical centerline of the image. This image format creates equilibrium similarly to a teeter-totter. Visual forces on each side of the centerline counterbalance each other to create the desired level of equilibrium.

A common way of using balance in a photograph is to apply the rule of thirds. This places the subjects on intersections of the lines dividing the frame in three equal parts vertically and horizontally. If one intersection is used, the image will produce a more dynamic balance than is found in a symmetrical arrangement.

Most often, balance is thought of as the equalizing of weight. Visually, this is a good way to look at this principle, but in reality, visual weight is a much more complicated issue than physical measurement.

Rule of Thirds

Visual weight is created by several variables. The most obvious one in a photograph is the size of the object in the frame. Thus, two similar objects of different sizes will be seen as having different visual weights. If size were the only variable in determining weight, then the photographer would use objects of similar size to accomplish balance. The other variables that influence a viewer's estimation of weight are darkness, sharpness, importance, perceived depth, and position.

A strong difference in brightness between visual elements and their surrounding area creates high contrast. As an object gets darker, its visual weight increases. This weight relationship holds even though lighter elements will often dominate darker ones in size. As a general rule, the viewer sees a light object as having less substance and thus less weight. In addition, sharper edges that result from increased contrast give the object a more recognizable shape and create greater visual weight.

The more important or recognizable an object, the greater its effective weight within the balance structure of the picture. This can be easily seen when looking at the effect of a face on the balance of a picture. When a human face is present, regardless of size or density, it will have more visual weight and more impact on the balance than other items of similar size or density in the picture. The same can be said about recognizable words in a photo.

When a picture is made to have a great sense of depth, it will also gain a great deal of visual weight. Usually, though not always, increased depth steadies an image because the elements have more detail, recognizability, density, or all three distributed in the lower portion of the frame. This organization increases visual weight and decreases visual motion.

When a subject occupies a position within the frame that creates motion, its visual weight will be increased. If the viewer perceives more motion in a downward direction, she or he attributes more weight to the element.

PERSPECTIVE. **Perspective** is the way the viewer of a photograph establishes a sense of three dimensions from a flat picture. The illusion of depth in a photograph is produced in nine ways. They are:

- linear perspective
- aerial perspective
- textural gradient
- apparent brightness
- size
- interposition
- motion perspective
- motion parallax
- shapes and shadows

As a set of parallel lines get farther away from the viewer, they appear to get closer together. The lines converge at visual infinity. Looking down railroad tracks gives a clear idea of **linear perspective.**

Classical painters use a type of perspective tool known as **aerial perspective.** They gray the colors and soften the detail of the objects in a scene as those objects recede into the space portrayed by the picture. This technique is used to mimic the effect of airborne particles that disturb the light coming from distant objects. This effect is quite observable and photographable in humid or dusty conditions.

Like the detail of an object in aerial perspective, the detail in a texture is lost as it gets farther from the viewer. This type of perspective is known as **textural gradient.**

The light reflecting from a subject is also a cue to the distance of the object from the viewer. **Apparent brightness** increases the closer a light or reflecting surface is to the viewer. In black-and-white photography, the brighter an object is, the closer it appears to be. Conversely, the duller an object, the apparently deeper in the picture space.

Morton International Offices:
Interior Architects Mekus-
Johnson.
Jon Miller, Hedrich-Blessing

Dune Detail, Death Valley National Monument, California, 1992
© Christopher Broughton

Interpreting shadows and shading is another way of defining the depth of space. Knowing the light direction allows the viewer to use the way shadows and shading fall in the picture to determine spatial relationships.

Size and interposition tell the viewer about the depth of the space in the picture. People learn that larger objects are closer than smaller objects. If the objects in a photograph are similar, then the relationship of size becomes a powerful clue to distance. Likewise, **interposition,** which is the placing of one object in front of another, orders the space in a picture. Objects that are in front of others will appear closer to the viewer.

Motion parallax and motion perspective will both help the viewer determine depth in still photography, but are not widely used for that purpose. These deal with the motion, or blur, created by the camera position moving in front of a deep subject. **Motion perspective** deals with the speed of apparent motion, or the amount of blur, of objects in the frame when the viewpoint is moving and the most distant point is being held steady. **Motion parallax** deals with both the speed and the direction of apparent motion, or the amount and direction of blur, when the point of focus is somewhere within the depth of the picture. In either case, points between the camera and its aiming point will blur in the direction of travel opposite that of the camera. For points beyond the aiming point, the blur goes in the same direction of travel. The blur increases as points in the picture's space come toward the camera or recede from the aiming point.

JUXTAPOSITION. **Juxtaposition** refers to the placing of one object next to another to allow either physical or conceptual comparison. The naturalness or strangeness of the positioning of the objects in the frame will affect the function of the various parts of the picture. Juxtaposition influences both the balance and the communi-

cation value of the picture. A special case is the isolation of a subject. In this case, by removing comparison with other objects, the photographer accentuates the subject.

Design Elements

Normally, when people talk of design, they speak about the elements that are used in creating the "look" of a picture. Within the realm of photography, seven elements work to create the general principles of composition and facilitate communication. One of these, color, has little meaning when discussing black-and-white photography. The remaining six are shape, value, line, texture, volume, and space.

SHAPE. **Shape** is the space enclosed by a perimeter line or defined by a boundary. Shape has no depth, only height and width; it is two-dimensional. It is mentioned first because it has the most effect on the identification of objects within a picture. The perimeter or contour around an object does the most identifying. The outer shape often is so powerful that no other information is needed to determine many aspects of the object. Silhouettes illustrate the amount of information available from just the shape of an object.

Within the two-dimensional structure of photographs are shapes that are created by objects and the spaces between objects. Normally, objects are considered figures, and the background is interpreted as continuing behind them. The figures are called **positive space,** and the background **negative space.** When the contour between the positive and negative space seems to belong to both, a figure-ground conflict occurs. In this instance, the negative space fights with the positive space for attention.

Classic Figure-Ground Conflict

Negative Space

Positive Space

Does this image represent two faces, or a vase?

Positive and Negative Space

VALUE. Black-and-white film has a great range of gray values available, which makes **value,** or the tones of the picture, important in the composition of photographs. The amount of variation in a final print will define the spatial relations, establish depth, influence the visual weight, give apparent shape to objects, and move the eye through the picture. At the extremes in using value are high-contrast images, which have dense black and bright white and little if any gray, and long-scale pictures, which have a rich black and a bright white and many different values of gray defining the form of the objects and light.

Value also defines an image's key. Key refers to the tonal make-up of a picture. Most photographers have a normal key with values of gray describing the subject and extremes and black and white as accents. High key refers to a picture with most values lighter than middle gray and few if any values darker than middle gray. A low-key picture is the opposite.

LINE. **Lines** are graphic elements within the scene. They also form the edges and contours that define the shapes and boundaries of objects, patterns, and shadows. But more important than how lines are created in pictures is the way they function. Lines lead the viewer's eyes through a picture, define depth through linear perspective, and become visual dividers within the picture.

Lines also have various qualities that can give emotion or feeling to a picture. Their hardness or softness helps establish quality for the overall image. Bold, contrasty, hard-edged lines become directive whereas soft, diffuse lines tend to be less dynamic. In Western societies, lines with a right end that is higher in the frame are seen as upward leading, and vice versa. Lines that leave the frame on the right side tend to take the eye off the picture. This effect is accentuated if the line ends at a corner of the image. When a line crosses from one edge of the frame to another, it can also divide the picture.

TEXTURE. **Texture** is the surface quality, either roughness or smoothness, of an object. Photography is primarily a two-dimensional medium. Because of its lack of physical depth, texture must be interpreted as an apparent texture. Texture is normally thought of as tactile, but in a photograph, it is a representation of a surface or a repeated pattern. The representation of a surface texture is the result of photographing discontinuities in the surface and shadows that are created by and within the physical texture. Lighting plays an important part in photographic texture. Strong textures have high contrast in their shadows, and sharp edges.

VOLUME. Like texture, **volume,** the amount of three-dimensional space an object occupies, is an **illusion** in photographs. Volume appears to have three dimensions: height, width, and depth. The idea that a subject in a picture has volume is created by the way values are used to render the subject. Silhouettes or very high contrast images give little feeling of volume, just shape. Volume is also enhanced by shading on the subject and by shadows cast by and on the subject.

SPACE. Beyond perspective, **space** refers to the partitioning of the frame. It also describes how the objects in a picture divide the frame.

USE OF DESIGN ELEMENTS. Most good photographs are successful because of the interaction of their visual elements. Only rarely does one element stand out above the rest in a good photograph—it is usually the interaction that makes the image strong. Understanding the push and pull of these elements within the frame of a photograph is critical to their use as compositional tools.

Untitled
Lawrence McFarland

Trees in Snow, Bozeman, Montana, 1990
© Christopher Broughton

COMMUNICATION

Photography provides one of the most effective communication methods known. Since its invention and release in 1839, it has been used to communicate the perception of reality. At the same time, photography has remained both a tool and a medium for artists, who incorporate symbolism in their images.

Perception

To communicate and produce art, photographers need to understand how photographic images function. Primarily three models can be used to describe how pictures communicate. These are replication, interaction, and reaction.

REPLICATION. **Replication** does what it implies. It shows what is in front of the camera, allowing the photographer to communicate what she or he saw. In this type of function, the photographic process is used to show the world around the photographer.

Though this approach to making images seems pure, the photographer makes several choices that affect the scene. Most important, the photographer selects what will appear in the photograph. Since the picture will not include everything, this first choice defines the picture. If the area next to the subject is uninteresting, it does not need to be included in the picture. By changing location, angle of view, lens length, distance to the subject, time of day, and more, the photographer can determine what is seen. Even when the photographer's concept is to make a perfect copy of nature, he or she still is editing what the viewer will see.

But within this type of photographic style, the picture tries to communicate simply and not trick the viewer. The photographer shows the viewer what the photographer wants to show, and lets the

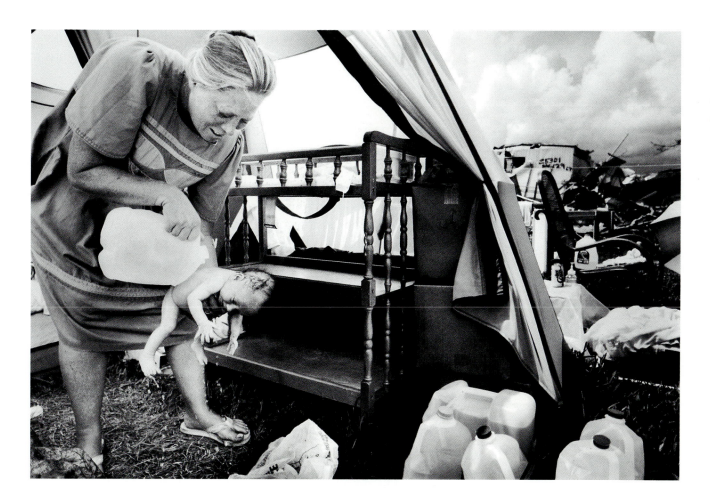

Andrew's Legacy. Jackie Cohen washes her newborn, Kaitlynn, from a water jug while living in the rubble of their trailer park, which was devastated by Hurricane Andrew, in Miami.
© Carol Guzy/Washington Post

Mind of Darkness—3
Nam Boong Cho

viewer's past experiences with the real world determine what information is gained from the picture. A photograph of a mountain is a picture of what the mountain before the camera looked like.

INTERACTION. Interaction forces the viewer not only to see the recognizable objects in the scene but to interpret how the picture works. This method of picture making involves the mind of the viewer as an active part of the process.

Interactive photographs actively create illusions. Though all photographs present illusions of the reality in front of the camera, interactive photographs have the viewer process the information in the image to uncover the illusion. Photographers use an interactive technique when they want to give viewers an idea, and to allow them to fill in information about the picture.

REACTION. Reaction creates a response in the viewer. This simply means that the photograph triggers something within the viewer to give meaning. Meaning may not be part of the picture, but the picture starts a reaction that results in meaning. The composition and design elements in reactive photographs cause the viewer to shift from gathering information from the picture itself or interacting with the picture to understanding different issues not included in the picture. These images are so individually involved for the viewer that what the photographer pictured is not their real message. As the noted photographer, educator, and philosopher Minor White said, "Photographers photograph better than they know."

USE OF PERCEPTION. Of the three ways pictures function, replication is the most easily read. Interactive pictures are more involved than replicative ones, and reactive pictures are the most difficult to use for consistent communication.

Mind of Darkness—4
Nam Boong Cho

Purple Heart and Silver Star
© Nick Vedros/Vedros & Associates

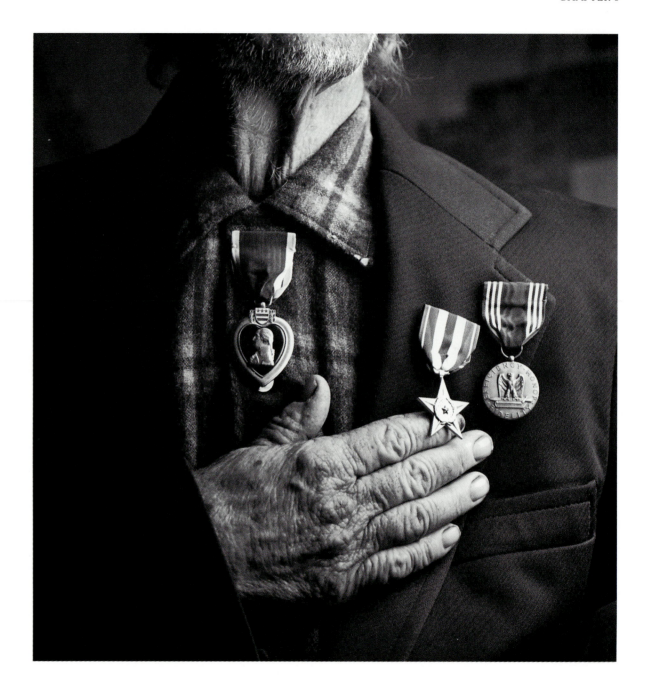

Symbols

Key in the way photographs communicate are the symbols the photographer chooses to use. **Symbols** are tangible visual objects employed to give meaning in place of another object or a concept. They are used to give substance to ideas, abstract concepts, and subjects that would be otherwise difficult to understand.

The easiest way to see symbols is to look at words. Language is symbolic. The letters form visual references to meaning. When people see the letters *t-r-e-e,* they cannot actually see a large object with leaves and branches but they understand the letters to mean what they have come to know as a tree.

To a certain degree, all photography is symbolic. Though people accept photographs as statements of reality, photographs are really only representations of reality. They are symbolic on the most basic level.

Some symbols are more universally accepted than others. The understanding of a symbol depends on the society in which it is viewed. For example, where a cross (+) structure within a photograph may have a religious symbolism in many societies, in Japan it may be seen as meaning 10 and in mathematical circles it indicates addition. The more universal the symbol, the more clearly the message tends to be communicated. On the other hand, the more universal the symbol, the less unique the photograph.

Like colloquial phrases, many symbols do not translate easily between societies. Photographs lose or change their meaning as they are viewed in societies different from that of the photographer. For this reason, many photographs do not communicate beyond individuals who have learned the symbols included in them. As the symbols used become less universal, retrieving the meaning from the photographs becomes difficult because the symbols are based on societal understandings and education about photography.

Kyoto, Japan
David Litschel

LIGHT, LIGHTING, AND FILTERS

Light is what makes photography possible. Without light as a source of energy to make the physical and chemical reactions possible, today's black-and-white photographic image-making process would not exist. The photographer needs to understand what light is, what different qualities of light look like, and how different types of light are produced. If a photographer understands the general principles of lighting, then a light is a light is a light.

- The way light is recorded in photography differs from the way light is perceived.

- The quality of light influences the message communicated by a photographer.

- Three prime types of light are used in photography: natural, continuous, and electronic flash.

- The major difference between electronic flash and continuous light is the way exposure is handled.

- Filters and their use can greatly influence the contrast and effects available in black-and-white photography.

- When filters are used, the exposure may need to be adjusted by an appropriate filter factor.

Herman Miller Facility: Architect Frank O. Gehry and Associates, Inc.
Nick Merrick, Hedrich-Blessing

The history of photography is the history of reproducing light. The first name for a photograph was **heliograph** (meaning "sunlight writing"). Early pioneers of photography needed great intensities of light because of the insensitivity of the films, and were forced to depend on long exposures in bright sunlight. The first photograph required an 8-hour exposure.

As films were improved, photographic images changed in their scope. The improved films meant that long exposures or great amounts of light were no longer needed to make photographs. Light became a critical yet variable part of the photographic process. This is even more evident in the 1990s, with photographers using light as a creative tool in addition to needing it for basic exposure.

The way the photographer uses light is the most important element in making a picture. For this reason, the photographer needs to understand the definition, qualities, and types of light, as well as methods for controlling and modifying it. Light has many characteristics, which when understood and controlled, make it a very powerful tool in communicating through photography.

DEFINITION OF LIGHT

Light is the energy source that makes vision possible. Dictionaries use the term *illuminating energy* to define light. Thinking of light as energy makes some imaging concepts easier to understand. Light is one of many related energies that affect the photographic process.

Physicists deal with light as an energy that is a small part of the **electromagnetic wave spectrum.** This defines light in the same energy family that includes radio waves and heat waves. The visible spectrum of light includes wavelengths that extend from violet at approximately 400 nanometers (nm) to red at 750nm. (A nanometer is 1 billionth of a meter.) Films can be engineered to read specific spectral ranges, though they normally read the range close to that of human vision.

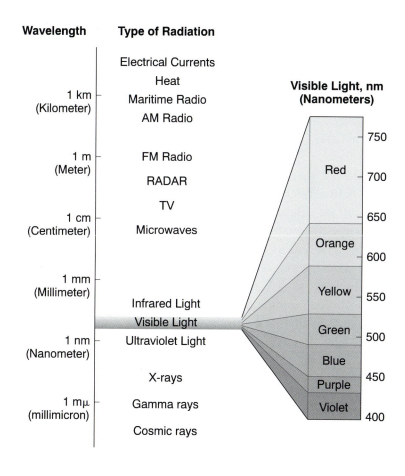

Eyes and film react to light intensities, and not to shadows, or darkness. Though darkness is talked about and learned in drawing, light is what affects vision and exposure. For the most part, the light used in photography is reflected from objects and not emitted directly from light sources—it is reflected light, not incident light. It becomes critical to understand the difference between the light falling on a subject and the light being reflected from the subject to the camera. The light seen or photographed is changed by surfaces, changed in color, concentrated, or altered in any of a number of other ways upon arriving at the subject before traveling to the film's surface.

Films do not react to light in exactly the same way human eyes do. Two light-rendering abilities of film are primarily different from those of vision. These are in the areas of **color sensitivity** and **intensity ranges.** Most films react to a wider range of energy than do eyes. Films have color sensitivity ranges that extend from ultraviolet (UV) waves, which are below 400nm, to infrared and heat waves, which are over 1,200nm. On the other hand, whereas most human vision can handle a 1,000,000:1 ratio of bright areas to dark areas, a range of slightly better than 1,000:1 is common for black-and-white film.

QUALITY OF LIGHT

The **quality,** or character, of light refers to its crispness or softness, the way it adds to the correct feeling in a photograph. The first critical variable in determining the quality of light is the distance the light is from the subject.

Undisturbed light from the sun or the light from a small, angular source is called **specular light.** The quality of specular light is commonly recognized by photographers. Specular light creates bright highlights, contrasty situations, and distinct shadows. Crisp is the best way to define specular light. The light is **hard** and tends to bring out texture detail in areas that it hits at an angle. The sun acts as a point source and is so distant from the subject that the light rays are parallel, creating crisp, dark shadows.

Specular light from the sun looks different on the coast or in the mountains. Atmospheric conditions create the differences in the way the light looks. In traditional artistic training, young painters would be taught that the way to increase depth in a picture is to gray down the background and provide less detail. This is to indicate aerial perspective, which simply means that the light reflected from distant subjects is softened by the particles of moisture or dust in the air. The light coming from the distance is **diffused light;** it is not as crisp when it is interfered with in this way.

A hazy day will spread the light somewhat, and an overcast day will create a very diffuse light source. Fog or heavy pollution breaks up the light in still other ways. Fog not only spreads the light out, it actually wraps the light around the subject.

Some attributes of diffuse light are most effective for the photographer. One is that when light is diffused, it spreads out over an area, as opposed to coming from one point. Diffusion is caused by the size of the light source relative to the size of the subject. It is the result of more than the size of the light; it is the product of the light surface acting as a group of light sources. Each point on a diffused source surface can be considered a light. This means that the larger the size of the light source in relation to the subject, the greater the number of angles of light that interact with the subject.

Santa Barbara
James Chen

Untitled
Jill Enfield © 1986

The more diffuse the light, the softer the shadow. Light angles from a vast number of points fill in and "open up" shadows. The light is soft, and becomes softer as its surface becomes greater in relation to the subject size.

Another powerful quality of light is seen as an artificial source changes its distance from the object to be photographed. When the light-to-subject distance is doubled, the light is reduced to one quarter of its original strength. This is known as the **inverse square law.** This is the same concept that was discussed in chapter 2. It affects the way the final image is seen as well as the light used for exposure.

Still another characteristic of light is that the distance from the light to the subject distorts the perception of depth. The human mind holds constant to the idea that an increase in light intensity is directly related to a shortening of the distance from the subject to the eyes. This means that something will look closer if it looks brighter. This is true whether the light source is incident or reflected.

Of course, at times, light will be coming from more than one source. When this happens, we see crossing shadows, and specular and diffuse effects. The lights, depending on their intensity, will fill in shadows or soften the stronger light effect. In artificially lit environments, this type of lighting is quite common. Scenes lit by streetlights, and interiors are good examples of multiple-source lighting. Some studio lighting also depends on this idea. Broad lighting or floodlighting is of this quality.

In **collimated light,** or parallel light, the light rays are controlled by lenses, mirrors, or light tunnels to become parallel. Sunlight is a parallel source. The large distance to the sun means that by the time its light reaches the earth, the light rays have no measurable difference in angle—they are parallel. In stage lighting or beacons, we can see the effects of collimated light. The light source is controlled to make it send out a beam of light that does not spread much over its effective range. The light is close to parallel in a small pattern created by the controlling device.

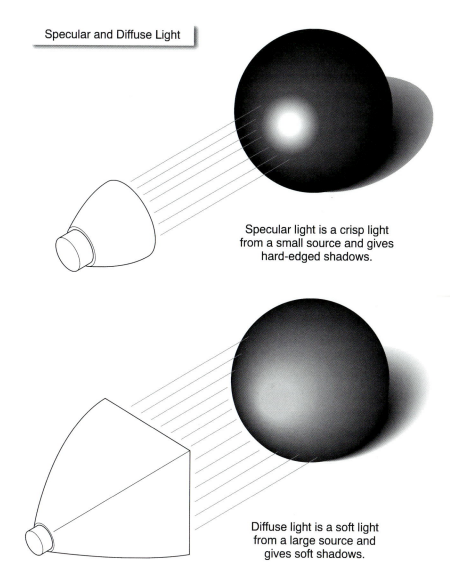

Specular and Diffuse Light

Specular light is a crisp light from a small source and gives hard-edged shadows.

Diffuse light is a soft light from a large source and gives soft shadows.

TYPES OF LIGHT

A photographer will use three major types of light. These are natural light coming from the sun, continuous incandescent light, and electronic flash. Any light can be used in photography, but these three are the main ones that are employed.

Natural Light

Most common light seen is reflected sunlight and sometimes a mixture of artificial sources, blended into a light environment. As the photographer moves from one light environment to another, the quantity and quality of light change. This is particularly true when she or he moves around in a light environment that is created by the sun. Though the sun itself is a very consistent source of light, the light environments on the surface of the earth vary depending on the time and atmospheric conditions. The scale of these lighting environments make the sun the least controllable source of light used in photography. For unlike other common types of lighting employed in photography, it is generally used as it presents itself in the environment.

It would simplify things if all natural-light photographs were taken under clear conditions. The intensity of the light would be consistent and exposure would be based on BDE. But this is not the case with natural light. Atmospheric conditions modify the quantity and quality of light. Bright sunlight is sterile and contrasty when it comes straight down at noon, not giving definition to the volume of most subjects. The bright sun's clear light has a very

Photo taken at a prison for young prisoners north of Russia from the series "Atonement," 1989
Igor Gavrilov

sharp, hard look. It casts deep shadows that stay crisp regardless of the distance they are cast. During midday contrast will often be beyond the range of the film under normal development. Early and late in the day, the light is raking, angular, and harsh. When the light hits the subject at an angle, it accentuates textures of any size.

The sky as it is seen or reflected in photographs also has a distinct appearance on clear days. If the sky is cloudless, its tone will be smooth with a gradual darkening away from the sun. A clear sky before sunup or after sunset is bright at the horizon and dark at the top of its dome.

A photographer may run into two dry cloud conditions: high-cloud haze and humidity-induced haze. **Haze** is created in two different ways. High thin clouds will lightly diffuse the sunlight and take off its hard edge; this is called high-cloud haze. High humidity causes water vapor in the air, which refracts some of the light as it passes through. This creates a small amount of diffusion, with the light scattered at all levels in the atmosphere. This is called humidity haze. In either case, the light is bright but not as harsh as sunlight on a clear day. The two types of haze look similar on the subject but have different effects on the objects around the subject.

High-cloud haze affects the light that illuminates the subjects and equally affects the way other objects are photographed. Humidity-caused haze affects the light illuminating the subject and also diffuses the light as it travels to the camera. Photographing a scene that includes distant subjects illustrates the difference between haze types. A high-cloud haze will photograph with a bright, somewhat flat light. This opens up the shadows and brings down the contrast range of the image. Objects that are far from the camera will stay sharp. If the haze is caused by humidity, the lighting will appear the same at the subject, but distant objects will be softened by the water in the air, which diffuses the light reflecting from all objects to the camera. High-humidity haze softens photographs more when the camera is pointed toward the sun. When photographs are taken with the sun coming from behind the camera, the haze effects will be greatly reduced.

As the cloud cover increases, several things happen that the photographer must take into account. The most obvious is that the light available for exposure is decreased. The thicker the cloud cover, or overcast, the less light available for exposure. Thick cloud cover also flattens out the light by increasing its diffusion. With a full overcast, the shadows will be almost completely opened up by the diffuse light. Highlights and shadows will be closer in intensity.

The diffusion effects are accentuated as the weather changes. Rain mixes the diffusion effects of overcast with the softening effects of haze. Photographing in the rain also gives great vitality to images, as the water dampens the subject surfaces. Rain makes the surfaces more reflective, and the moisture deepens the tones of textured materials. If the camera and photographer are kept dry, the effects of rain are worth going after.

Fog softens everything. The light is scattered and reflected by the water vapor. This fills in the shadows with light and diffuses the camera's view of the subject. The fog also isolates the subject, since depth of field is controlled by the density of the fog.

Receding Poles, Lindisfarne,
Northumberland, England
© Michael Kenna

Viaduct, Berwick, Northumber-
ton, England
© Michael Kenna

Continuous Light

⊘ CAUTION: Many lights are continuous. The term **continuous lighting** in photography refers to light that is generated in lighting equipment and remains illuminated. Normally, this light is produced by **tungsten filaments** that are constructed to glow as steady electrical current is passed through them. This creates an illumination that continues as long as the current stays on and the filament stays intact. Though in some cases fluorescent or glowing gas light sources may be used, most continuously lit fixtures in studio photography are incandescent, filament-type lights. These are also called **hot lights** because the filaments create heat as they stay on. A quartz-halogen source can radiate 750 degrees Fahrenheit (399 degrees centigrade) at close distances.

Two main types of bulbs are commonly used in studio lighting equipment: photofloods and quartz-halogens. **Photofloods** are bulbs that are designed like household bulbs or floodlamps. An inert gas in the bulb keeps the filament from burning up as the electric current passes through. The most convenient part of this bulb type is that it uses commonly available sockets.

⊘ CAUTION: More common in studios in the 1990s is the use of **quartz-halogens.** The length of life and the light consistency in the quartz bulb is much greater than in photofloods. Some quartz bulbs will last over 100 hours. *Quartz* refers to the type of glass used in the construction of the bulb. It is employed to withstand the heat needed for the iodine reaction used for the atmosphere in the bulb to give extended life; iodine is a halogen. The chemical reaction makes these bulbs so hot that the smallest amount of oil from fingers will combine with the high heat to flux, or melt, the surface of the glass. This can either shorten bulb life or pop the bulb. This is why care must be taken when installing new bulbs. New quartz bulbs are usually packaged with paper or plastic wrapped around the glass. This paper or plastic should be used to hold the bulb while installing it or removing it.

The designs of the light fixtures are divided into three main types. They are floodlights or broad-pattern lights, focusing lights, and diffuse lights. The simplest light fixture is the **floodlight** type. In this design, the bulb is open to the front and a reflector gives general direction to the light. This is the least expensive construction used most commonly by the amateur. The normal characteristic of the floodlight is moderately sharp shadows. Floodlights will usually have a hot spot, a brighter area in the center of their circle of illumination. These lights are specular and this design also allows for the use of higher-power bulbs without requiring an elaborate housing size or design.

Focusing lights, or **spotlights,** use mirrors, lenses, or a combination of both to direct and focus light on a subject. The most common reflective design employs a polished spherical or parabolic mirror. In a parabolic design, the bulb is placed at the focus of the mirror, with its light directed toward the mirror. Often, a small mirror or a reflective coating on the bulb housing restricts the light and forces it to reflect off the parabolic mirror. With this design, a light can be created that appears parallel. If the bulb is not at the focus of the parabolic mirror, the light will vary from parallel. When the light is moved farther from the back surface of the mirror, the light will focus on a point closer to it. For this reason, most variable spots have the bulb positioned and mounted to allow for movement to increase or decrease focus.

Lights are also focused by lenses. In most cases, these are **fresnel-designed lenses.** Commonly called spotlights, these lights are mainstays of continuous studio lighting. A fresnel lens has concentric circles, or ridges, on the lens that spread the light evenly and collimate it.

The advantage of spotlights is that they are highly controlled. This means that their illumination can be placed in or on the subject with accuracy. These lights come in sizes from small spots, which are called inky spots and are 3 inches in diameter, to very large spots which are called suns and are 4 feet in diameter. The most common design uses both a parabolic mirror and a movable bulb behind the Fresnel lens. This construction gives maximum control of the beam to allow a range from some softening to hard focus with even distribution of light.

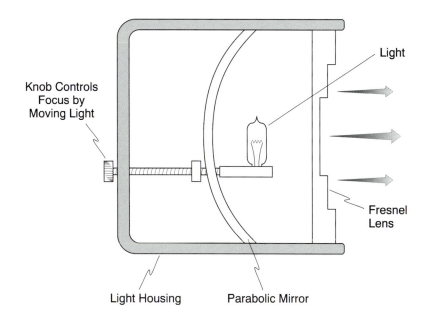

Construction of a Fresnel Spotlight

Knob Controls Focus by Moving Light

Light

Fresnel Lens

Light Housing Parabolic Mirror

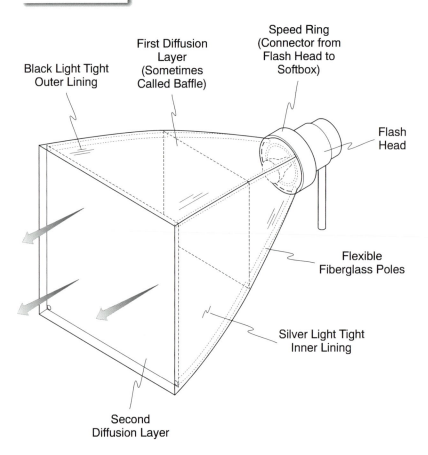

The Softbox

Speed Ring
(Connector from
Flash Head to
Softbox)

First Diffusion
Layer
(Sometimes
Called Baffle)

Black Light Tight
Outer Lining

Flash
Head

Flexible
Fiberglass Poles

Silver Light Tight
Inner Lining

Second
Diffusion Layer

Continuous lights are made into diffuse lighting equipment by refracting or reflecting the light into scattered patterns. Diffuse continuous lights use a softbox to scatter the rays of a light source. The **softbox** is constructed in two distinctive ways. First is the reflective type. This mounts a bulb or bulbs behind a light baffle so that the light is reflected off a lightly textured or white surface. The effect is to use the indirect light from a large lit surface as the light source to create diffuse light. Softboxes of this type use high wattages of light to create the soft lighting without needing to use large reflective boards. The second way a softbox is constructed for continuous lights is using a material that is highly reflective to direct the light from a bulb through a diffusing panel, which is made of a material that scatters the light. Only one side is not opaque, the diffusion panel. Whether a softbox employs a diffusing disk in front of a reflector or a tent design, dissipation by air flow of the heat generated by the bulb will make it last.

Electronic Flash

Electronic flash can be used similarly to continuous lighting, with some variations that require special attention.

A major breakthrough in photography has been the development of effective high-power light of a short duration. This allows more live models and action to be employed as an integral part of photography without the need for high-power continuous light. In the early development of flash photography, many products were developed: flash powder with its smoke, and flashbulbs, with shredded metal are two examples. These made short-duration photography possible within their limits. It was not until the development of the electronic flash that short-duration lighting was really accessible to the photographer.

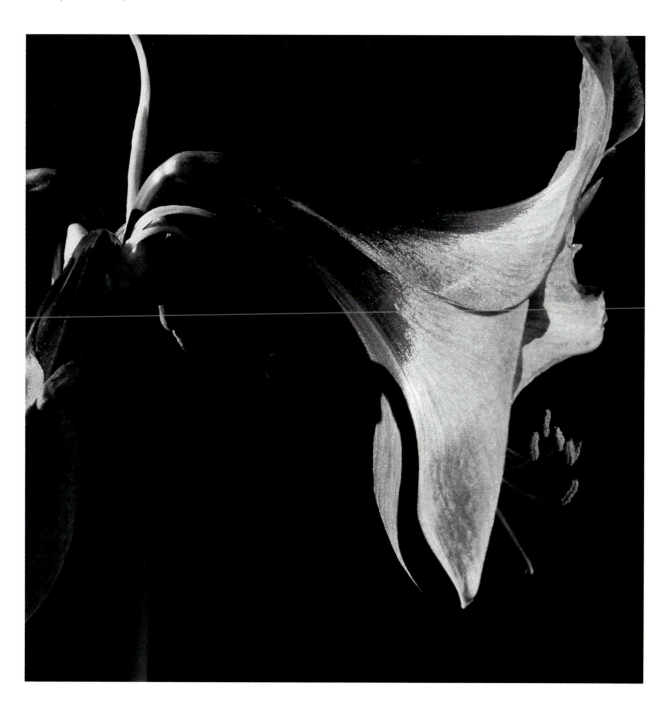

Amaryllis
© Dorothy Potter Barnett

The **electronic flash** uses a function of atomic structure to produce light. The flash of light is created when an electronic charge is passed through an inert gas, such as xenon, in a flashtube. As the electric charge is released into the gas, the electric flow causes electrons of the atoms to absorb the energy and raises them to a higher energy state. When the electric charge is ended the process reverses and the electrons release their added energy. This release of energy held in the atoms causes the gas to glow for a moment. This process happens at an extremely high speed. It lasts 0.01–2 milliseconds. This means that the flash time is comparable to a shutter speed of 1/500 second or faster. The higher the power output (the more light), the longer the duration of the flash. A capacitor holds the electrical charge so that it can be released at any given instant. A **thyristor** is an automatic sensing window on most on-camera flashes that acts like a light meter to turn off the flash (in automatic mode) when correct exposure has been achieved.

Two basic types of flash designs are used in photography. The first of these is the self-contained flash, or integrated type. On-camera flashes fall in this group. This is the most common type of flash equipment. These units either attach to a **hot shoe** on the camera or are attached to the camera shutter release through a sync cord. The hot shoe is the part of a camera that can be electrically connected to a flash unit. A sync cord is a wire that connects the camera and the flash. The shoe or cord allows the flash unit to produce light at a specific time in relation to the opening of the camera shutter. Other cameras or flashes preflash to supply a short burst or bursts of light just prior to the main flash, to avoid **redeye** problems.

The self-contained electronic flash design uses a capacitor in the same housing as the flashtube. This design has all circuits, controls, and power for the flash in a single unit. This has some advantages and some major disadvantages. Because of the design, these units tend to give greater output in relation to the size of the capacitor, but the weight of the capacitor will greatly affect the design of the unit. For this reason, these units tend to have lower power outputs than other designs. Another drawback is that the controls for the unit are on the unit. This becomes a problem if the light is required to be located in a way that makes it difficult to operate the controls. A last concern is the effects of using the flash directly on the camera, which can be a flattening of the photographic vision, flare when the flash is fired at a highly reflective surface, deep shadows when the subject is too close to the background, and red eyes in the subject.

The second major design for electronic flash systems is the use of a central power supply flash with cables to the light heads. Though this is a common studio design, it also comes in portable units. In this design, a capacitor or bank of capacitors powers one or more flashtubes. This design can be used to build electronic flashes with a very large light output. The limiting elements are the construction techniques for the capacitors and flashtubes. Since the capacitor along with its controls is connected to the flash heads by cables, very large capacitors can be used without having great weight at the flash head or on the camera. This gives the photographer the opportunity to employ lightweight flashlamps and to place them where they will do the most good. Also, the flashes are operated at the central capacitor location, allowing for more sophisticated controls such as flash duration control, remote control of the flash, and power splitting.

Self-contained Flash

Flashtube
(Xenon Gas)

Capacitor

Power Source
(Batteries)

Thyristor Sensor

PC Connection

Hot Shoe

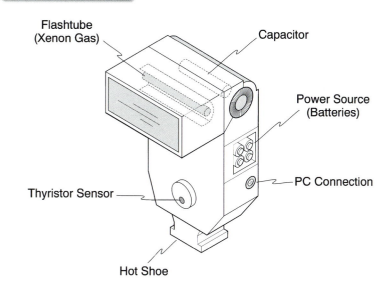

Central Power Supply Flash

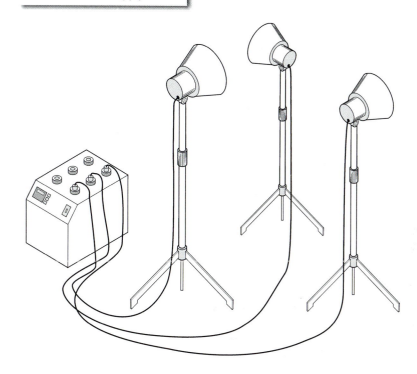

EXPOSURE WITH FLASH

Because of the very short interval of light available for exposure, the aperture, or f-stop, is the major variable in calculating an electronic flash exposure. The shutter speed of the camera is important. The shutter must be opened to allow the entire frame surface to be exposed during the short time the light is on the subject. Leaf shutters open and expose the entire frame at one time and can be synchronized to any particular speed throughout their speed range. Focal plane shutters differ in their synchronization needs for flash. The exposure pattern of these shutters requires that the shutter speed be slow enough to ensure that the entire frame surface will be exposed to the light burst.

Creating a photograph with an electronic flash is similar to doing so using any other method of exposure—it is just that the light is of very short duration. As with continuous light, all methods of determining the correct exposure are available to the photographer. Nonmetered exposure calculation uses guide numbers, and meters that read incident and reflected light are available.

A **guide number** is the power rating of a flash relative to the film speed. All flash units have manufacturer guide numbers. Once the guide number has been established, the exposure is controlled by the distance the flash is from the subject or the f-stop selected for exposure. Each film speed–flash unit combination has its own guide number. To arrive at the proper f-stop setting for an exposure, the photographer divides the guide number by the distance from the flash to the subject. For example, a self-contained electronic flash might have a guide number of 110 for ISO 100 speed film. If the subject is 10 feet away from the flash, the exposure will be at f11 (110 divided by 10). With the same flash, if an ISO 25 film is used, the exposure will be proper at f5.6 if the subject is 10 feet from the flash. The guide number can also be used to set the distance the subject must be from the flash to use a predetermined

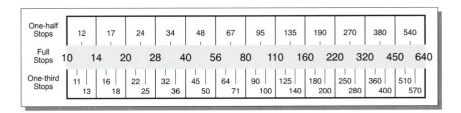

Guide Number Ruler

f-stop. If f22 must be used for proper depth of field with the guide number 110, then the proper distance between the flash and the subject is determined by dividing the guide number by the f-stop: 110 divided by 22 equals 5 feet.

When photography gets more involved with lighting patterns and/or the nature of the work becomes more critical, a flash meter is required. Flash meters read flash light impulses and gives an effective f-stop for the exposure. Many flash meters take into account all the light present during the flash. This means that the light from other sources will also be read to calculate the exposure. Two types of flash-metering systems are used. One type reads all light from the time it is activated until the flash impulse. The second type has a built-in shutter circuit. This type meter is synchronized to measure only light present during the flash for the length of time the camera shutter will be open. This gives the ability to match the exposure of the flash with the ambient light.

FILTERS

One key to controlling the contrast in a photograph is to change the way the light reflecting from the scene affects the film. This can be done by filtering the light as it enters the camera. Many types of filters are available, and they work in the same basic way. A filter is normally a piece of glass, plastic, or other material that changes the light coming from the scene before it reaches the film. Most filters are attached in front of the lens so that the light that enters the camera must first pass through the filter.

Three basic types of filters are used in black-and-white photography. These are absorption filters, interference filters, and special effects, or gadget, filters.

Absorption Filters

The most commonly used filters are the **absorption filters.** These are designed to reduce the intensity of part of the light as it enters the camera. These filters have different densities and spectral compositions. The density of the filter determines the total amount of light that can pass through and reach the film. The color of the filter changes the color relationship of the scene before the light reaches the film.

With **neutral-density filters,** the color relationship of a scene is not changed, only the total amount of light that reaches the film is changed. These filters are color balanced to reduce the light by absorbing equal amounts of all parts of the light reflecting from the scene. This means that they act as if they were an aperture adjustment without affecting either the depth of field or the shutter speed. The effect of a neutral-density filter is rated by the same mathematical function that is used throughout photography: the 2:1 ratio. Only these filters are rated by using logarithmic values. With this method, each 0.3 measurement of density equals one stop decrease in exposure. A 0.9 neutral-density filter will reduce the light passing through it by three stops.

Contrast filters are more commonly used in black-and-white photography than neutral-density filters. A **contrast filter** is a colored filter that is designed selectively to change the color relationships in a scene. It is used either to accent or to reduce the effect of a part of the scene. Because this filter will reduce the effect of certain spectral intensities represented in the negative, it can be used to increase the contrast between positive and negative areas to enhance the photographer's concept of the image.

Dunes, Death Valley National
Monument, California, 1992
© Christopher Broughton

The contrast filter absorbs colors that are not present in its spectral makeup. This allows the colors that are present in the filter to pass through the filter without excessive interference. This reduces the effect that colors *not* present in the filter have on the negative, resulting in thinner negative areas for those colors, whereas the negative appears to be intensified in areas where the colors of the filter were present. Though no actual intensification in the negative occurs because of the filter, the change in contrast relationship between areas of the scene having colors present or not present in the filter gives the illusion of intensifying part of the negative.

The most common contrast filters used in black-and-white photography are yellow, red, and green. A yellow contrast filter is commonly used to increase contrast between clouds and the blue sky. In this case, the yellow filter lessens the exposure of both the blue in the sky and the ultraviolet in the scene. Since blue is not present in the filter, blue light from the sky is absorbed by the filter and creates less density in the negative, resulting in a darker print value for the sky.

A red contrast filter is also a common filter for landscape photography, since it reduces the exposure effects of both blue and green. Green in the landscape will appear darker in the final picture, and blue will also darken. This means that trees, vegetation, and the sky will be dark in relation to natural light, and the reddish tones of land, buildings, and other materials along with white clouds will appear brighter.

A green contrast filter is used to darken flesh tones and brighten vegetation.

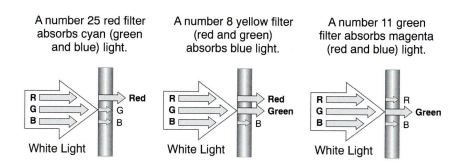

How Contrast Filters Work

A number 25 red filter absorbs cyan (green and blue) light.

A number 8 yellow filter (red and green) absorbs blue light.

A number 11 green filter absorbs magenta (red and blue) light.

Three commonly used contrast filters in black-and-white photography are #25, #8, and #11.

FILTER NO.	COLOR OR NAME	SUGGESTED USES	f/STOP INCREASE PAN DAYLIGHT	TUNGSTEN
3	(Aero 1)	Aerial photography, Haze generation	2/3	—
3N5	Yellow	Combines =3 with 0.5 neutral density	2	1 2/3
6	Yellow 1	For all black and white films, absorbs excess blue, outdoors, thereby darkening sky slightly, emphasizing the clouds.	2/3	2/3
8	Yellow 2	For all black and white films, most accurate tonal correction outdoors with panchromatic films. Produces greater contrast in clouds against blue skies, and foliage.	1	2/3
8N5	Yellow	Combines =8 with 0.5 neutral density, for control of high speed films with same application of #8 (yellow 2) filter.	2 1/3	2 1/3
9	Yellow 3	Deep Yellow for stronger cloud contrast.	1	2/3
11	Green 1	For all pan films. Ideal outdoor filter where more pleasing flesh tones are desired in portrait against the sky than can be obtained with yellow filter. Also renders beautiful black and white photos of landscapes, flowers, blossoms and natural sky appearance.	2	1 2/3
12	Yellow	"Minus blue" cuts haze in aerial work, excess blue of full moon in astrophotography.	1	2/3
13	Green 2	For male portraits in tungsten light, renders flesh tones deep, swarthy. Lightens foliage with pan film only.	2 1/3	2
15	Deep Yellow	For all black and white films. Renders dramatic dark skies, marine scenes; aerial photography. Contrast in copying.	1 2/3	1
16	Orange	Deeper than =13. With pan film only.	1 2/3	1 2/3
21	Orange	Absorbs blues and blue-greens. Renders blue tones darker such as marine scenes. With pan film only.	2 1/3	2
23A	Light Red	Contrast effects, darkens sky and water, architectural photography. Not recommended for flesh tones. With pan film only.	2 2/3	1 2/3

FILTER NO.	COLOR OR NAME	SUGGESTED USES	f/STOP INCREASE PAN	
			DAYLIGHT	TUNGSTEN
25A	Red 1	Use with pan films to create dramatic sky effects, simulated "moonlight" scenes in midday (by slight under-exposure). Excellent copying filter for blueprints. Use with infra-red film for extreme contrast in sky, turns foliage white, cuts through fog, haze and mist. Used in scientific photography.	3	2⅔
29	Dark Red	For strong contrasts; copying blueprints.	4⅓	2
47	Dark Blue	Accentuates haze and fog. Used for contrast effects.	2⅓	3
47B	Dark Blue	Lightens same color for detail.	3	4
56	Light Green	Darkens sky, good flesh tones. With pan film only.	2⅔	2⅔
58	Dark Green	Contrast effects in Microscopy, produces very light foliage.	3	3
61	Dark Green	Extreme lightening of foliage.	3⅓	3⅓
64	Green	Absorbs red.	f STOP INCREASE BASED ON USE AND PROCESSING	
70	Dark Red	Commercial darkroom work only.		
72B	Dark Orange	Commercial darkroom work only.		
74	Dark Green	Mercury lamp, commercial darkroom work.		
23A + 56		Creates night effects in daylight, with pan film only.		
87		For infra-red film only, no visual transmission.		
87C		For infra-red film only, no visual transmission.		
89B		For infra-red film only.		
113		For infra-red film only, no visual transmission.		
Neutral Density	All Film Types Color or Black and White	For uniform reduction of light with high-speed films for still and movie cameras. No change of color value.	Available .1, .2, .3, .4, .5, .6, .7, .8, .9. 1.00 Neutral Densities. Available in all series sizes.	
Polarizer	All Film Types Color or Black and White	Eliminates surface reflections, unwanted glare or hot spots from any light source. The only filter that will darken a blue sky and increase color saturation.	2	2

Interference Filters

Interference filters use various coatings to affect the way light waves pass through them. They can either control certain types of light waves or create a special effect by scattering the light.

Polarizing filters use interference technology to control the wavelength characteristics that are allowed to reach the film. This type of filter controls light coming from highly reflective surfaces or the sky. It is constructed by coating the filter surface with a fine layer of microcrystals. This coating has a linear quality in that the crystals act like a series of parallel or concentric lines. The coating and its linear quality are not visible. The idea behind the function of the filter is that light has a wave action at radial angles in relation to its axis of direction. Light will have this type of wave motion until it reflects from a surface. As light reflects from a surface, the wave motion becomes aligned with the surface. This is called polarization. Light can be naturally polarized in the sky depending on the sun's angle to the camera.

Parallel polarizing filters are placed on the lens with an orientation so that the light from the highly reflective surface is perpendicular to the filter's lines. In this way, the filter interferes with polarized light. Since other light in the picture will be coming from objects that are reflecting waves at all angles, the filter reduces only the polarized light. Since the lines in the filter are not able to be seen, some filters are marked to show their direction. For ease of use, the filter is also constructed so that it can be rotated perpendicular to the polarized light without being loosened from the lens.

Concentric polarizing filters do not need to be rotated. These filters will allow more polarized light through. They have been made for use on autofocus cameras.

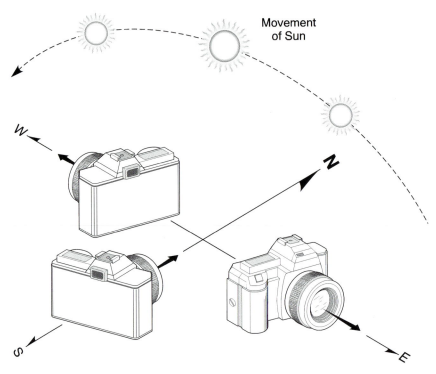

The Natural Polarization of the Sky

Maximum Polarization of the Sky Occurs:

1. Along East/West line at midday, very little effect occurs earlier and later.

2. Along North/South line early and late in the day with very little effect at midday.

How Polarizing Filters Work

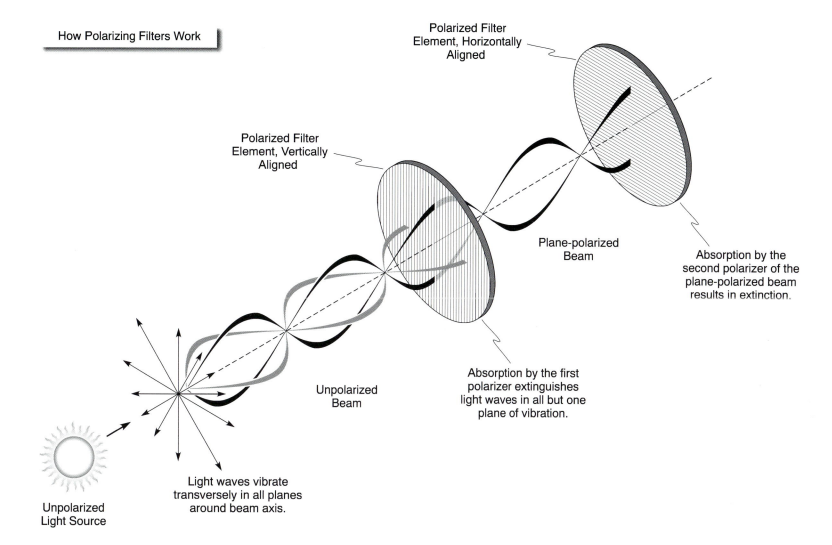

Polarized Filter
Element, Horizontally
Aligned

Polarized Filter
Element, Vertically
Aligned

Plane-polarized
Beam

Absorption by the
second polarizer of the
plane-polarized beam
results in extinction.

Unpolarized
Beam

Absorption by the first
polarizer extinguishes
light waves in all but one
plane of vibration.

Light waves vibrate
transversely in all planes
around beam axis.

Unpolarized
Light Source

Special Effects Filters

Some **special effects filters** are also interference filters. These interfere with the light to give a picture optical effects. One major group diffraction filters, create cross-stars, rainbow effects, and halos. These filters are made of a series of patterned lines that diffract, bend, and concentrate the light in various patterns. The other major interference-type filter group is **diffusion filters.** These filters diffuse the light coming through the lens, to soften the picture. They are used in portraiture to soften the hard edges in pictures. A special-function diffusion filter is a fog filter, which approximates the effect of fog in a scene.

Many manufacturers offer gadget filters. Filters that are faceted, mirrored, or graduated all fall into this category. One example is a graduated filter that has half of its surface red, with the red fading to clear. This filter could be positioned to darken the sky while not affecting other areas of the picture.

FILTER FACTOR

Regardless of its type, a filter affects the amount of light passing through to the film for exposure. This means that the exposure may need to be adjusted because of the filters used and the light reduction at the film plane. This adjustment is known as a **filter factor.** Depending on the type of metering, this filter factor will need to be used to calculate proper exposure. If the photographer is using a TTL meter system, the filter factor is taken care of because the light reading is made through the filter. But if a hand meter is used or a TTL meter is used before the filter is placed on the lens, a filter factor will need to be considered. The factor should come with the literature packaged with the filter. In some cases, it will be part of the information that is etched on the filter ring.

The filter factor is expressed in a number that is based on the 2:1 concept. A filter factor of 2 requires an increase of one stop of exposure, a filter factor of 4 requires an increase of two stops of exposure, a filter factor of 8 requires an increase of three stops of exposure, and so on.

Low level flights over western
Michigan
Ken Baird

Jack Carravelles, Cocos Island, Costa Rica
Ernest H. Brooks II/Brooks Institute

ADVANCED PRINTING

In many instances, standard printing falls short of the photographer's desires. In these situations, printing techniques must be used to expand, contract, or vary the contrast range within part or all of the print. Several options are available to the photographer needing to alter the contrast of a print.

■ Developer action can be used to control the contrast of the print.

■ The type of enlarger will affect the contrast of the print.

■ Multicontrast papers can be used to control overall contrast or contrast in specific areas of a print.

■ Toning of the print changes the contrast of the print.

■ Toning of the negative permits control of contrast during printing.

Even with well-made negatives, the photographer sometimes needs to add some special techniques to printing to create the desired results. These advanced printing techniques utilize particular characteristics of the paper, process, or equipment to fine-tune the print. Methods of changing final print contrast can be categorized into local and overall approaches. Local contrast refers to the contrast in isolated parts of a photographic print, as opposed to overall contrast, which involves the contrast of the whole print.

MULTIPLE-FILTER PRINTING

One advantage of multicontrast papers is that the contrast-rendering range can be changed at various locations on the paper. For example, in a negative of a landscape with a sky that contains a higher-than-normal density range and a foreground that contains a normal range, the sky will not fit within the range of a grade 2 or 3 paper but the foreground will. With multicontrast paper, two filters can be used to print the image selectively on one piece of paper: a low-grade filter can be employed to reduce the contrast in the sky, and a normal filter can be employed to print the foreground.

Though this sounds difficult, many photographers find this technique relatively easy to accomplish. This method is used when the negative was made in extreme lighting conditions with large local areas needing varying contrast in the final print. For example, the major portion of a negative may print well on grade 2 paper, whereas a portion of the negative needs grade 4. When the print is made, the photographer can increase the contrast of the paper by using a magenta filter applied to the local area needing increased contrast. To decrease the local contrast rendering of the paper, additional yellow filtration is added.

The filtration can be added by either supporting a piece of cut filter in a filter holder below the enlarger lens or attaching the filter to a dodging wand and filter dodging the print. Filter dodging tends to be preferred because it lessens concerns about alignment. The filter could also be placed over the opening of a burning tool to selectively change the contrast in a given area, along with the density.

Holyman, Vasarasi, India
Chris Rainier

CONTRAST REDUCTION

Flashing is a valuable technique often used to reduce overall print contrast. It expands the exposure scale of the paper, and it works with graded and multicontrast papers alike. It is often used in extreme contrast situations, when the photographer's supply of lowest-contrast paper is exhausted or not yielding enough of a change.

The flashing technique can be applied prior to or after enlargement exposure. The negative is removed from the enlarger, and the paper is exposed to white light from the enlarger. This usually works best with a minimal exposure—0.1–0.4 seconds—and requires a timer that can produce very short intervals. The negative is then put in the enlarger, and the print is made as normal.

Flashing, like burning, can also be applied to selected areas of the print.

Testing for the proper amount of flashing is performed similarly to testing for exposure, before the final print is made. The enlarger is used to make a test strip using a series of brief exposures—for example, in 0.1–second steps at f5.6. The proper flash is the one just prior to the flash producing noticeable tone on the paper. This level of flashing brings the paper up to its **threshold of exposure,** which will allow the slightest increase in exposure to trigger the development of tone. Though a slight amount of gray within highlights may be desired, grayed print highlights frequently indicate that flashing has been overdone.

Bleaching is a standard means of changing local print contrast or lightening a local print area. Photographic bleaches can be made from a variety of chemicals. The most popular are potassium iodide and iodine, potassium permanganate, and potassium ferricyanide. Bleaches convert the metallic silver of a print back to silver salts. This allows the silver salts to be removed from the print area by using a fixer. A bleach solution should be prepared according to the manufacturer's recommendations and a brush or cotton swab used to apply the bleach locally where desired. When the tone is reduced to a desired level, the print is placed in fixer to remove the part of the image that has been converted to silver salts. Prior to fixing, the print may be redeveloped to reverse the bleaching process.

Blue Shark Profile
Ernest H. Brooks II/Brooks Institute

CONTRAST INCREASE

Paper, just like film, is made up of a silver halide emulsion. This means that the chemical effects available to film will have some similar effects on paper. The two major differences are that paper developing tends to be a completion process, and the developing speed of paper emulsion is slower than that of film emulsion. **Completion development** refers to the chemical process in which full development occurs within a specific developing time. Film processing is not a completion process because film can be overdeveloped by being developed well beyond normal time. In paper processing, the emulsion can only develop to a maximum density. Both of these characteristics of paper allow for some contrast control within the printing of the photograph. This latitude control is limited by the speed and the completion tendency of the paper.

The overdevelopment of paper can increase its contrast range to a limited degree. It will have the most effect on fiber-based papers. The paper emulsion type will also make a difference. Within the range of normal development of papers is room to use this latitude. The normal developing time of fiber paper is recommended at 1½–2 minutes. The development range of the paper extends to 4 minutes. Overdevelopment occurs between 2 and 4 minutes in the developing solution. After 4 minutes, no gain in contrast will be effected with additional development because completion will have been achieved. Overdevelopment adds between one-third and one-half of a grade increase in contrast.

Chlorobromide emulsions will be affected more than bromide emulsions. The contrast increase that occurs from overdevelopment of a chlorobromide paper is up to one-half of a paper grade, whereas bromide papers can gain one-third of a grade. A slight problem with paper fogging occurs with this process. If either the overdevelopment is too long or the developer is too strong, a chemical fog can be formed. This will appear as a graying of the white paper base. This fog can be removed by bleaching, but that will lower the increased contrast.

⊘ **CAUTION: Toning** of the negative is another way that the overall contrast of the print can be adjusted. This can be accomplished in two ways. One way is to use selenium toner on the entire negative surface. The toner will increase density in the developed silver. It will have more effect in areas that have received more exposure; that is, dark areas will take more toning than thin or light areas of the negative. This increases the overall contrast of the entire negative. Selenium toner works most effectively when mixed 1:1 with hypo clearing agent. Selenium is a heavy metal and toxic, and care should be taken in handling and disposing of solutions. For safety, this process should only be used in a well-ventilated area.

A second way to tone a negative is to apply selenium toner to only small portions of larger negatives. Thirty-five–millimeter negatives, and other smaller-sized negatives, may not be suitable for this technique. This method increases contrast only in the local area where the toner has been used. A fine brush can be used to apply the selenium toner directly to the emulsion in areas where the contrast of the negative needs increasing. The toner in this case is used in a strong solution—straight from the bottle or mixed 1:1. The photographer must be extremely careful, since once the toner acts on the negative, the process cannot be reversed. If an error is made, it will be difficult if not impossible to repair.

A last way of increasing print contrast is to accelerate the development process by using stronger- or hotter-than-normal developers. Several Phenidone-type developers will increase the contrast of a print. Like excessive overdevelopment of a print, overuse of these developers can fog the paper.

Doll Shop, Oregon
Robert G. Smith

Kange
© 1983 Nancy M. Stuart

SPLIT DEVELOPERS AND WATER BATH DEVELOPMENT

Two of the most common developing agents in photography are hydroquinone and Metol. Print developers containing mainly hydroquinone are considered high-contrast developers, and those with Metol low-contrast. Most general-purpose developers contain some of both. **Split developers** are formulated using both developing agents in separate solutions, and allow for the amounts to vary in accordance with the printing contrast requirements.

Beers developer is made by mixing each dry chemical ingredient with water, then bottling and labeling these stock solutions separately; one solution will be bottled and labeled Beers Part A (the Metol-based solution), and the other Beers Part B (the hydroquinone-based solution). Through various dilutions of part A, part B, and water, and use of these dilutions in various combinations, a wide range of contrast can be achieved. Though this developer can be used with both graded and multicontrast papers, its greatest advantage comes with graded papers. Beers developer yields the ability to create intermediate contrast grades between whole grades of paper. Use of the hard-contrast developer followed by the soft developer lowers the contrast of a graded paper by as much as one-half of a grade.

For those who do not wish to go to the trouble of mixing two developers from scratch, a close approximation of the Beers system, sometimes called a pseudo-Beers system, can be made with packaged developers readily available off the store shelf—one Metol based and the other hydroquinone based. A bottle of each can be mixed, and these stock solutions can be labeled Part A and Part B and used like Beers solution.

PSEUDO-BEERS DEVELOPER SYSTEM

	CONTRAST	PART A	PART B	WATER
Low	1	1	0	1
↑	2	7	1	8
	3	3	1	4
Normal	4	5	3	8
↓	5	1	1	2
	6	3	5	8
High	7	1	7	0

Contrast 1 is soft for negatives with great differences in density, representing a large number of tones available for printing (a dense negative).

Contrast 4 is for normal negatives.

Contrast 7 is hard for negatives with small differences in density, representing a small number of tones available for printing (a thin negative).

Part A is Kodak Selectol Soft Developer, a Metol developer.

Part B is Kodak Dektol Developer, a hydroquinone developer.

A second method of controlling print contrast through development is **water bath development.** In the process, a normal dilution of print developer is placed in a tray, and alongside it is placed a tray of water. The exposed print is placed in the developer for 15 seconds and agitated vigorously. It is then placed in the water bath and kept completely still for 1 minute. Then, the print is placed into the developer for 5 seconds with agitation, and removed to the water bath for an additional minute without agitation. The cycle continues with 5 seconds of development and 1 minute of water bath until the print is processed to expectations by visual inspection. This method is especially useful with negatives that possess extremes in density and whose tonal range will not fit onto the print by conventional means. Most papers will work in water bath development, but the new RC papers that incorporate developer in the emulsion will not.

Doll's Arm Blessing, from the Niche Series
Beth Linn

ENLARGER EFFECTS

Enlargers are basically divided into two types: condenser and diffusion. **Condenser enlargers** use glass condensers that are simple lenses to concentrate the light at the point of the negative. The result of this concentration is an increase in the specularity of light and a subsequent increase in print contrast.

Diffusion enlargers, on the other hand, do not contain condensers to concentrate the light; they use devices that scatter the light, making it more diffuse. Two common examples of diffusion enlargers are color enlargers and cold-light enlargers. The color enlarger, which can be used for black-and-white enlarging, uses a standard specular light source, but the light is scattered in a mixing chamber—a small white boxlike structure that is constructed in such a way as to bounce light off its surfaces before allowing it to exit through a diffusing element made of ground glass or Plexiglas. This mixing chamber is placing between the light source and the negative in the enlarger, creating soft, diffused light for printing the negative. The color head of the color enlarger may be used to dial in filtration for multicontrast filters, rather than purchasing separate filters.

The **cold-light enlarger** utilizes a fluorescent tube that has been zigzagged back and forth to provide even illumination across the negative area of the enlarger. The fluorescent tube provides soft, diffused light. Cold-light enlargers extend the range of the light used to expose the paper by adding more ultraviolet wavelengths. Attempting to use a cold-light enlarger with multicontrast filters, without correcting for the blue color of the light due to the ultraviolet wavelengths, will result in an increase in print contrast due to the color of light. The blue light from the fluorescent tube has to be neutralized with yellow filtration before multicontrast filters can be used with this type of enlarger. To overcome this limitation of the cold-light head, a 40 yellow filter can be added to the filtration pack.

Many photographers who own condenser enlargers find that these can readily be converted to cold light by the purchase of an aftermarket kit. Whether a color enlarger or a cold-light enlarger is used, the diffused quality of its light creates a lower-contrast print than is produced with a condenser enlarger.

Monticello, Indiana
Vernon Cheek

Sand Dunes and Truck on Coastal Pan American Highway near Chala, Peru
© Marilyn Bridges, 1989

Advanced Control of Film

Several methods enable a photographer to maximize the abilities of the film developing process. These allow the photographer to extend the film beyond its manufactured recommendation for either speed or contrast.

- Every film has its own characteristic curve, which relates development to exposure and density.

- In speed testing, a photographer uses his or her own equipment, developing materials and technique, and printing methods to determine a film's proper exposure index.

- A photographer can change a film's effective speed by controlling the film's exposure and processing.

- Pushing and pulling the development of a film are two ways to change the film's effective speed.

- In the zone system, a photographer previsualizes the tonal values of an image and then adjusts the various elements of photography to achieve those values in the final print.

Rocket Chair
© Nick Vedros/Vedros & Associates 1992

The photographer often wants to extend the use of a film beyond its normal exposure expectations. The advanced photographer often wants to know the thresholds of exposure to maximize the photographic process. At times, a film is either too fast or too slow for the available light. At other times, the photographer may want to adjust the way a film reacts to light to meet expectations for the print. In all these cases, the first key is to have baseline data on the way the exposure is related to the film and development. Characteristic curves summarize this information in an easy-to-read format. A film speed test provides the photographer with a method to determine the exact function of the film in relation to the photographer's light-metering equipment, camera, development, and printing. This testing of the film's actual speed, or **exposure index (EI),** is the key to advanced photographic systems for controlling the exposure-processing relationship, and zone placement.

FILM CHARACTERISTIC CURVES

Sensitometry deals with the way light in a scene is represented in photographic films, photographic papers, and reproductions of the scene in print. Photography graphs are used in sensitometry to represent the light input plotted against a reading of the density produced. The sensitometric process includes light, processing, and the sensitized material. It compares the characteristics of the photographic material in various ways. This process is known by several names: Hurter & Driffield (H & D) curve; density-log exposure (D-log H, formerly known as D-log E); and **characteristic curve.**

Many photographers believe that characteristic curves are difficult to understand. They are simple. Density is plotted on the vertical axis. On the horizontal axis, exposure is plotted. In the case of film, the reading of the density is the logarithm of the amount of light transmitted through the film at a given set of processing conditions. The exposure is plotted by using the logarithm of the change in exposure.

The 0.3 logarithm is a basic unit in photography, and is used as a standard within sensitometry. This logarithm is consistent in geometric form with the 2:1 ratio of light found in f-stops, shutter speeds, and ISOs. The vertical axis is divided into units equal to one-stop changes in density. The horizontal axis is divided into 0.15 log units. This means that the horizontal scale is set up in one-half–stop increments.

The photographer does not need to be a scientist to understand these curves. Logarithms are used because they are shorter in length than the real numbers, which keep doubling. The basic logarithms of exposure in the characteristic curve can be thought of as numbers representing one-half–stop units, and densities as numbers representing the opacity, or darkness, of the negative. This means that the graph is a simple comparison of the number of stops of exposure and the opacity of the negative. Since all the numbers related to the curve use the same numerical base, they do not need to be changed back to real numbers from the logarithms.

The shape of the characteristic curve tells the photographer about the contrast and level of sensitivity to various light.

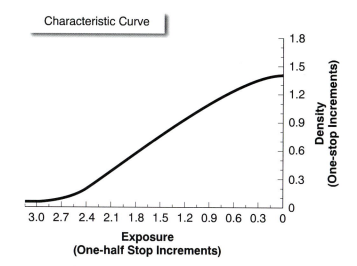

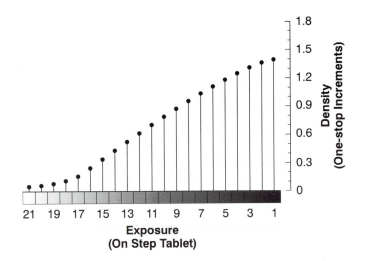

Step Tablet Exposures Plotted on a Characteristic Curve

Density (One-stop Increments)

Exposure
(On Step Tablet)

Creation of the Curve

The best way to understand characteristic curves is by seeing how one is created. The first part of the process is to expose film with a step tablet. **Step tablets** are density scales produced in twenty one tones from clear to a predetermined density equal to 3, which is equivalent to a ten-stop range of light in equal one-half–stop intervals. For the laboratory, a standard light source with a built-in step tablet, known as a **sensitometer,** is used to expose a test film. The information obtained from the test exposures is used to create characteristic curves.

By exposing the film to the step tablet, a characteristic curve can be made. The outcome of the exposure is a negative that should have several of the most dense steps of the tablet being represented as clear film. The film is read on a densitometer. A **densitometer** passes light through the film and is calibrated to determine the amount of a standard light that can pass through the test portion of the film. This gives opacity and density. Each step is read and recorded, from the clearest area of the film to the most dense.

Each density is plotted against the step number of the tablet. By connecting the points on the resulting graph, a characteristic curve is made. The lowest value, reading from what appears to be clear film, represents the density value of base plus fog (**B + F**). This is the part of the test film that was made by the most dense portion of the step tablet. It is the density of the support base material plus any chemical fog caused in processing with no effect of exposure to light. The highest area on the curve, which was made by the clear area of the step tablet, is **maximum black,** or the maximum density developed. The curve formed by plotting the density-step points between these two extremes is in the shape of a flattened S.

Parts of the Curve

By understanding the various parts of the characteristic curve, the photographer can use the total latitude of the photographic material and understand the limits of a film's reaction to light. The photographer needs to know how much of the light intensities in a scene can be used to expose the film. Critical in this determination are Dmax, Dmin, and gamma, or the contrast index.

Dmax is the maximum density that is usable on a film. This is defined by the **American National Standards Institute (ANSI)** to be a value of 90 percent of maximum black. **Dmin** is the least value of light that is usable, as set by ANSI. This is defined as a density reading of 0.04 above B + F. Gamma, or **contrast index,** is the slope of the portion of the curve that is approximately a straight line. Dmax and Dmin may remain similar with changes in development whereas gamma is always affected by changes in development. The slope (gamma) will become steeper, having a higher numerical value and yielding higher contrast, with increases in development.

Dmax, Dmin, and gamma are all related to the specific densities for one film at a given set of development conditions. This means that any characteristic curve is only accurate for one film at one set of development parameters. But it gives a great deal of information about these conditions. First, the distance between Dmin and Dmax along the horizontal axis tells the range of light in the scene that the film processing will differentiate. If the light in the scene is more than this value, the film will not record the total amount of variation. Because the horizontal values in the characteristic curve are in one-half–stop increments, the photographer can relate the light in the scene to the camera and to the amount of light in the scene the film will record. This concept is referred to as the **log exposure range** or **subject brightness range (SBR).** This means that by looking at the characteristic curve, the photographer can determine the way the film will react or how to develop the film to

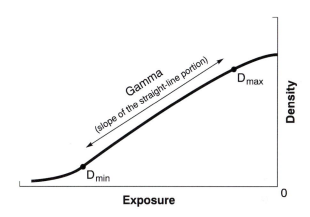

D_{max}, D_{min}, and Gamma on a Characteristic Curve

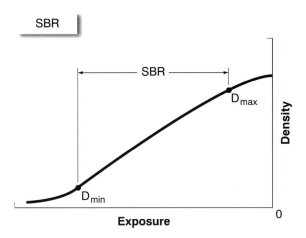

SBR

Exposure

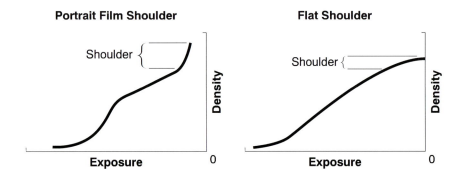

Shoulder Shapes

Portrait Film Shoulder

Shoulder {

Exposure

Flat Shoulder

Shoulder {

Exposure

have it fit the lighting conditions in the scene. This is the basis of zone-based systems, which will be explained later in this chapter and in chapter 13.

Visually, a photographer can learn to look at a characteristic curve and interpret how the film will react under the conditions used to make the curve. Parts of a characteristic curve that can tell the photographer functions of the film are the shoulder, the toe, and the straight-line portion.

The **shoulder** is at the top of the curve and is related to the most dense area of the negative and the brightest part of the scene. Several films are engineered to have specific shoulder shapes. This means that the films will react to bright light in certain ways. For example, portrait films have either a steep or a reversing shoulder to allow the bright highlights in flesh tones to build density. These films fill in light imperfections in highlight areas, such as blemishes in the skin. Other films have flat shoulders, which spread the light values in the highlight areas of the scene for better tone separation.

At the low end of the curve is the **toe.** This represents how the film reacts to the low light levels found in the shadow detail of a scene. A short toe means that the film will lose shadow detail more quickly with underexposure. A short-toe film will give better shadow detail if it is overexposed.

Between the toe and the shoulder is an area that is approximately straight. This part of the characteristic curve is called the **straight-line portion.** It represents the middle tones in the scene. The major effect on the straight-line portion is found in the processing effect on the slope. The value of the slope, or gamma, for normal development is 0.52–0.60 for diffusion enlargers, on grade 2 paper. If the value of gamma is greater than 0.60 then the film is overdeveloped. When the light in the scene has a shorter SBR, the film is purposely overdeveloped. This is known as **expansion,** and spreads the effect of small changes in light intensities. Underdevelopment, or **compaction,** reduces the slope and adjusts a long range of light to fit the limits of the film. The amount of change in slope is referred to as the contrast index of the film.

An important measurement that can be seen in the characteristic curve is the **range** (density difference). This is the vertical measurement of the difference between Dmax and Dmin. It is the density difference that will become the exposure index for the print. As the photographer understands how this and the other parts of the characteristic curve relate to the print, the outcome of the photographic process becomes more controlled.

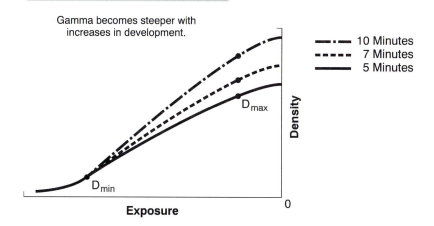

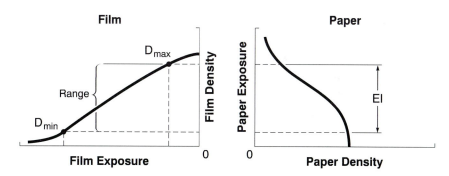

If the illustration is turned 90° counterclockwise, the paper characteristic curve has the same basic form as the film characteristic curve.

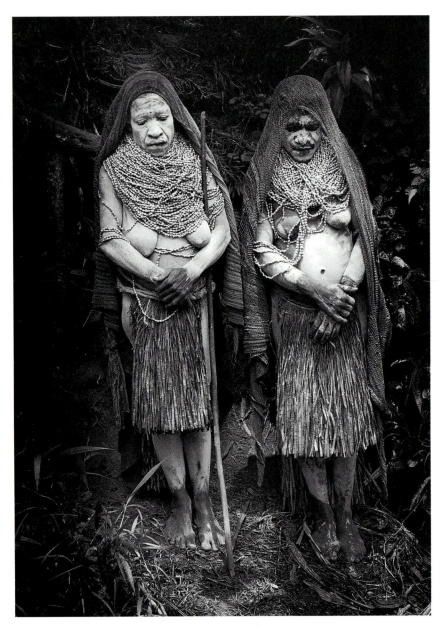

Two Women Mourning, New Guinea
© Chris Rainier

FILM SPEED TESTING

All films need personal testing. The characteristics of a film-camera-processing system are unique, making it important for photographers to use their own equipment, developing materials and technique, and printing methods to arrive at the proper EI for a film. This EI will be called the photographer's working EI for that film. Each piece of equipment or method will affect the performance of the film. A speed-tested film allows a photographer to fine-tune and control the creation of the negatives.

The film speed in ISO is the manufacturer's general speed rating of that film. The EI is the actual tested ISO number at which the film performs best. Though usually the EI is near or the same as the ISO, all films vary from emulsion batch to emulsion batch and should be tested for optimum performance. With specialized films, where no single ISO is given, the EI is varied based on the development of the film. Some developer manufacturers also recommend the use of EIs that are different from the actual ISO. Once the photographer finds the EI that gives the desired results, the photographer has defined a baseline EI that will be used for future work.

To **speed test** a photographic system accurately, the photographer needs to use a densitometer. Though a visual examination can be used to approximate an EI other than the manufacturer's recommendation, this will not be the most accurate method. The following method defines how to speed test for the establishment of an accurate working EI for the individual photographer.

Black-and-white films are excellent at accepting changes in exposure and processing, but photographers must realize that this advantage requires care when handling and processing these films. Changes in development time, temperature, or agitation will have marked effects on all black-and-white films. Properly testing a film allows the photographer to judge how equipment and processing influence the effective film speed.

The speed test establishes a working EI. This procedure is based on the first usable density above the fog level of the film. Regardless of care in processing, film will have some base density created in the emulsion. This density results from the density of the support material and any development fog. As development is extended, the amount of fog increases. This base and fog (B + F) density represents the areas of the film that are below the threshold of camera exposure and will be the areas of maximum black in the print. Aging effects and process irregularities affect B + F density.

Equipment, film, and processing will all influence the final results. The photographer must establish a working EI for each meter-film-camera-processing combination. A series of exposures is made in increments that are as fine as functionally possible with the equipment—usually one-half–stop or one-third stops. If the camera lens does not permit one-third stops, 0.1 ND (neutral density) (one-third–stop) and 0.2 ND two-thirds–stop) filters can be used to get more precise exposures. The camera is set up on a tripod at a distance needed to fill the frame completely with an 18 percent gray card that is evenly lit and perpendicular to the axis of the lens. The lights are arranged with the illumination striking the card at an angle that does not create flare. The test uses the lens focused at infinity and the metering technique normally employed with the equipment to establish a base exposure.

Measurement of the light is based on the manufacturer's recommended ISO that is used to make the test. The exposure system is then stopped down six full stops below the meter reading of the gray card. The first exposure is made with the lens cap on. Then the cap is removed and exposures are made at one-half–or one-third–stop intervals until exposures have been made at five stops over and under the meter reading—for a total of twenty two exposures with one-half–stop intervals or thirty three exposures if one-third–stop filters are used. The roll is finished off and processed. The exposures made on either side of the chosen exposure are called bracket exposures.

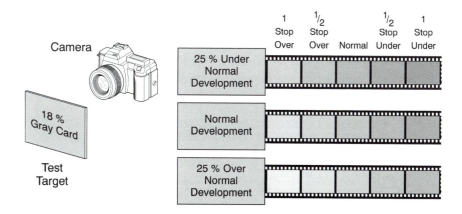

To test for EI, bracket film exposures allowing over- and under-exposures from the normal meter reading. Repeat this bracketing until exposures have been made at five stops under and over the meter reading.

A Second Method of Testing for EI

Use the film and devloper combination that you wish to make your standard. Use the film manufacturer's recommended ISO. Use the developer manufacturer's recommended developing times as normal.

Shooting Photographs

Frame	1 and 2 Blank	3 One Stop Over	4 1/2 Stop Over	5 Normal	6 1/2 Stop Under	7 One Stop Under

Frame	8, 9, 10, and 11 Blank	12 One Stop Over	13 1/2 Stop Over	14 Normal	15 1/2 Stop Under	16 One Stop Under

Frame	17, 18, 19, and 20 Blank	21 One Stop Over	22 1/2 Stop Over	23 Normal	24 1/2 Stop Under	25 One Stop Under

Frame	26, 27, 28, and 29 Blank	30 One Stop Over	31 1/2 Stop Over	32 Normal	33 1/2 Stop Under	34 One Stop Under

Processing Film

1. Cut the film into four equal segments by first cutting the end from the film, then folding the film in half and cutting it on the fold, and then folding each of those two sections in half and cutting them on the fold.

2. Develop the sections of film as follows:
 - First section at 25 percent under normal
 - Second section at normal
 - Third section 25 percent over normal
 - Fourth section 50 percent over normal

Printing Pictures

1. Make a proof sheet of the four strips with the negatives arranged in order from the underdeveloped strip to the 50 percent over developed strip.

2. Choose the frame with the best contrast and use the data – exposure setting and development time – for your standard on future rolls of the same film.

Care must be taken in the processing. A record of the starting temperature and ending temperature of the developer should be kept. This is done by pouring the developer into a container with a thermometer in it before using and again before disposing of the developer. If a large discrepancy separates the starting temperature and the finishing temperature, the processing may not be as consistent as is required for the control the photographer wishes. The photographer needs to be consistent in agitation and as accurate as possible on the time between the addition of the developer and the introduction of the stop bath. The key to the speed test is the ability to replicate the processing. The photographer uses this processing as a standard; the test establishes the working speed of the film when processed by the same method and under the same conditions.

At this point the negatives are read with a transmission densitometer. The first reading made is of the $B+F$, which is read on the exposure made with the lens cap on. The exposure that gives a density of 0.10 above $B+F$ is the speed point of the film. If one-half–stop units are used in making the test and the sixth exposed frame is $B+F+0.10$, the film should be rated at the published ISO. If the density 0.10 is found on some other frame, then the EI should be adjusted up or down from the published ISO. If 0.10 above $B+F$ is read on the eighth exposed frame, the EI should be one-half, or one full stop slower than, the published ISO. If the 0.10 is on the fourth exposed frame, then the EI should be two times, or one full stop faster than, the starting ISO.

U.S./Mexican Border: Texas
Ken Baird

EXPOSURE-PROCESSING CONTROL

Perhaps the most common exposure challenges that face the photographer using black-and-white are lighting conditions that require some contrast control of the film. This contrast is seen in three ways: the contrast range, the effective film speed, and color-tone relationships. The **contrast range** is the number of values, tones, or zones present in the scene. The film's **effective speed** is its ability to shift in nonnormal lighting conditions. The **color-tone relationship** is the way the various colors in the scene will be translated into the black-and-white photograph. The photographic process translates the scene into a new reality of the print. The photographer can utilize the control and flexibility of the film processing system by changing the film's effective speed.

The methods and techniques presented in this chapter deal with adjusting the film processing system to meet the lighting requirements of the scene as it will be translated into the photographic print. The control of exposure to adjust for scene contrast is a major step that allows this and gives the finest negative exposure. The contrast of film can be controlled either through using on-camera filters (which were discussed in chapter 9) or through altering the development of the negative.

Lighthouse, Maine
D. A. Horchner

Boxer Bill Graddy lies on the mat after being knocked out by Marion Starling
© Anacleto Rapping

DEVELOPMENT CONTROL

A common problem is that photographers find they have calculated an exposure for a scene that cannot be supported by the film speed. For example, a photographer may need to make an exposure at f11 to have enough depth of field within the picture. The meter suggests that to accomplish this with the photographer's ISO 100 film, a shutter speed of 1/15 second is required. The scene contains motion that the photographer wishes to stop, however, and a shutter speed of 1/125 second might be needed for this purpose. These two requirements pose a three-stop difference. If neither the depth of field or the stopping action can be compromised, and no faster film is available, then the effective film speed or EI must be adjusted from the standard to accomplish the photograph.

Since EIs are calculated on the 2:1 ratio, recalculating the EI of the film is not difficult. The three-stop difference between the rated speed and needed speed of the film in the example requires an ISO of 800. If the photographer does not have an ISO 800 film, then he or she can **push** the ISO 100 film the three stops. To push film, the photographer will need to increase its development time. With an increase in development, the film can utilize an exposure in a way similar to that of a higher-speed film. It is important to realize that the film will not act exactly like a higher-speed film with the increased development, but it will function in a similar manner.

Pushing the film changes only the way the film is developed, not the actual speed of the film. Pushing increases the contrast of the film. This will be seen as an increase in the slope of the characteristic curve—steeper gamma. The overdevelopment of the film increases the density of the highlight and midtone areas in the film.

This gives the appearance of the film being of a higher ISO. A loss of shadow details can be seen when the film is pushed. The overdevelopment cannot actually make the film lower the absolute threshold for exposure. It increases the densities that are exposed, but it does not increase the sensitivity of the film. Therefore, shadow detail will be the area that shows loss in exposure.

By pushing the film's development the three stops, the photographer can use an ISO 100 film as if it were rated ISO 800. This means that as the film is exposed, the photographer must plan on overdeveloping it. When the film is removed from the camera, it should be marked to indicate the amount of development compensation that will be required by the changed EI. In the use of roll film, once one picture on the roll is pushed or pulled (pulling is discussed later in this chapter), the entire roll must be used at the new EI.

Each film type will require a different amount of development based on the film speed change. There are even films that are not rated with one ISO; instead, the manufacturer gives the photographer a series of developing times related to film EIs. If the photographer intends to manipulate the film's speed on a regular basis, testing needs to be done to establish a personal working relationship between development and film speed. This relationship will need to take into account not only the EI but also the film type, the time and temperature of the developing, and the type of developer used.

As a general guide, the development will need to be increased by 15–20 percent for each stop pushed. This increase is called a **push factor.** If the need is to push three stops, as in the preceding example, then the development might be as follows: Assume a developing time of 8 minutes. This is equal to 480 seconds. If the 15 percent push factor is used to calculate the development change, then the new time will be 480 seconds plus 15 percent, or 552 seconds, for the first stop; 552 seconds plus 15 percent, or 635 seconds, for the second stop; and 635 seconds plus 15 percent, or 730 seconds, for the third stop. This equals 12 minutes 10 seconds, which will be the new developing time for the three-stop push. This is an example; to be accurate, the photographer will need to test the film. Also, specific developers are designed for push processing, and these should be considered as a method of increasing quality if pushing is necessary. To use one of these developers, see the manufacturer's directions and effective EIs for each film.

Just as the photographer can choose to push a film for added speed, she or he can also **pull** the film to slow the film speed. Once again, this is done through development. With pulling, the film is overexposed and underdeveloped. Pulling has the opposite effect of pushing. The process flattens the characteristic curve, or decreases the gamma. It reduces the contrast index of the film.

Pulling and pushing differ in two ways. First, since the film is being overexposed in pulling, it will record shadow detail. Second, owing to the need to underdevelop, pulling cannot be manipulated to as great a degree as pushing.

Pulling the film comes closer to the general rule of exposure-development relationships, which is: expose for the shadows and develop for the highlights. This is because the shadow details are the areas least affected by development changes. Therefore, when the film is pulled, the shorter development time will affect the lighter areas of the scene, but will leave the shadow details at the appropriate levels of development. As a result, the pull reduces the EI. Underdevelopment cannot be extended as far as overdevelopment. This means that pulling film does not add as much latitude as pushing.

Mind of Darkness—1
Nam Boong Cho

Zone Ruler

0 I II III IV V VI VII VIII IX

ZONE PLACEMENT

Ansel Adams is responsible for codifying the concepts that are now called the **zone system.** Adams made it popular to look at photography as one continuous process, as opposed to a series of related but separate steps. The notion that a photograph is previsualized is the basic concept of the zone system. **Previsualization** means that before exposure is calculated, the photographer makes judgments about how the scene will be translated into the print. The zone system uses development of the film to change contrast relationships. **Zone placement** allows the photographer to choose and place a tone within the zone scale (from black to white).

When the nature of one area of a picture becomes the key to the success of the photograph, then a method must be used to expose that area accurately. This is where the photographer needs the most discerning eye, to estimate the impact of the critical area and then assign the final tonal value of the print before making the exposure. This is previsualization. It is using the desired look of the final print to help determine the way the photograph will be exposed, developed, and printed. Exposure can be improved by placing an area in a given value and then making an exposure that concentrates on that area.

Establishing 18 percent middle gray as a meter reading is the first of two concepts that are used in the zone placement method. The second is that each full-stop change in exposure will move the subject one tonal value, or zone.

This method requires the photographer to be aware of what the zones available are and to compare a scene to these zones. A **zone ruler** can be used for this purpose. This is a tool that shows the zones capable of being produced with the method being used by the photographer. For most black-and-white photographic methods, a zone ruler will have nine value changes from black to white. The black is considered zone 0 and represents exposure below the threshold of the film or no effective exposure on the negative.

White is the maximum density used on the negative and is represented as zone IX. The intervening zones are numbered in Roman numerals from I to VIII.

Within the range of zones represented on the ruler are some important relationships. The first is that each zone requires twice as much exposure of the negative as the previous zone—representing a 2:1 relationship. This is true for all zones beyond zone I. Inversely, each zone from zone VIII down requires one-half as much exposure as the next-highest zone. This means that the zones function in the same 2:1 relationship as the f-stops and the shutter speeds. A one-stop differential separates the zones.

If the photographer is viewing a scene and sees that one area of detail is so important to the picture that in the print it needs to have a specific tonal value, then the photographer makes a mental or written note of the intended final value of the critical area. This value is compared against a zone ruler to determine the tone of the critical area in the final print. The ruler, like the note, might be a mental or physical tool.

The next important relationship is what the photographic process will be able to accomplish. This is the way the photographer will decide how to use the method. Each zone has not only an exposure differential but also a texture-detail differential. This can be seen through an examination of each zone on the ruler:

ZONE	DESCRIPTION
0	Maximum black
I	The first tone distinguishable from black with no detail
II	The first visible texture in a very dark area
III	Black with detail—a highly textured dark area with distinct detail; this zone is considered the shadow detail area for average value metering
IV	Dark gray
V	Middle gray, with 18 percent reflectance
VI	Light gray
VII	White with detail; the lightest area in the photograph that will have distinct texture or detail; this is the highlight area for the average value method
VIII	The brightest tone distinguishable from white
IX	Paper white

Once the zone of the critical area in the scene is identified, the photographer then uses a metering system to take a reading of the critical area. The settings, if used, would give an exposure that would result in the area being reproduced as 18 percent reflective. Unless the critical area is to be middle gray, the settings will need to be adjusted to accomplish the desired tonal representation in the negative. Since the zones are based on a 2:1 light ratio, each change of a zone is directly convertible to f-stops or shutter stops.

Cairo, Egypt
Paul Liebhardt

The photographer takes the desired zone number for the critical area and finds the difference between it and zone V. This is the number of stops that will need to be adjusted in the camera settings to accomplish the desired exposure of the critical area. If the zone of the critical area is below zone V (zones 0, I, II, III, or IV), then the camera is stopped down using (a smaller aperture, or faster speed); if the zone of the critical area is above zone V (zone VI, VII, VIII, or IX), then the camera setting is opened up using (a larger aperture or slower speed) a corresponding number of stops. Thus, if the photographer wants the critical area to be zone III (two stops below zone V and the meter reading is f/5.6 at 1/60 second, then a camera setting two stops down, or f/11 at 1/60 second, will accomplish the proper exposure to place the area in the appropriate zone.

When the exposure is changed, it affects all areas of the picture. This means that the relative contrast within the scene will remain similar with the new exposure. When the critical area is moved to the desired zone, all other zones within the picture will be shifted in exposure the same direction.

Courtesy of Architects Keating, Mann, Jernigan, Rottet
Nick Merrick, Hedrich-Blessing

THE VIEW CAMERA

The view camera, with its single-sheet film and optical movements, provides the photographer with advanced control of composition, perspective control, and increased control of the photographic process.

- The basic parts of a view camera are a front and a rear standard, a bellows, and a support for the standards.

- Three types of view cameras are in common use: studio, field, and press cameras.

- A view camera has several advantages and disadvantages compared with other cameras.

- A view camera is set up on a tripod, with the front and rear standards balanced over the tripod mount. The rear standard should be used for focusing, and the bellows extended to the distance equal to the focal length of the lens.

- Contemporary view camera lenses incorporate the camera shutter and are called leaf or in-lens shutters.

- Sheet film is usually used in a view camera.

- Sheet film holders, instant film holders, factory-loaded film holders, and roll film holders are all available for view cameras.

- A view camera has four basic movements: rise-fall, shift, tilt, and swing.

- The plane of focus can be controlled by adjusting either the front or rear standard.

- The rear standard can be adjusted to correct the size relationship of the subject or subjects in an image.

- Bellows compensation is a measure of the amount of light lost when the bellows is extended to focus at short distances.

- Sheet film may be processed using a dip-and-dunk or a tray method.

The View Camera

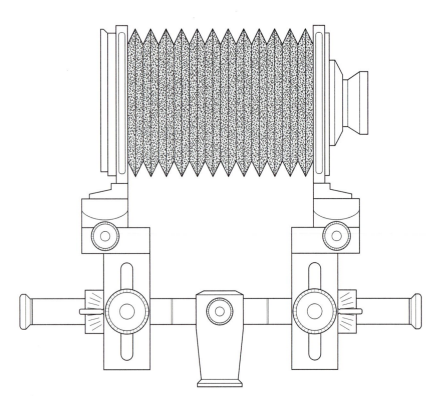

The earliest cameras designed to accept photographic film were modified camera obscuras. The basic parts of the camera obscura have been improved to create the view camera. The term *view camera* refers to a camera that projects the image that will form the photograph onto a ground glass. This allows the photographer to see and work with the image exactly as it will be transferred to the film.

VIEW CAMERA PARTS

View camera is a generic term describing a broad category of cameras that have a front and a rear standard, a bellows, and a support for the standards (either a monorail or a camera bed). These cameras are usually designed to accept large-format film and to be used on a tripod.

The view camera is the simplest design of all the camera types. Its scale and simplicity offer a clear insight into the fundamental workings of all cameras. The view camera's **front standard,** or lens standard, consists of a lens mounted on a rigid board, **lens board,** and the mechanism needed to position the lens. The camera's midsection consists of a lighttight, flexible, accordionlike enclosure; this is referred to as the **bellows.**

Its flexibility allows the camera to extend or compress to accept a variety of lenses and to accomplish close-up work. A **ground glass** for focusing and viewing is installed at the camera's rear, on what is known as the **rear standard** or is sometimes called the film standard. The ground glass can be lifted away from the film plane after focusing, to allow the film holder to be inserted in its place.

To use a view camera successfully, a tripod will be required. Most models of view cameras have movable front and rear standards, which allow the camera to be balanced over the tripod. This is accomplished by adjusting the front or rear standard or both, or a clamp that allows the camera to slide on a monorail (for monorail-type cameras), until the weight of the camera is evenly distributed on the tripod.

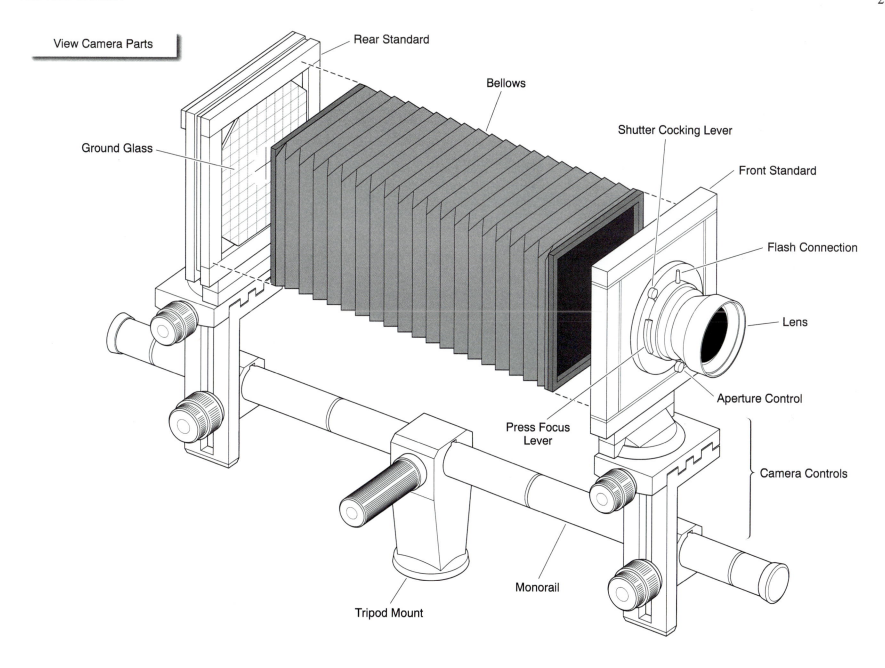

View Camera Parts

Rear Standard

Bellows

Shutter Cocking Lever

Ground Glass

Front Standard

Flash Connection

Lens

Aperture Control

Press Focus
Lever

Camera Controls

Tripod Mount

Monorail

Morning Fog, Yosemite Valley,
Yosemite National Park
D. A. Horchner

The lens is opened to allow focusing. By moving the press focus lever on the lens, the photographer opens the lens to the aperture setting. Unlike a preview button on a 35mm camera, this lever does not open the aperture wider than its setting. To allow for a brighter image on the ground glass, the aperture must be set at its largest f-stop.

The rear standard is normally moved for focusing. This method is preferred over moving the front standard so as not to change the lens-to-subject distance. Once the camera is focused, the lens is stopped down to the desired aperture and the press focus lever is closed. The shutter speed is set, and the shutter is cocked. A loaded film holder is then inserted in front of the ground glass and seated in place. The dark slide of the film holder is pulled from the holder, allowing light to pass through the lens to expose the film when the shutter release is activated. View cameras normally utilize a cable release for activating the shutter.

VIEW CAMERA TYPES

Studio view cameras usually do not collapse into compact units; they are heavy and bulky. They provide a full range of movements on the front and rear standards, which are mounted on a monorail support. Most models have interchangeable bellows, and many have calibrated movement scales.

Field cameras are another type of view camera. They differ from the studio view camera in several important ways. Field cameras are designed to be used in the field and are therefore more compact, foldable, and lighter weight. They are designed to be positioned on a tripod for use. Some of them lack the ability to provide the full range of camera movements offered by the studio view camera. Many field cameras do not have the ability to change bellows. Field cameras typically have a bed type of support for the front and rear standards.

Press cameras are yet another type of view camera. They have many of the features of the field camera, being lightweight, foldable, and portable with a bed support. These cameras are designed to be handheld, though they can be placed on a tripod. They typically have very limited movements and lack the flexibility of the studio view camera.

All these types of view cameras are set up and operated in the same way.

VIEW CAMERA ADVANTAGES AND DISADVANTAGES

The advantage of the view camera is its ability to record images of incomparable quality. This is so because the camera uses a relatively large film size and therefore the fine grain of the film is magnified less when the negatives are enlarged and printed. It is the instrument of choice for photographers when image quality is of overriding concern.

The disadvantages of the view camera are the slow, methodical manner in which it must be used, its bulk and weight, and the greater expense involved in materials for its use.

VIEW CAMERA SETUP

A good, sturdy tripod should be the foundation of support for the view camera. Many tripods have adjustments on the bottom of their legs that allow for a rubber-tipped or a spike-tipped end to touch the ground. The spike-tipped end is most commonly used outdoors.

When setting up the tripod, care should be taken to have one of the legs facing in the direction of the subject. When a tripod is oriented in this manner, it adds support by ensuring that the camera cannot tip over forward and allows for the camera operator to stand conveniently in between the remaining two legs while taking pictures. This position is preferable to straddling a tripod leg while shooting.

The camera will attach to the tripod with one of two sizes of bolt threads: 1/4 × 20 (meaning a 1/4-inch-diameter bolt with twenty threads per inch), which is the U.S. standard, or 3/8, which is the European standard. Some cameras will have openings on their tripod mounts to accept both thread sizes. For cameras having openings only for the European thread size, adapter bushings are available to allow them to accept the 1/4 × 20 bolt.

Care must be taken to attach the camera to the tripod in such a manner so as to make the tripod controls usable. Each tripod is designed to have the lens of the camera face a certain direction in relationship to the tripod handles that control pan, tilt, and leveling (pan is horizontal rotation, tilt is vertical rotation, and leveling is side-to-side rotation). Look at the tripod carefully to determine the correct camera positioning.

It is advisable to use the rear standard of the camera, not the front, for focusing. Focusing with the front standard also changes lens-to-subject distance. When setting up the camera, the front standard should be placed near the end of the monorail or bed and the camera balanced over the tripod mount. This allows for the use of lenses with different focal lengths without any risk of including the monorail or bed in the lens's view.

The bellows should be extended to a distance equal to the focal length of the lens. For example, with a 210mm focal length lens, move the front and rear standards apart until the bellows extension is equal to 210mm, or about 8 inches. The bellows extension is measured from the center of the lens to the film plane. Since the center of the lens may be difficult to determine, use the front lens board as that reference point. When using a view camera, it is possible to set up the camera on a tripod and have the scene in focus without ever looking through the camera. This is because the focal length is defined as the length from the center of the lens to the film when the camera is focused on infinity.

Toronto
Glenn Rand

VIEW CAMERA LENS AND SHUTTER

The controls of lenses for view cameras differ from those of lenses for SLRs and other types of cameras. Contemporary view camera lenses are integrated with the camera shutter. These shutters are leaf shutters, sometimes called in-lens shutters.

Most view cameras have two f-stop indicator scales: one located on the top and the other on the bottom of the shutter housing of the lens. These scales serve identical functions and are included in the design to allow convenient viewing of the scale whether the camera is placed high above the head or low near the ground.

Also located on the shutter housing is an aperture control lever, which adjusts the aperture. The extremes of the f-stop numbers used on view cameras differ from those used with smaller-format cameras. The maximum apertures (the speed of the lens) is smaller (slower) than that of typical 35mm or 2-1/4-inch cameras. A typical maximum aperture for view camera lenses might be f/5.6, f/6.3, or possibly f/4. Additionally, the minimum aperture will be smaller, with some lenses for a 4×5-inch format having a minimum aperture of f/64.

The shutter speed control is the outer ring of the shutter housing. It rotates to allow the selection of a variety of shutter speeds. The shutter is cocked by pressing a shutter-cocking lever located on the shutter housing. It must be cocked before each exposure. View cameras are very limited in the minimum duration of the shutter, which is 1/400 second. On the long-duration end of the shutter speed scale are speeds B and T. B stands for bulb, derived from the old-time pneumatic triggering device for shutters. When B is depressed, the shutter will stay open as long as the shutter is depressed. T, which stands for time, locks open the shutter when it is depressed, allowing the photographer to walk away from the camera. The shutter stays open until the shutter release is pushed once more, and then closes. B and T are always used with a cable release to prevent camera movement during exposure. B is useful

when exposures are over 1 second and under 10 seconds. T, on the other hand, is appropriate when exposure times are 10 seconds or over. With older lenses that lack a T setting, the B setting can be used in conjunction with a special cable release that has a locking capability. The connection for the cable release is located on the shutter housing.

Since the view camera uses the same lens for viewing and taking the picture, it is necessary to have a way to preview the image before making a photograph. This is accomplished through the use of a press focus lever. The press focus lever is located on the shutter housing. When put in the preview position, it locks open the lens at the present aperture setting, allowing the photographer to view the image on the ground glass. In normal situations, both the press focus lever and the aperture will be opened to allow the maximum amount of light to strike the ground glass, facilitating focusing and composition. In other situations, the f-stop could be positioned at the working aperture to allow for a previewing of depth of field. The press focus lever must be closed, and the aperture returned to its working position, before a photograph is taken.

The flash synchronization socket (PC connection) is located on the shutter housing. Connecting a cord from this receptacle to a flash will coordinate the flash and the camera shutter. In-lens shutters will synchronize with a flash at all shutter speeds. Some cameras offer a choice of flash synchronization positions. Although rare on contemporary equipment, these may be encountered when older equipment is used. The three positions are X, M, and FP.

X is used with electronic flash. When this position is used, the shutter and the flash circuitry are activated simultaneously when the shutter release is depressed.

M is used with flashbulbs. When this position is used, opening the shutter is delayed to allow the flash circuitry to trigger the flashbulb and give it time to reach full power before the shutter opens. If this setting is used with electronic flash the flash will fire before the shutter opens, yielding no flash exposure on the film.

FP is a little-used setting designed for special flashbulbs that were created for use with focal plane shutters.

The open lens admits light onto the ground glass viewing system. The image that is projected onto the ground glass will take some getting used to when adjusting for composition. This image is up-side-down and laterally reversed. It is also quite dim in comparison with the scene's illumination in front of the camera. Some manufacturers make attachments to turn the image right-side-around, but most photographers simply adapt to the image as viewed on the ground glass. Many photographers state that the upside-down and reversed image allows them to see their composition more objectively.

A **dark cloth** is designed to shade the ground glass from the illumination of the scene and allow the photographer to see the image clearly. A typical dark cloth is white on one side and black on the other. The black side faces the camera to absorb stray light and create a dark environment. The white side is placed away from the camera and photographer to reflect the maximum amount of light and keep the camera and photographer cool.

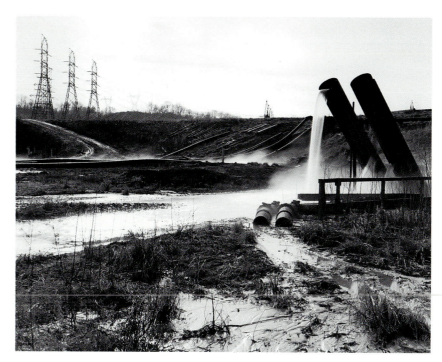

Kentucky #46, 1983
Barry Andersen

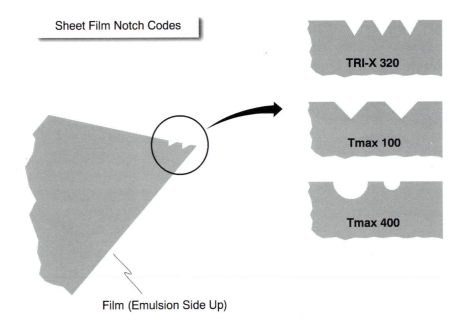

Sheet Film Notch Codes

TRI-X 320

Tmax 100

Tmax 400

Film (Emulsion Side Up)

VIEW CAMERA FILM

View cameras normally use sheet film that is precut to size. It is packaged in boxes that are designed to create a light baffle that protects the film. This design consists of a box within a box within another box.

The sheet film has a system of notches along its edge to tell the photographer, even in total darkness, what type of film it is and which side is the emulsion side. The type of film is determined by the shape, number, and spacing of the notches. For example, three triangular notches in a row would designate a particular film, two triangular notches separated by a wide space a different type film, and two triangular notches side by side followed by a square notch yet another type film. No matter which film is selected for use, the method for determining the emulsion side will be the same. When the film is positioned so that the notches are on the top edge in the right-hand corner, the emulsion side will be facing the photographer.

VIEW CAMERA FILM HOLDERS

A variety of film holders are available for view cameras. The most common is the sheet film holder that holds two sheets of film, one on each side. Instant film holders allow for the use of film that does not need the traditional wet film developing process. These are manufactured to accept single sheets or packs of film. Another type of holder accepts individual paper envelopes containing one sheet of film, a factory-loaded disposable film package. A roll film holder permits use of 2-1/4-inch film on a continuous roll. Though not commonly used, these roll film holders can be found. Their use, however, will not be covered in this book.

Sheet Film Holders

The **sheet film holder** consists of a dark slide, a film compartment with grooves or rails to hold the film in place, a flap to make loading of the film possible, a light trap, a lock, and a place to write in exposure information.

The top portion of the **dark slide** has a white side and a black side. The white side should face out when the film is unexposed; the black side faces out after exposure of the film. Additionally, the white side has a series of little bumps that will identify the unexposed side of the dark slide—useful in the dark when the photographer is loading the film. Place all dark slides in the film holder with their white sides facing out in preparation for loading the film.

Film holders must be cleaned before use. Dirt, lint, or dust that remains in a film holder can become a problem if it moves to the film surface during exposure. If this happens, the debris will reduce or block exposure. Clean the holders with a brush and compressed air. Take care not to apply too much direct air pressure to the light trap.

Because dust on the film is a significant problem with film holders, it is recommended that clean film holders be stored in plastic bags (such as resealable freezer storage bags), a small portable cooler, or both to keep dust accumulation to a minimum.

After the holder is cleaned, the film can be inserted. Do this in total darkness by opening the hinged flap at the bottom of the film holder and positioning the film with the emulsion side facing out. Slide the film in and under the film guide rails located on both sides of the film holder. When the film is in the holder correctly, the film flap should close in position easily. Push the dark slide down until it slips in place in the film holder flap, then lock the dark slide by twisting one of the locking wires across the top of it.

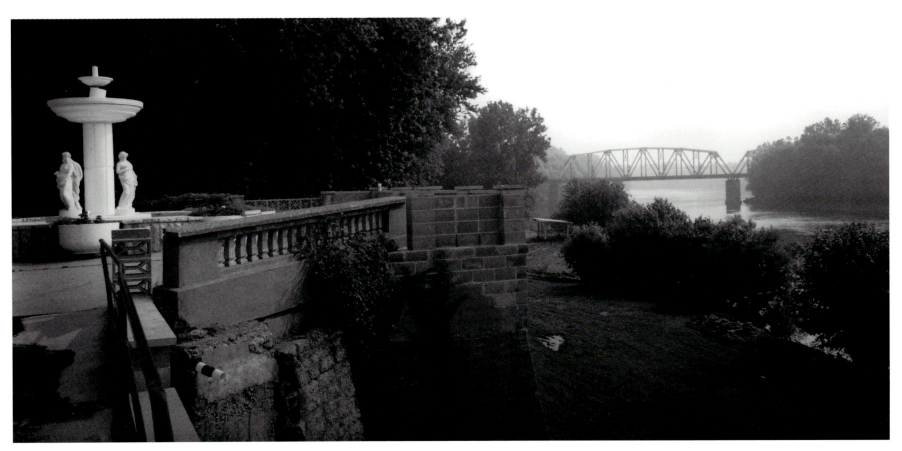

Wabash River
Gary Cialdella

To load the film holder into the view camera, locate the camera opening for the film holder by finding the way the ground glass is hinged to separate from the film plane. Slide the film holder in with the flap end first. Continue to push the film holder into the camera until the ridge located just above the image opening of the film holder meshes with a corresponding groove in the camera. When this meshing occurs, the holder will feel seated and will be difficult to move out of position.

After the press focus lever is closed, the dark slide can be removed from the film holder. Pull the slide all the way out of the holder, and wait for the camera to steady. Then, press the cable release to take the exposure. After the exposure, replace the dark slide with its black side facing out to indicate that the film has been exposed. Lock the dark slide with the wire lock, and remove the film holder from the camera.

Instant Film Holders

Instant film holders are somewhat different than sheet film holders in design and operation. They have two machined metal rollers that are designed to squish a chemical packet and spread chemicals evenly over the film for instant development. Before loading one of these film holders, check these rollers for any sign of dirt or dried chemical that may interfere with the successful operation of the holder. The rollers can be cleaned with a cloth dampened with water.

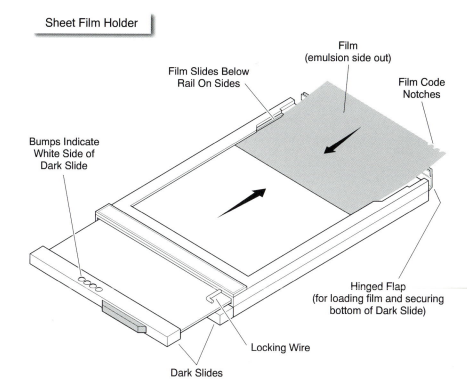

Sheet Film Holder

Film (emulsion side out)

Film Slides Below Rail On Sides

Film Code Notches

Bumps Indicate White Side of Dark Slide

Hinged Flap (for loading film and securing bottom of Dark Slide)

Locking Wire

Dark Slides

Instant film holders come in two categories: single-sheet and pack holders. A single-sheet holder utilizes film in a paper envelope with a thin metal strip on one end and a chemical packet at the other. Load the film holder by pushing a lever on it to L, for load; this places the metal rollers apart and allows the film to be inserted without harm to the chemical pack. Push the film in until you hear a click; this sound is the metal strip on the film envelope locking into the bottom of the film holder. Take care to have the emulsion side facing out. The paper envelope housing the film will have printed on the emulsion side This Side Toward Lens; it will also have a circle with a cross marked in it, indicating the same thing.

Once the film holder is loaded, place it in the camera in a manner similar to that used for a normal sheet film holder, and it will seat into place. After closing the press focus lever, pull the paper end of the film sticking out of the top of the film holder, until it stops. This is the paper envelope enclosing the film, and it serves as the film's dark slide; it should not come all the way out of the holder. Once the paper envelope stops, the film is ready for exposure.

After exposure, slide the envelope back into the holder until it stops. Then, turn the lever on the film holder to P for process; this places the metal rollers together. Pull the film by the paper envelope end slowly and firmly without hesitation, taking about 1 second to pull it all the way out. The film envelope will go through the metal rollers, and the contents of the chemical packet will be spread over the film, causing the film to develop. Check the manufacturer's instructions for time and temperature for the film in use, and open the film after the appropriate developing time. The instant sheet film is opened by grasping the two sides of the top of the paper envelope and pulling the envelope firmly apart. Inside will be the instant picture, face-down. Peel the picture away from the envelope by lifting it from one corner.

Instant pack film holders operate in a similar manner but incorporate up to ten sheets of film in a pack. Usually, these film holders have conventional dark slides and utilize a system of paper tabs that are pulled to bring another sheet of film into place. A piece of paper is pulled out of the pack between the metal rollers, and the print is separated from it after instant development.

Factory-Loaded Film Holders

Factory-loaded (ready-load) film holders are paper envelopes that contain regular film, not instant film. They use instant film holders or specially designed holders that are placed in the camera. They operate the same as instant sheet film holders, with a paper envelope serving as a dark slide, except that the film is not developed instantly.

The advantages of this system are that a photographer does not have to worry about cleaning film holders or the problems of dust on film from loading. These potential problems are handled at the factory. The assumption is that these factory loads will be clean and trouble free. They are also very light, requiring the carrying of only one film holder to place them in the camera. Nature photographers and others to whom weight is a serious consideration will want to take note of this advantage.

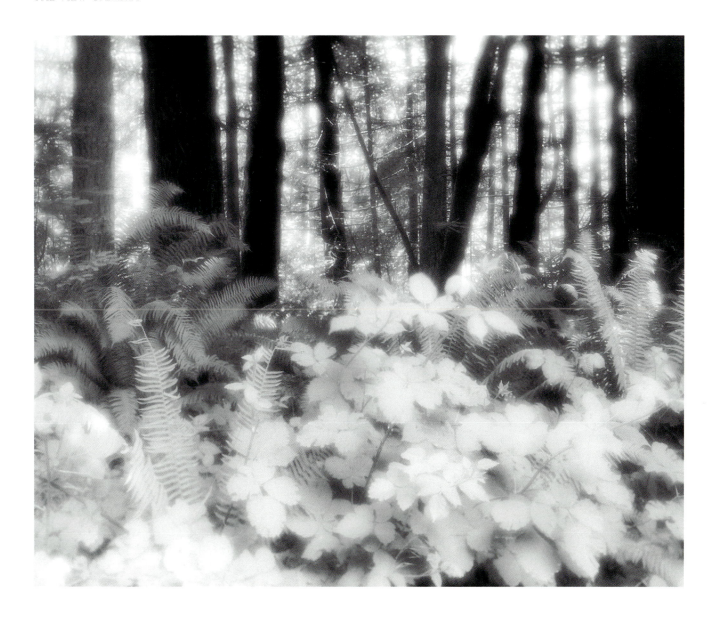

Untitled
Nick Dekker

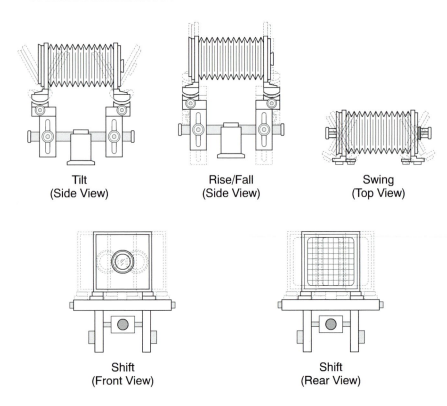

Basic View Camera Movements

Tilt
(Side View)

Rise/Fall
(Side View)

Swing
(Top View)

Shift
(Front View)

Shift
(Rear View)

VIEW CAMERA MOVEMENTS

The four basic view camera movements are rise-fall, shift, tilt, and swing. Most view cameras will have some movement on both front and rear standards.

Rise-Fall

Rise-fall is a vertical movement of the front standard or the rear standard. On the front standard, it is used to reposition the viewpoint of the camera without moving the camera and tripod. This front standard movement changes the relationship of the foreground to the background by repositioning the lens higher or lower. It is the same effect as that achieved by a photographer with a handheld camera, taking a new camera position either higher or lower in relationship to the subject.

On the rear standard, rise-fall frames different parts of the scene within the rectangle of the ground glass. The rear standard movement does not change the relationships of the subjects within the frame, as does the front standard movement. Rather, it is similar to the movement of a printing easel around the projected image of an enlarger to choose the best picture cropping.

Shift

Shift is a horizontal movement of the front standard or the rear standard. It has the same effect horizontally as rise-fall has vertically on the camera image. The front standard will again cause a change in the foreground-to-background relationship through a horizontal repositioning of the lens. The rear standard will simply serve the same framing or cropping function as with rise-fall.

Tilt

The **tilt** movement consists of a rotation of the front or rear standard around a horizontal axis. When the front standard is tilted, it will cause a tilting of the plane of focus. A tilt of the rear standard will cause a change in the plane of focus, as with the front standard, and a change in the size relationships of objects in the scene. Both of these changes are seen in relation to the vertical position about the axis of rotation.

Swing

The **swing** movement is a rotation of the front or rear standard around a vertical axis. It will cause the same change horizontally that tilt effected vertically.

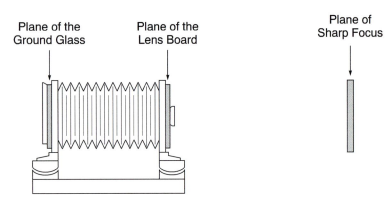

Parallel Planes

Plane of the Ground Glass Plane of the Lens Board Plane of Sharp Focus

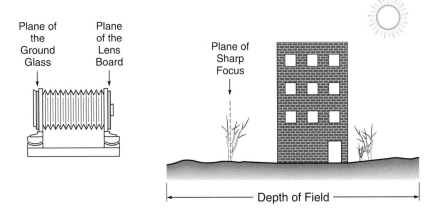

Using F-stops to Achieve Depth of Field with Parallel Planes

Plane of the Ground Glass Plane of the Lens Board Plane of Sharp Focus

Depth of Field

CONTROL OF THE PLANE OF FOCUS FOR OVERALL IMAGE SHARPNESS

To appreciate the application of tilt and swing on the view camera to change the plane of focus, something must first be understood about overall image sharpness and depth of field. Two positions achieve maximum overall sharpness with a view camera. These positions are parallel planes and Scheimpflug.

Parallel Planes

The **parallel planes position** is established when view camera tilt and swing are set in the zero or neutral position—that is, no tilt or swing camera movements are utilized. This positioning places the lens board (front standard) parallel to the ground glass (rear standard). The plane of sharp focus will be parallel to the film plane of the camera in this position.

To achieve maximum depth of field using parallel planes, the f-stop will be used to stop down to allow the depth of field to extend in front of and behind the subject. This method works best when the subject is one with parallel planes (such as a building) and is at a great distance from the camera.

Scheimpflug

Tilting or swinging the front standard or rear standard or both away from the parallel position will change the way in which the plane of sharp focus intersects the subject. The Scheimpflug effect is useful when the shape of the subject or the arrangement of objects in space dictates a change in the placement of the plane of sharp focus or in the alignment of the depth of field or in both. The **Scheimpflug principle** states simply that maximum overall image sharpness will result when the plane of sharp focus intersects with the plane of the lens board (front standard) and the plane of the film (rear standard) at a common point.

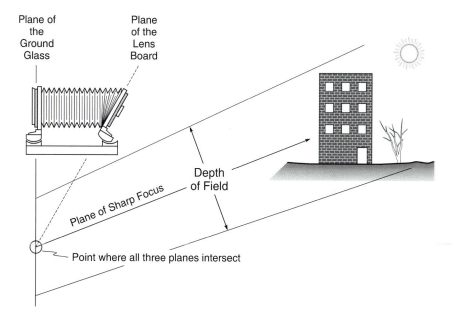

CONTROL OF THE REAR STANDARD FOR SUBJECT SIZE RELATIONSHIP

Tilts and swings on the rear standard change the size relationship within a photograph. The classic example is the use of a view camera to photograph a high-rise building. If the camera is set on parallel planes and then tilted up to include the top of the building, the vertical lines of the building are now not parallel to the film plane (rear standard). This situation makes the top look farther away, and therefore smaller, on film than the bottom of the building. The building will appear to taper to a smaller size on top; this is called **convergence.** To correct this size relationship, the camera is set up with parallel planes and the rise-fall control is used to raise the front standard and drop the rear standard to include the entire structure.

The same principle can be applied to the rear swing control. When photographing a long, low building that appears to change in size as it recedes in space, convergence can be corrected by setting the camera up with the front and rear standards parallel to the building and shifting the front and rear standards to include the entire structure.

Correcting for Vertical Convergence

Uncorrected

Final Photograph

Corrected

Final Photograph

Correcting for Horizontal Convergence

Uncorrected

(Top View)

Final Photograph

Corrected

(Top View)

Final Photograph

BELLOWS COMPENSATION AND THE INVERSE SQUARE LAW

Normal exposure on a view camera is based upon an infinity focus—that is, with a lens of 210mm (approximately 8 inches) focused at infinity, the lens and the film plane are one focal length apart. As the focus is shifted closer to the camera, at some point, the bellows will need to be extended and the distance between the lens and the film increased. When this occurs, the intensity of the light striking the film from the lens will be reduced at the rate of the square of the distance between the lens and the film plane. This principle is the inverse square law. When a view camera is used, this situation can be avoided if the distance from the lens board to the subject is kept at eight times the focal length. With the example of the 210mm lens, approximately 8 inches times 8 inches, or 64 inches, will be the minimum distance from the subject before light falloff is experienced.

Many times, photographers want to use a view camera to make close-up images of their subjects. When this situation occurs, **bellows compensation** (or bellows factor) is used to figure the loss of light and make an adjustment to exposure. Bellows compensation is used to increase exposure to account for light loss based on the law of the inverse square. Bellows compensation is necessary with all cameras, 35mm included, but it is not normally encountered because of the infrequent use of bellows in the 35mm format and because TTL metering systems automatically account for the light loss. It is the amount of extension or draw of the bellows that requires compensation in exposure.

Many methods are employed to figure bellows compensation. One method is to utilize a formula that divides the image distance (the distance from the center of the lens to the film) by the focal length and squares that number. The answer will be an exposure factor. An exposure factor is the amount of exposure that is required to make up for bellows extension or other factors that reduce the amount of light reaching the film. For example, with a 210mm 8-inch lens set on 16 inches of bellows draw, the equation is $16 \div 8 = 2^2 = 4$. A factor of 4 represents a change of two stops more light needed in aperture or shutter speed for bellows compensation.

A bellows ruler shows, from the left to right, the progression of whole $\frac{1}{2}$ and $\frac{1}{3}$ f-stop numbers from f/1 to f/64. When figuring movement of the lens from the film plane in close-up photography, the light from the lens falls off according to the inverse square law. The f-stop numbers can be used as *inches* to figure the amount of lens falloff or bellows draw, and the correction can be calculated. For example, using a 210mm lens on a view camera, the normal bellows distance would be eight inches (from the lens to the film). When the camera is used for a close-up the bellows extends to eleven inches, or a decrease of one stop in the amount of light striking the film (figured as the difference between f/8 and f/11).

Bellows Factor with a 210mm Lens

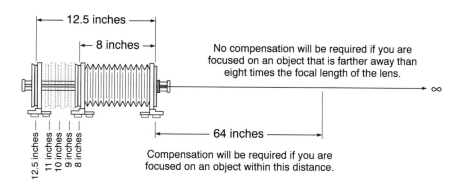

No compensation will be required if you are focused on an object that is farther away than eight times the focal length of the lens.

∞

Compensation will be required if you are focused on an object within this distance.

At 12 inches of bellows extension, you will have lost one and one-third stops of light with a 210mm lens.

Bellows Ruler

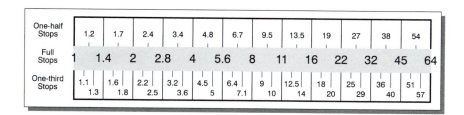

San Francisco City Hall
© Erhard Pfeiffer 1993

SHEET FILM PROCESSING

A variety of methods are used to process sheet film. The two most common are dip-and-dunk and tray processing. Regardless of which method is chosen, the chemistry involved is the same as that used in all film processing (see chapter 5).

Dip-and-Dunk Processing

Dip-and-dunk processing or tank processing, requires **film hangers,** which are metal devices designed to hold film firmly in place while it is moved in and out of the processing chemistry. The most common hanger size holds one 4×5-inch sheet of film. The chemicals are located in tanks that generally hold ½ gallon of straight (non-diluted) chemistry. A minimum of five tanks will be needed to dip and dunk. The chemistry itself is reused time and again.

To benefit from the economics of reuse, the photographer must employ a developer that has been designed to be replenished. Replenishment is accomplished by adding replenisher to the developer after film processing. Both replenisher and developer are mixed and stored in lighttight bottles. The developer bottle is marked to indicate the 1-gallon level. After the film has been developed, replenisher is added to the developer bottle in direct proportion to the number of sheets of film processed. The exact proportion needed is determined by the manufacturer. Then, the exhausted developer is poured back into the developer bottle from the developing tank. Any excess developer—developer that would fill the bottle above the 1-gallon line—should be discarded.

Stop bath, fixer, and hypo clear also can be reused until the limits of the chemistry are reached. Rinsing and washing can be accomplished by running water in the same type tank that is used for the other chemicals, or in special-purpose washers. When the sheet film is hung to dry, one corner is clipped and the film is allowed to hang diagonally.

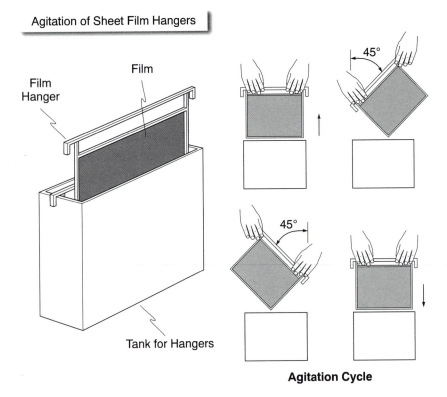

Agitation of Sheet Film Hangers

Film Hanger

Film

Tank for Hangers

45°

45°

Agitation Cycle

The first half of an agitation cycle is accomplished by slowly lifting a hanger out of the chemistry, tilting the hanger about 45 degrees to one side, and then slowly returning the hanger to the vertical position and replacing it into the tank. Repeating this process once more but with a 45-degree tilt to the opposite side completes one agitation cycle.

In the developer, agitation begins with an initial light tapping of the metal hanger against the top of the developing tank to loosen any air bubbles clinging to the film. It continues with one agitation cycle each minute for the entire developing time.

Surge is a problem that may be encountered with film hangers. This is an unevenness on the film caused from overagitation. The small holes on the film holder's periphery that are designed to allow chemistry to flow through the hanger can become areas of high turbulence if the agitation is too vigorous.

Tray Processing

Tray processing is an alternative to the dip-and-dunk approach. In this process, multiple sheets of film are placed in trays in a stack and then leafed, or shuffled, through the chemistry. Care must be taken not to scratch the film during this procedure.

Tray processing eliminates surge and allows a minimal use of developer chemistry. It utilizes diluted developer only once. The developer is fresh each processing session and does not require replenisher.

Flat bottomed trays that are one standard photographic size larger than the film—for example, 5×7 inch trays for 4×5 inch film—are recommended for developing sheet film. One more tray will be needed than the number of tanks in tank processing. This additional tray will be used for the water bath, which is the first step in tray development.

The water bath allows the film to be presoaked before the developer step. This removes any possibility of uneven development or damage caused from placing multiple sheets of dry film into developer. To presoak the film, place one sheet at a time in the presoak, at 30-second intervals. Then, agitate the sheets until they have been in the presoak for a total time of 1–5 minutes.

Water Tower, Snow Hill, North Carolina
Buck Mills

Agitation of Sheet Film in Tray Processing

Holding the films lightly like a hand of cards, count the corners to be sure you have them all and that they are separate.

Keep one hand dry. Insert the first film into the developer solution, emulsion-side-down, and pat it down to be sure it is completely immersed.

Place the other sheets, one at a time, emulsion-side down, on the surface of the developer and pat each one down to wet it thoroughly before adding the next.

Herd the sheets gently into one corner of the tray.

Commence the agitation by sliding the bottom sheet out from under the stack and carefully laying it flat on the surface of the solution.

Pat it down and extract the next sheet from the bottom of the stack. Continue this sequence throughout the development time.

Agitation in tray processing is accomplished by holding the sheets of film by the edges and arranging them in a loose stack while they are immersed in the chemistry. The bottom sheet of film is then lifted up and placed carefully on top of the liquid in the tray and over the rest of the film. This sheet is then pushed down under the chemistry with one hand, and the next sheet is pulled from the bottom on the stack. This agitation process is continuous for the remainder of the processing time. Every 30 seconds, the entire stack—or the entire tray, whichever is easiest—is rotated 180 degrees. This is done to remove any possibility of overagitation from the increased temperature where the hands contact the film.

The main problem with tray processing is that the film can become scratched. This could happen if the sheet of film being lifted to the top of the stack is placed into the tray with its corner striking the film already on top of the stack. Care should be taken to have the film parallel to the surface of the chemistry when placing it back in the tray. All emulsion sides of the film should be placed down when tray processing. If the film is scratched, it will only be a superficial scratch to the base of the film and not damaging to the emulsion.

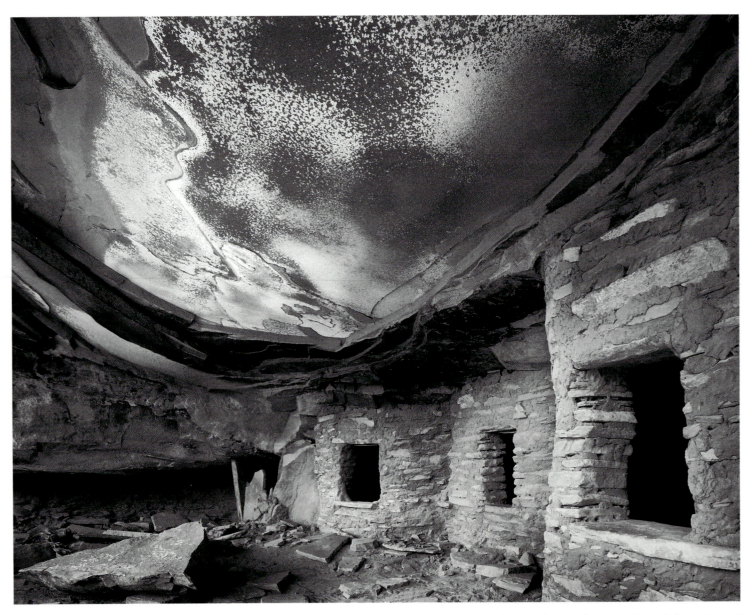

Ceiling House Ruin from "Places of Power: Sacred Sites Series"

THE ZONE SYSTEM

To many, the zone system approach to making black-and-white photographs is the highest level of the photographic art. The system is based on total control of the photographic process. The basic principles of the zone system can be utilized without the heavy testing that is required to maximize the system.

The use of the zone system takes into account many aspects of the film-processing-printing system. This type of approach allows the photographer to previsualize a photograph, including the characteristics of the paper on which the print will be made, the type of film that will be used, the developer, the light range in the scene, and the desired rendering of the tones within the scene as they will be seen in the final print. When viewing the light range in the scene, the photographer chooses the tonal range of the print. With this concept of the final print, exposure is calculated and used to make a negative that will print properly. The system is not as difficult as it might look, but it does depend on testing and knowledge of the materials and process to be used.

PREVISUALIZATION

The critical aspect of successfully using a zone system is to consider the final print prior to exposure of the film. This is previsualization. Previsualization allows the exposure and development to be adjusted to meet the requirements of the print.

The paper the photograph will be printed on becomes the primary limit of the system and the first area of concern. The critical element of the paper that will determine the rest of the system is its exposure scale. The exposure scale indicates the limits of light that will affect the paper. Light levels that are below the exposure scale for a particular paper will not be exposed, and light levels that are too high will not gain the additional density needed. Once the maximum range of light that the paper can record is known, then this information can be used to determine the total range of density that needs to be present in the negative. The paper's exposure scale and the developed density of the film should be the same. This is why the print is the key to previsualization.

The exposure capacity of the paper determines the values of the negative densities, from the minimum to the maximum usable density, which will translate into the black-and-white scale in the print. The exposure capacity of the paper is expressed as the log exposure, or subject brightness range, that the paper is capable of using. This is represented as the horizontal difference between Dmin and Dmax on the paper's characteristic curve. If the paper has an exposure capacity of 1.5 (five stops), then the properly exposed and developed negative will have a range of 1.5. The range of the film is the vertical dimension between Dmin and Dmax on the film's characteristic curve.

With this idea in mind, the photographer chooses tonal values, or zones, that should appear in the print and uses a meter to take a reading from areas in the scene. It is not important which zones are chosen—whether in the highlight, midtone, or shadow areas. The relation of the zones to exposure is 2:1, with each zone step above zone I requiring one additional stop of exposure. Unlike zone placement, a zone system sets the tonal range of the film and not just a single zone. This range does not necessarily represent all the tones present in the scene. The photographer can select not only how several tonal areas of the picture will be represented but also how the amount of contrast or tonal range within the scene will translate to the print. This understanding is a powerful tool for the black-and-white photographer.

Once the range of zones to be present in the final print is chosen, it is measured with a meter to determine the darkest and the brightest critical areas of the picture. It is important to use a method to record the measurements, since this is a system that must be followed, not a series of individual steps. This is a previsualization step. The photographer determines how the range will be represented in the print by assigning a range to be in the negative. This range will need to be translated into a density value equal to the exposure capacity of the paper. Though the concept can be simplified to use two standard points such as highlight and shadow details, any two values in the scene can be used to set the range. For even if the steps are both shadows or both highlights, the difference between these zones establishes the system's control.

Chair, Bodie, California
Robert G. Smith

BACK TO THE ZONE SYSTEM

The key element of the zone system is a visual ruler that allows photographers to visualize and actually measure the difference between normal-, low-, and high-contrast subjects. This is called the zone ruler.

A zone can be defined in three simple ways:

1. Print Values: Each zone symbolizes a different range of dark, gray, or light tones in a finished print. For example:
 Zone 0 Black
 Zone 5 Middle Gray
 Zone 9 White
2. Texture and Detail: Every zone contains a different amount of texture and detail. This allows zones to be associated with actual objects. For example:
 Dark hair is usually zone 3
 Snow is usually zone 8
 Cement is usually zone 7
3. Photographic measurement: Zones can be measured in terms of f-stops, shutter speeds, and meter numbers.

PRINT VALUES

The first definition of a zone, or print value, is easy to understand. Look at the tonal values of a normal black and white print. You will see that almost any photograph has within it the total range of possible print tones, from the blackest black to the whitest white.

Each zone represents a small range of slightly different tones.

Ten distinct steps go from black to white.

To use a zone system for a photograph, assign a number of each tonal step in the photograph, starting with 0 for the black section and going to IX for the white one. The steps are now officially zones. Remember that each zone can be related to values in any photograph.

Your goal is to look at any photographic subject and say, "In the finished print, I want that tree to be zone III and the sky to be zone VI" or whatever; this is what the zone system is designed to do.

TEXTURE AND DETAIL

To relate zones more closely to the real world, let's define each zone in terms of the way it should look in a normal print:

Zone 0: The blackest black that photographic paper can produce, with no texture or detail.

Zone I: Also black without detail; appears in dark recesses, tiny cracks; slightly lighter than zone 0; off-black.

Zone II: Slightly textured black. This is the first zone in which you can begin to detect a trace of texture and detail.

Zone III: Extremely important zone. Black with detail. Texture and detail are only barely visible in a zone II area of the print, whereas zone III is always textured and detailed. Note: A common mistake is to consider the darkest shadow you can find in the subject as zone III. This is not true. Very dark shadows are generally zone II. Remember that zone III is the first dark zone that is *fully textured.* Zone III is defined as the zone for important shadows.

Zone IV: Best described as dark gray with full texture.

Zone V: Fully textured middle gray, or 18 percent gray; a dark blue north sky, a stone in natural light, or weathered wood. A gray card is used as an exposure guide, representing zone V.

Zone VI: Light gray. Fully textured and easy to describe because it can be related to skin tone. Caucasian skin that is not overly tanned usually prints as zone VI.

Zone VII: White with detail and fully textured; sunlit concrete, light clothing. Note: Just as zone III is the first zone that is fully textured and detailed, zone VII is the last. For this reason, zone VII is defined as the proper zone for important highlights. Beyond zone VII, the remaining zones become progressively less detailed.

Zone VIII: White without detail; slightly darker than zone IX; off-white.

Zone IX: The whitest white that photographic paper can produce, with no texture or detail.

Slide Lake, Flat Tops Wilderness, Colorado
© Jim Elliot

CALCULATING THE SYSTEM

The zone relationship is calculated by using a meter to read the critical tones and counting the number of stops that separate the meter readings of the areas. This is then compared with the previsualized (predetermined) concept of the relationship between these values. If, for example, the photographer previsualizes a dark area as zone II and a light area as zone VIII, then the relationship between them should be six stops, or the light area should be 2 to the power of 6, or sixty four times more light. If the meter reads f/2 for the dark area and f/16 for the light area, then the six-stop relationship is already in existence and normal development will achieve a properly developed negative.

But the concept of previsualization means that the photographer can choose the relationship to be a range different than that actually present in the scene. The only restriction is that the zones must stay in a relationship of dark to light. The photographer cannot choose to make a dark area of the scene appear lighter than the recording of a light area in the same scene.

If the photographer previsualizes a print where zone II in the scene is measured at f/2 and zone VI reads f/16, then the range is not normal. Six stops separate the actual metered values, and the photographer has chosen to represent these values as being four steps apart. To accomplish this print, the photographer will need to compensate by underdeveloping the film to achieve a negative that will have the proper density for the paper.

In this case, the photographer will need to do three operations before exposure calculation can be successfully accomplished. The first operation is to determine the type of development that will be required. In zone system language, **normal development** is named **N development.** If the number of stops in the scene is less than the previsualized zone difference for the print, then overdevelopment will be required, and this is referred to as **N+ development,**

or expansion. If compensation is required to adjust the film to reduce the number of steps between zones, than underdevelopment, or compaction, is necessary, and a minus sign is used to refer to this situation: **N− development.** The amount of over- or underdevelopment is referred to by the number of stops to be adjusted. In the above example, the requirement would be N−2 development because the meter readings indicate two more stops between the zones than is previsualized.

The second operation in a zone system is to previsualize the change of value relationships within the scene. This requires a change in the effective EI. Changing zone relationships is the same as pushing or pulling the film. The overdevelopment for N+ control is pushing. Conversely, underdevelopment or pulling of the film is used for N− situations. Pushing and pulling the film development changes the film's effective EI. This means that to maximize the zone system potentials, the photographer must change the metering system to reflect a higher EI when overdeveloping (using N+ development) and use a lower EI when underdeveloping using (N− development).

The third and last of the three operations required in making the exposure for a zone system is to expose for the shadow detail. Even though the range may have been set using other areas of the scene, the shadow detail will be the key to making the negative properly. Since the photographer will be compensating in development, the new development effect will place the highlights in the proper density range on the negative. The photographer is exposing for the shadows and developing for the highlights. Even if zone III is not one of the zones used to previsualize the print and set the development range, it should be used to calculate the exposure with the compensated-effective EI.

With the exposure made, the photographer then uses the development compensation employed in the exposure calculations to process the film. This should produce a negative that matches the

Untitled
© Nick Dekker

density requirements of the paper for printing and at the same time represents the values in the scene as the photographer previsualized them in the final print.

To use a zone system successfully, the photographer will need to test and document film development to determine the amount of over- or underdevelopment required to adjust to various N+ or N− situations. The following approximate set of numbers has been generalized for Kodak TMax 100 film developed in Kodak D76 1:1 and will require personal adjusting for best results. The chart includes percentage development times for N+2 to N−2. This range is easy to accomplish without changing developers. With specialized developer solutions, it is possible to have a range from N+4 to N−4. The paper used was grade 2 Kodak Elite Fine Art paper that was selenium toned.

DEVELOPMENT	STOPS BETWEEN ZONES III AND VII (LIGHT CONDITION)	EFFECTIVE EI	PERCENTAGE DEVELOPMENT
N+2	2 (very flat; low light)	160	130
N+1	3 (flat; overcast)	125	113
N	4 (normal)	100	100
N−1	5 (bright)	80	85
N−2	6 (extremely bright)	64	75

Dunes, Death Valley National Monument, California
© Christopher Broughton 1992

N+ DEVELOPMENT

The problem is making a printable negative from a scene that has too little contrast (is flat, overcast, or rainy).

The print is dull and lifeless because the negative was given normal development and printed on a normal grade of paper.

To compensate for a lack of contrast, the development time must increase enough to raise a zone VI negative density to zone VII, and a zone VII density to zone VIII. This is called normal development plus one zone, or simply N+1. Increasing the development time does not affect the shadow densities as much as it does the highlights.

The Effect of N+1 Development

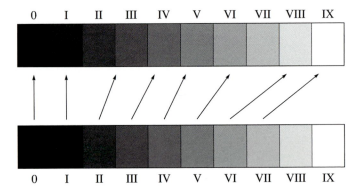

The Effect of N+2 Development

N − DEVELOPMENT

The problem is that a combination of bright sunlight, white surfaces, and deep dark shadows makes for a very contrasty situation. The goal is to show detail in the shadow areas while maintaining the subtle texture and brilliance of the highlights. For example, if the photographer were to place the shadow readings on zone III and give the film normal development, the result would be a negative with overly dense highlights. In the print, the highlights would appear as glaring whites with no separation or detail. In this situation the photographer underdevelops to bring the light extremes of the scene within printable limits.

The Effect of N − 1 Development

Notice that with N − 1 development, the zone VIII negative density is reduced to a density equivalent to zone VII, while the zone IV decreases by less than one zone.

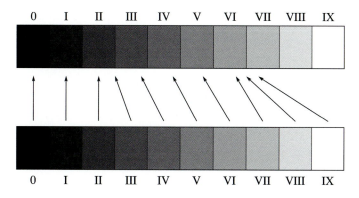

The Effect of N − 2 Development

Shortening the development time reduces the overall contrast of the negative.

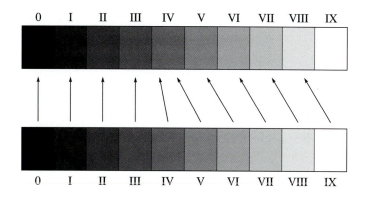

When a film is given less than N − 2 development, a noticeable loss of negative density occurs in the lower zones.

To remedy this situation, place the textured shadow reading on zone IV instead of zone III, when the contrast of the scene is extremely high.

Will Barnet, New York City, 1993
© 1993 Arnold Newman

EXHIBITION, PORTFOLIO, AND REPRODUCTION

The photographic process is finished only when the photographer presents the work to the viewer. Several methods might be used to present work, and limits can be expected in different presentations. The three basic forms of presentation are exhibitions, portfolios, and reproduction.

- Exhibiting photographs involves determining the best size for the prints, making groups of prints consistent, adjusting the development of prints to take advantage of the lighting in the exhibition space, and finishing the prints for presentation.

- Preparing a portfolio involves many of the same concerns as exhibiting photographs. Two types of portfolios are compiled by photographers: one presents a body of work to prospective clients or representatives; the other displays a group of related work together in an exhibition or collection.

- Making prints for reproduction requires special consideration for making halftone images.

When a photographer is asked to present or exhibit his or her work, a higher level of print concerns must be approached by the photographer. These presentations are done either through exhibition or through the use of a portfolio. The difference in quality-quantity requirements is that a portfolio tends to be a smaller group of pictures that will be viewed in normally a less formal setting—on a desk or table.

Usually, the work to be printed for an exhibition or portfolio has already been printed previously, and for this reason, many of the concerns for cropping and basic treatment have been addressed. But in an exhibition or portfolio, the photographer may need to consider a different set of printing conditions compared with what was used for the original final print.

EXHIBITION

When a photograph is presented at exhibition, it is held up as an example of the finest work of the photographer. And though it might seem that a final print would be good enough for exhibition, the work might for many reasons be reprinted to different standards. The exhibiting photographer needs to take into account four major concerns. These are the size requirements of exhibition prints, the consistency needed in a group of prints, the light of the exhibition space, and the presentation finishing needed for the exhibition.

A special set of concerns might also be assumed when the work to be presented will then either be retained by a museum or added to an existing collection of photographic art. Because photographs that are acquired into collections are exhibited over long periods of time, special archival printing techniques must be used.

Print Size

Photographers work in different sizes for reasons of storage, assignment, or personal taste. These sizes might not meet the needs of the exhibition space.

One rule of presentation that is often applied to viewing pictures is to maintain the proper **viewing distance.** This is the diagonal measurement of the picture. If a picture is 12×16 inches, then the proper viewing distance is 20 inches. This means that the smaller the image is, the closer the audience of the exhibition will need to be in order to see the picture well.

Understanding the way the viewing distance is controlled by the size of the print, a photographer gains a great influence on the audience by controlling the size of the pictures. The photographer can control how the exhibition space will function. If the photographer wants the images to be perceived as private and involving maximum attention, he or she can make the prints small. A small print will draw the audience in close. At the other extreme, the photographer might want to dominate the space and make a print more public by making it large. A very large image allows more than one person to view it at one time. It makes sense to keep in mind that big prints are not necessarily better than small prints. Many times, photographers are consumed with the idea that bigger is better. Bigger is only bigger, and how an image functions is more important than largeness alone.

Photographers as well as exhibition spaces tend toward standard sizes. Though the frame should not determine the size of a photograph, it is often a controlling concern. In the United States 8×10, 11×14, 16×20, and 20×24 inches are common sizes used for precut photographic paper. Exhibition and framing concerns will tend to deal in 8×10, 11×14, 11×17, 16×20, 22×24, and 22×28-inch sizes. In other countries, the standard will be close to these sizes when converted to rounded metric measurements.

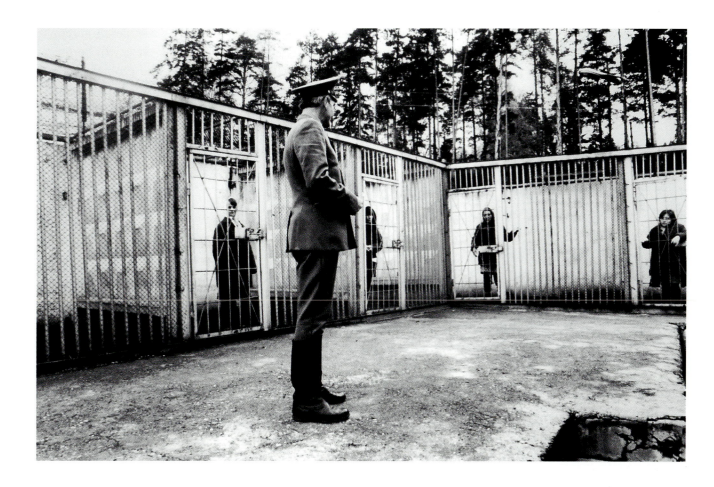

USSR Women's Prison. Exercise cells for prisoners in solitary confinement.
© 1993 Jane Evelyn Atwood/Contact Press Images

Yevgeniya Gurulyova-Smirnova, Navigator, 125th Dive Bomber Regiment, Soviet Army Air Force, WWII
1991 Anne Noggle

Print size will also have a great effect on the way detail is handled in the picture. The larger a print is, the easier it will be for the audience to deal with detail in the image. The problem with great enlargement of a print is that the graininess of the print will become apparent. If the graininess of the print becomes unacceptable at some enlargement, then that concern will limit the size of the print.

Consistency

The second need of many exhibitions is for the images of one photographer to work well together. This is especially true when the work revolves around a central theme or project. Even if the work is from varying times in the photographer's career, the exhibition may require the images to have the same appearance. This type of consistency may be missing in the original prints of less-experienced photographers in particular.

Consistency in presentation does not always mean that all the images are the same in all respects. This is of course one way to approach this issue. Consistency in presentation might also mean that the works have enough points of visual similarity that the audience will conclude that they are from one photographer or part of one group.

A photographer needs to look at five basic areas when striving for the consistency required in exhibition. Beyond any theme, the five are size relationships, print formats, image quality, print tone, and presentation type. Some diversity in any of these areas will not undercut consistency, provided that single images do not appear different from all the other images.

Size

The size of the images or presentations in an exhibition will have a strong unifying effect. If most or large groups of the images have a similar size, then they tend to look as though they belong together. Even if a few larger images are included, the group holds together, with the larger images gaining importance because of their size relation to the group. The photographer can thus use the size of the print to accent a particular image in an exhibition.

FORMAT. **Format** is also strongly unifying. If an exhibition has a clear format, such as all square pictures, the format reinforces the consistency of the pictures. Format classifications include the shape of the images and the orientation (either vertical or horizontal) of the pictures or presentation. Also, format accents such as the inclusion of full-frame indications (notches on sheet film or dark negative edges) in the print are unifying to a group of photographs.

QUALITY. A strong reason to reprint for exhibition is the need to match image quality across the body of work. Printing, like any other aspect of photography, changes from time to time. It is part of the personality of the photographer to make prints that she or he likes at the time. From the time a print is first made until it is exhibited, the photographer may have changed preferences to harder- or softer-looking images, or for a different tone for prints. If the images for exhibition come out of a period of time when the photographer was growing in technical skills, it is likely that the photographer will be able to make better exhibition prints than the originals.

The paper that is used will be an area of differences. Prints made on chlorobromide paper will have a warm tone, whereas prints made on a bromide paper will be cool in tone. The paper surface for some prints may be different than that for others. These differences in an exhibition or portfolio have a tendency to break up consistency.

TONE. Of the unifying areas of print quality, **tone** seems to stand out as its own concept. The tonal scale of the pictures will hold together an exhibition. This means not that all the pictures should be light or dark but that they should have the same tone within each one's limits. If two images of similar scenes have vastly different tones, they are more difficult to exhibit together. One print with a Dmax of 1.9 and another with a Dmax of 2.1 will look dissimilar, even when they are printed in the same way. The tone of the printing should accomplish the same density in maximum black areas of the prints and give the same reflective whites. The tonal range in between light and dark should appear to be the same from print to print even though the subjects of the pictures may not present that range.

For exhibition prints, one way to maintain a consistency in print tone is to use toners. It is possible to tone prints after they have been dried, but this is not the best method of toning. Though toning will affect papers in a predictable manner, it will vary from paper emulsion to paper emulsion. Chlorobromide papers take toner more noticeably than do bromide emulsions. The way RC papers absorb will vary from one type to another. For these reasons, the photographer may want to reprint all photographs on the same paper and then tone the prints to gain tonal consistency.

Three types of toners are commonly used. These are color toners and dyes, metallic enrichments, and redevelopment toners. Of the three, color toners and dyes are the least used for general exhibition purposes. These are employed to change radically the monochromatic nature of a print. **Color toners** are used to give an image

Cousteau diver, Santa Cruz
Island, California
Ernest H. Brooks II/Brooks Institute

a color other than the range of grays found in the normally processed paper. **Dyes** work on the paper base and change it from its normal tone to the color of the dye. **Dye couplers,** which are normal in color film, can also be used on monochromatic prints in developing the image. These types of dyes and toners give the photographer the ability to use color in some ways not normally associated with black-and-white photography. Dye couplers are chemical treatments that are used in conjunction with the developing process. As the silver in the emulsion changes from a silver halide to a metallic silver, the coupler attaches only to the developing silvers and gives them the color or tone of the dye.

The most common type of black-and-white toner is the **metallic enrichment toners.** These darken and slightly shift the color of a print. For exhibition and museum work, selenium toners and gold toners get the most use. Depending on the strength of the toning solution, these will give no noticeable color shift or a slight change. Owing to cost, selenium toner is more common in use than gold toner. The best point at which to tone in paper processing is just prior to the final wash. Many photographers and several manufacturers recommend that a small amount of selenium toner be mixed with the hypo eliminator. Normal recommendations are for one part selenium toner to thirty to forty parts water or hypo eliminator bath. This dilution of toning solution will darken a print's tone but not change the color or the white of the paper base. Toning in this way can add approximately one stop, or 0.3 log units, of density to the final print.

CAUTION: Sepia toner is an example of **redevelopment toners.** Sepia refers to the yellowish-brown tone of the photograph after this process. In redevelopment toning, after a print has been totally fixed, a ferricyanide solution is used to reverse the development of the emulsion to silver halide. Once this is done, a redeveloping solution of selenium and sulfur is used to "bring back" the image in a new tone and color. The fumes emitted from the sepia toning process are strong and present a safety concern. Sepia toning should only be done in a well-ventilated area.

Both metallic and sepia toners provide more than just tonal consistency to exhibition-quality prints; they make the images last longer. Gold toner is used more for its archival qualities than its tone rendering.

ENVIRONMENTAL NOTE: Metallic toners, because they are heavy metals, should be disposed of through environmentally safe means, and never poured down a drain.

Dagfin Cobos and Manuel Cobos, San
Cristóbal Island, Galapogos, Equador
© Stacy H. Geiken, 1993

Exhibition Lighting

A primary concern about the local conditions in which an exhibition will be held is the amount and type of light that will be used to exhibit the pictures. If the light is low in illumination, then the prints might be printed slightly lighter to aid their being seen in the exhibition space. With bright light, the prints can be printed slightly darker to enhance their richness.

The brighter the light in the exhibition space, the higher the contrast available for use in the photographs. With higher-intensity illumination, the richness of dark tones in prints becomes more important. With low illumination, highlight detail will be accented.

Print Finishing

The finishing of a print should include local corrections such as spotting and bleaching, and presentation effects such as flattening, mounting, and perhaps framing. Owing to local printing conditions, work is not always printed to the same standards from one period of time to the next. Toners may not be consistent from year to year, or the amount of dust on the printed negatives and required spotting of the prints will change as work is printed over a long period of time. These will add inconsistencies that can be removed by reprinting for exhibition.

LOCAL CORRECTIONS. Most prints need to be spotted. Regardless of the care taken in the printing process, spots caused by dust on the negative will appear on the final print. Both opaque material and transparent dyes are used to correct these flaws. Opaque paints come in different tones and are used to cover dark areas and spots caused by blemishes in the negative or dirt that was present at the time of exposure. Dye-type spotting fluid is used to spot white areas caused by dust on the negative during printing. Spotting is done by using a pointed brush and applying the dye in small dots to the tone blemish on the print.

CAUTION: Bleaching can be used to lessen the contrast of an overall print or to reduce locally the density of a point in the picture or a blemish in the border of the print. If prints need to be bleached for any reason, the chemical potentials of the bleaching process must be carefully watched. The problem comes about when the bleach is not totally removed after the process. Since the bleach reverses the chemical process that changed the silver halides to metallic silver, the result of the bleaching process is to create light-sensitive prints if the process is not completed properly. With time, a bleached print can redevelop and stain where the bleached silver halides have not been totally removed. Another side effect of improper bleaching occurs when potassium ferricyanide is not totally removed from the print surface after the process. The potassium ferricyanide can become a light-sensitive material when dried. If this happens, the areas where the residual chemical stays can become blue as they are acted on by light and the atmosphere.

Arrival or Departure (After Hitchcock)
Betty Hahn, 1987

PRESENTATION EFFECTS. The last consideration of unifying an exhibition is in the presentation. Whether the pictures are dry mounted, overmatted, flush mounted, or unmounted, consistency in the presentation indicates that they are meant to be seen as one exhibition. If colored mat board is used, it can be the same or different from picture to picture, provided that consistency is employed. For example, if four colors or tones are used somewhat equally in an exhibition of twenty prints, the dissimilarity may not affect the unity of the exhibition.

In the presentation of prints, the size of the mat, mount, or framing materials influences the way an image is perceived, but not the viewing distance equation. The material around the image, unless the image itself is very large, adds to the image's importance. A small image on a large mat will increase in visual importance through its isolation on the mat. Unless the mounting format is out of proportion to that of all other images in the exhibition, this concept holds.

The prints in an exhibition need to be carefully handled to maintain the quality of the presentation. Special care should be taken to avoid surface damage. Two activities can have a harmful effect on the final exhibition of the photographs. One is the flattening, mounting and framing process; the other is shipping.

To get the work to the exhibition site, any mode of transport can be used. But regardless of type of transportation, the work will need to be protected in the shipping. A few simple precautions take care of most of the hazards. First, clean, soft protective material should be placed over the picture surface of each print. This can be done with interleaving tissues or polypropylene bags. This will keep the prints from scratching each other as they are shipped. If the pictures are overmatted with a hinged mat, the tissue can be placed over the print before closing the mat. If the prints are overmatted, covered with glass, and framed, the air between the print surface and the glass of the frame will protect the print surface. If the glass is in contact with the print surface, however, any grit on the surface can damage the print when the work vibrates in shipping. The glass should not be in contact with the surface of the print.

Dream Reader
J. Seeley, 1992

Vasarasi, India
Chris Rainier

PORTFOLIO

The term *portfolio* is used in two ways in photography. One is to describe a group of photographs that are used to demonstrate a photographer's abilities. Every photographer will likely at some time want to produce this type of portfolio. If a photographer is either a professional or an artist, the use of a portfolio will become a necessity. A professional photographer uses a portfolio to sell work and get jobs. In a similar sense, an artist photographer uses a portfolio to convince either a gallery to show or represent her or his work, or collectors and museums to purchase the work.

The other use of the term *portfolio* is to describe a group of related photographs that are presented together. This is a presentation of several images that utilize a single concept or point of view. It may be used as an exhibition or collector's piece.

Many of the ways that are used to put together an exhibition are used to prepare a portfolio. If the primary concern of the portfolio is to acquire employment, then the prospective client must be able to conveniently view the work. For this reason, the size of this presentation should be easy to handle and its form should not require special presentation equipment. A secondary concern is that the work be aimed at the interests of the client. In this regard, it is helpful to use images in the portfolio that accent the photographer's abilities in the client's area of interest.

REPRODUCTION

Special printing considerations must be taken into account when images are to be reproduced by halftone. An image that is in an exhibition will not necessarily reproduce well in an announcement or poster. High-quality black-and-white images can have more than 7 stops of density difference between the highlights and black, whereas a printer's density range of 3.57 stops is considered good tonal reproduction. Printing processes do not have the same amount of latitude in the densities when applying inks to paper. Very good printing processes can reproduce a range of only about 1.9 density, which is the same as 3.57 stops for the photographer. This means that quality is often lost from the black-and-white image to the printed page. To avoid printing problems, photographers often make special prints for the specific purpose of having offset prints being made.

Untitled
Sam Wang

Specific printing procedures can be used to make photographs reproduce with higher quality in **halftone.** These have to do with special printing processes and treatment of the printing paper. Three printing processes extend the range that can be gained in the publishing process. These processes all use multiple ink runs with separations done on a tone basis. The simplest is the **duotone** process. This is the use of one halftone run with black ink and a second run with either a second black ink to accent the dark areas of the picture, or a gray ink to stretch the range into the highlight areas of the picture. Tritone and quadratone printing processes are extensions of the duotone concept to use three and four press runs respectively. Because various inks are being used, the halftone range for each run can be different and thus expand the separation of tones.

Though printing technique, the number of lines per inch, and dot form will make a difference in how well a picture is reproduced, the paper and its treatment are the single most important element in high-quality reproduction of photographs. Coated, glossy, hard-surface papers give the best results. And the printing can also be varnished to give more tonal separation.

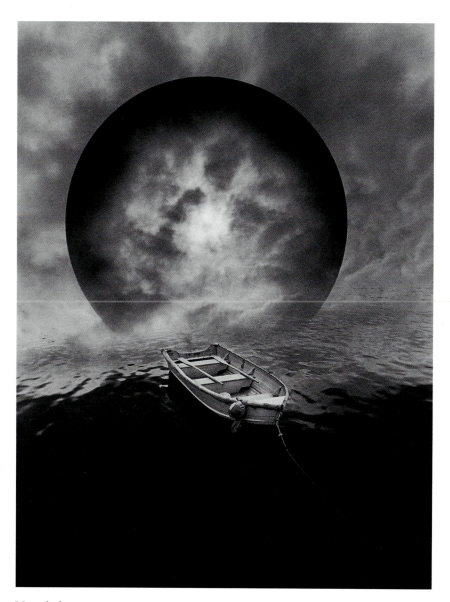

Untitled
Jerry Uelsmann

MILESTONES IN THE HISTORY OF PHOTOGRAPHY

ERA	PHOTOGRAPHY	POLITICAL, ECONOMIC, AND SOCIAL EVENTS	THE ARTS
PRIOR TO 1820	1553 Giovanni Battista della Porta describes the camera obscura c. 1790 Thomas Wedgewood makes his first silver nitrate prints		
1820–1840	c. 1827 Nicephore Niepce creates the first permanent photograph 1835 In England, William Henry Fox Talbot makes positive prints from negatives 1839 In Paris, Louis Jacques Mande Daguerre announces the photographic daguerreotype process 1840 Bayard, *Self-Portrait as a Drowned Man*	1825 First passenger railroad begins operation in England 1833 Oberlin College, the first coeducational U.S. college, opens 1834 Charles Babbage, English mathematician, invents "analytical machine" (forerunner of modern computer)	1824 Beethoven, *Symphony No. 9* 1830 Berlioz, *Symphonie Fantastique* 1830 Delacroix, *Liberty Guiding the People* (painting) 1834 Hugo, *The Hunchback of Notre Dame*
1841–1860		1844 Samuel F. B. Morse patents telegraph 1846 Irish potato famine 1848 Political revolutions throughout European continent 1848 Karl Marx and Friedrick Engels issue *Communist Manifesto*	1840–60 Construction of Houses of Parliament, London 1844 Wagner, *The Flying Dutchman* (opera)

ERA	PHOTOGRAPHY	POLITICAL, ECONOMIC, AND SOCIAL EVENTS	THE ARTS
		1849 California gold rush	
1841–1860	1851 Frederick Scott Archer invents collodion "wet plate" process		1851 Melville, *Moby Dick*
			1852 Harriet Beecher Stowe, *Uncle Tom's Cabin*
			1854 Thoreau, *Walden,* or *Life in the Woods*
			1855 Courbet, *The Artist's Studio* (painting)
			1855 Whitman, *Leaves of Grass*
	1857 Rejlander, *The Two Ways of Life*		1856 Flaubert, *Madame Bovary*
		1859 John Brown raids Harper's Ferry	
1861–1880	1863 Gardner, *Home of a Rebel Sharp-shooter, Gettysburg*	1861–65 American Civil War	1863 Manet, *Le Dejeuner sur l'herbe* (painting)
		1863 Emancipation Proclamation	
	1864 B. J. Sayce and W. B. Bolton produce dry plate	1864 Pasteur invents pasteurization	
	1864 Cameron, *Annie, My First Success*		
			1865 Lewis Caroll, *Alice's Adventures in Wonderland*
		1866 Alfred Nobel invents dynamite	
		1868 Fourteenth Amendment to U.S. Constitution is ratified, recognizing civil rights for African-Americans	
		1869 Completion of first U.S. transcontinental rail route	
		1871 Chicago fire	
			1874 First Impressionists Exhibition, Paris
		1875 First running of the Kentucky Derby	
			1876 Brahms, *Symphony No. 1*

ERA	PHOTOGRAPHY	POLITICAL, ECONOMIC, AND SOCIAL EVENTS	THE ARTS
1861–1880	1878 Muybridge, *Galloping Horse*		1879 Ibsen, *A Doll's House*
1881–1900	1884 Mach uses electronic spark illumination to photograph bullets in flight 1887 Muybridge, *Animal Locomotion* 1888 George Eastman introduces the Kodak camera 1888 Riis, *How the Other Half Lives* 1889 Peter Henry Emerson publishes *Naturalistic Photography for Students of the Arts* 1890 A flexible nitrate film base is developed 1891 Peter Henry Emerson publishes *The Death of Naturalistic Photography* c. 1893 Development of roll film	1883 Brooklyn Bridge opens 1892 Homestead steel strike 1894 Dreyfus Affair in France 1894 First public showing of Edison's kinetoscope (motion picture) 1895 X-rays discovered by German physicist Wilhelm Roentgen 1896 Marconi patents the wireless 1896 First modern Olympics held in Athens	1880s Rise of the skyscraper in Chicago and other major American cities 1884–86 Seurat, *Sunday afternoon on the Island of La Grande Jatte* (painting) 1884 Twain, *Huckleberry Finn* 1886 Rodin, *Burgers of Calais* (sculpture) 1889 Van Gogh, *The Starry Night* (painting) 1889 Tchaikovsky, *Sleeping Beauty* 1890 Wilde, *The Picture of Dorian Gray* 1894 Debussy, *Prelude to the Afternoon of a Fawn*

ERA	PHOTOGRAPHY	POLITICAL, ECONOMIC, AND SOCIAL EVENTS	THE ARTS
1881–1900	1900 Kasebier, *Blessed Art Thou Among Women*	1900 Freud, *The Interpretation of Dreams*	
1901–1920	1902 Alfred Stieglitz forms the Photo Succession group 1903 First issue of *Camera Works* 1904 Demachy, *Struggle* 1907 Davison, *The Onion Field* 1907 Stieglitz, *The Steerage* 1916 Strand, *The White Fence, Port Kent, New York* 1918 Christian Shad produces first schadograph	1903 Wright Brothers successfully fly first powered airplane, Kitty Hawk, N.C. 1903 First modern World Series, Boston vs. Pittsburgh 1906 San Francisco earthquake 1909 Robert Perry reaches North Pole 1913 Sixteenth Amendment is ratified, introducing the income tax 1914–18 World War I 1915 Einstein, *General Theory of Relativity* 1917 Russian Revolution 1919 Nineteenth Amendment grants women the right to vote	1907 Picasso, *Les Demoiselles d'Avignon* (painting) 1907–09 Wright, Robie House, Chicago 1910 Foster, *Howard's End* 1911 Matisse, *The Red Studio* (painting) 1913 Kandinsky, *Improvisation, No. 30* (painting) 1913 Stravinsky, *The Rite of Spring* (ballet) 1913 Mann, *Death in Venice* 1915 D. W. Griffith, *The Birth of a Nation* (film)

ERA	PHOTOGRAPHY	POLITICAL, ECONOMIC, AND SOCIAL EVENTS	THE ARTS
		1922 Mussolini leads Fascist march on Rome	1922 T. S. Elliot, *The Wasteland* (poem)
		1922 Irish free state proclaimed	
		1923 Trial of Leopold and Loeb, defended by Clarence Darrow	1923 Schoenberg, Twelve Tone Method
	1924 Available light photography becomes practical with production of the Ermanox camera	1924 Native Americans are granted citizenship and the right to vote	
	1925 Cunningham, *Magnolia Blossom*		1925 Fitzgerald, *The Great Gatsby*
			1925–26 Groupius, Shop Block, The Bauhaus, Dessau, Germany
		1927 Charles Lindberg solo flight from New York to Paris	
		1929 Stock market crash, beginning of the Great Depression	
	1930 E. Weston, *Pepper #30*		1931 Dali, *The Persistence of Memory* (painting)
1921–1940	1932 *Group f/64* is formed		
	1932 Cartier-Bresson, *Place de L'Europe, Paris*		
	1932 Heartfield, *The Spirit of Geneva*		
	c. 1933 Release of Kodak SS Pan Film, first panchromatic emulsion	1933 Hitler appointed German Chancellor	
		1933 Franklin D. Roosevelt becomes president and begins New Deal	
	1935 A group of photographers is assigned to document the Depression (they later became known as the FSA)		
	1936 First issue of *Life* magazine	1936–39 Spanish Civil War	1936 Wright, *Falling Water*, Pennsylvania
	1936 Capa, *Death of the Loyalist Soldier*		1936 Charles Chaplin, *Modern Times* (film)
		1937 Aviator Amelia Earhart lost in Pacific on flight around the world	

ERA	PHOTOGRAPHY	POLITICAL, ECONOMIC, AND SOCIAL EVENTS	THE ARTS
1921–1940	1938 Dorothea Lange, *Migrant Mother* 1939 Edgerton develops electronic flash	1939 Germany invades Poland, provoking World War II	1939 Steinbeck, *The Grapes of Wrath*
1941–1960	1941 Adams, *Moonrise, Hernandez, New Mexico* 1941 Karsh, *Winston Churchill* 1945 Eisenstaedt, *V-J Day, Times Square, New York City* 1947 Land invents instant photography 1948 Callahan, *Weed Against Sky, Detroit* 1951 W. E. Smith, Spanish Village photo essay in *Life* magazine 1953 Kodak TriX Film released 1955 *The Family of Man* exhibition	1941 Japanese attack Pearl Harbor December 7 1945 First use of the atomic bomb at Hiroshima and Nagasaki 1946 First meeting of UN General Assembly 1946 Winston Churchill gives Iron Curtain speech 1946 Beginning of baby boom in U.S., lasts until 1964 1947 Marshall Plan to rebuild war-torn Europe 1948 Gandhi assassinated in New Delhi 1948 Nation of Israel proclaimed 1950–53 Korean War 1954 Supreme Court rules in *Brown vs. Board of Education of Topeka* 1954 Dr. Jonas Salk begins inoculation of children against polio	1941 Orson Wells, *Citizen Kane* (film) 1948 Williams, *A Streetcar Named Desire* 1950–55 Le Corbusier, *Notre Dame du Haute Ronchamp*, France 1950 Pollock, *Autumnal Rhythm* (painting) 1955 Rauschenberg, *First Jump Landing* (painting)

ERA	PHOTOGRAPHY	POLITICAL, ECONOMIC, AND SOCIAL EVENTS		THE ARTS	
1941–1960		1956	Revolt against Communist domination in Hungary		
		1956	Elvis Presley appears on The Ed Sullivan Show		
		1957	Russians launch Sputnik, first Earth-orbiting satellite	1957	Dr. Seuss, *The Cat in the Hat*
	1958 Frank, *Les Americaines*			1958	Mies and Johnson, Seagram Building, New York
		1959	Cuban Revolution		
		1960	John F. Kennedy elected president		
1961–1980		1962	John Glenn is first American to orbit Earth	1962	Warhol, *Marilyn Diptych* (painting)
		1962	Cuban missile crisis	1962	Rachel Carson, *Silent Spring*
	1963 Arbus, *Boy with Toy Hand Grenade, Central Park*	1963	Assassination of President Kennedy		
		1963	Dr. Martin Luther King delivers "I Have a Dream" speech in Washington, D.C.		
		1964–73	Viet Nam war		
		1965	Malcolm X shot to death in Harlem		
		1965	Watts race riot in Los Angeles		
	1966 Davidson, *East 100th Street, New York City*				
		1967	First Super Bowl played, Green Bay vs. Kansas City		
	1968 Sleet, *Coretta King Comforting Bernice*	1968	Rev. Dr. Martin Luther King and Senator Robert Kennedy assassinated		
	1968 E. Adams, *Execution of Viet Cong Suspect, Saigon*				
		1969	First moon landing		

ERA	PHOTOGRAPHY	POLITICAL, ECONOMIC, AND SOCIAL EVENTS	THE ARTS
1961–1980	1970 Filo, *Kent State University* 1978 John Szarkowski, *Mirrors and Windows* book and exhibition	1972 Invention of the compact disc 1974 President Richard Nixon resigns in wake of Watergate scandal 1979 Margaret Thatcher is chosen first woman British Prime Minister 1979 Iranians seize U.S. Embassy in Tehran 1980 Ronald Reagan elected president 1980 John Lennon shot and killed in New York City 1980 Lech Walesa leads Polish labor union Solidarity in confrontation against Communist authorities, opens decade of unrest in Eastern Europe	1970 Robert Smithson, *Sprial Jetty* (sculpture) 1972–76 Christo, *Running Fence* (sculpture) 1976 Alex Haley, *Roots* 1980 Laurie Anderson, *United States Part II* (performance art)
1981–present	1981 Rick Smolen and David Cohen publish first *Day in the Life* book, *A Day in the Life of Australia.* 1983 Mary Ellen Mark, *Street Wise* 1984–85 Sebastiao Salgado, *Ethiopia* 1984 Mapplethorpe, *Ken Moody and Robert Sherman* ·	1981 AIDS epidemic starts to spread 1981 Sandra Day O'Connor first woman appointed to Supreme Court	1982 Maya Ying Lin, Vietnam Memorial, Washington, D.C. 1982 Spielberg, *E.T.* 1983 Glass, Glassworks

ERA	PHOTOGRAPHY	POLITICAL, ECONOMIC, AND SOCIAL EVENTS		THE ARTS
1981–present	1986 Kodak TMax films released	1986	Space shuttle *Challenger* explodes after launch at Cape Canaveral	
		1986	Accident at Soviet Union's Chernobyl nuclear power station	
				1988 Rushdie, *The Satanic Verses*
		1989	Fall of Berlin Wall followed by German reunification	
	1990 Kodak and Phillips announce photo CD	1990	Nelson Mandela, black nationalist leader in South Africa, is released from prison after twenty-seven years	
		1991	Communist domination in Soviet Union ends	

PHOTOGRAPHERS

Barry Andersen
Jane Evelyn Atwood
Alexandra Avakian
Ken Baird
Stephen Beck
Marilyn Bridges
Ernest H. Brooks II
Christopher Broughton
Vernon Cheek
James Chen
Nam Boong Cho
Gary Cialdella
Nick Dekker
Jim Elliott
Jill Enfield

Igor Gavrilov
Stacy Geiken
Peter Glendinning
Carol Guzy
Betty Hahn
Greg Heisler
D. A. Horchner
Adam Jahiel
Michael Kenna
Thia Konig
Gerald Lang
Ike Lea
Claudia Liberatore
Paul Liebhardt
Beth Linn

David Litschel
Mary Ellen Mark/Library
Lawrence McFarland
Nick Merrick/Hedrich-Blessing
Jon Miller/Hedrich-Blessing
Buck Mills
Arnold Newman
Anne Noggle
Erhard Pfeiffer
Dorothy Potter Barnett
Chris Rainier
Glenn Rand
Anacleto Rapping
Herb Ritts
Sebastiao Salgado

Leena Saraste
J. Seeley
John Sexton
Robert G. Smith
Jerry Stratton
Nancy M. Stuart
Sami Suojanen
G. Pasha Turley
Jerry Uelsmann
Nick Vedros
Linda Wang
Sam Wang

GLOSSARY

Page references follow the definitions.

absorption filters Filters that change the effect of light on the film by absorbing parts of the light. (179)

acetic acid A liquid acid used as a stop bath. (93)

acutance The film's ability to produce sharp, focused images. (56)

aerial perspective The way objects gray and soften in detail as they recede in space. (148)

alkaline developers Chemical solutions that reduce the latent image's silver halides to metallic silver. (86)

American National Standards Institute (ANSI) An agency that has set standards for sensitometry. (206)

American Standards Association (ASA) A film speed rating system used in North America. (55)

ammonium thiosulfate A chemical used to fix the emulsion. (94)

ANSI *See American National Standards Institute (ANSI).*

antihalation backing A coating on the back of the film that reduces reflections. (62)

aperture The opening in the lens. (37)

ASA *See American Standards Association (ASA).*

average value metering Measuring the light from the highlight and the shadow and using these values to set the exposure. (73)

averaging meters Meters that measure the light over a large area and average all intensities. (71)

balance A principle of composition that defines the stability of a picture. (145)

base plus fog (B+F) The density measurement of areas of the emulsion that have received no exposure. (121, 204)

basic daylight exposure (BDE) A nonmetered exposure system based on the sun being a constant light source. The BDE rule is 1/ISO at F/16 on a bright, sunny day. (66)

BDE *See basic daylight exposure (BDE).*

Beers developer Commonly used split developer solutions. (196)

bellows The part of a view camera that facilitates focusing, allows for lens and film plane movement, and permits close-up work. (224)

bellows compensation An adjustment required to attain proper exposure with a view camera at focusing distances closer than eight times the lens focal length. Also known as bellows factor. (244)

bleaching A contrast reduction technique that changes developed metallic silver to a halide so that it can be removed with fixer. (192)

B+F *See base plus fog (B+F).*

burning A method for darkening areas of the print selectively. (125)

cadmium sulfide (CdS) meters Resistance-based light meters. (70)

camera obscura *Dark room* in latin. The first camera. (5)

characteristic curve A graph that represents the effects of the development, exposure, and density of an emulsion. Also known as a Hurter and Driffield (H&D), D-log H, or D-log E curve. (202)

cold-light enlarger A tool that uses a fluorescent-type tube to produce diffused light for enlarging. (198)

collimated light Light created by lighting equipment that is in a column or parallel. (167)

color sensitivity A measure of how black-and-white film reacts to various colored lights. (56, 164)

color-tone relationship The way various colors are recorded by black-and-white film. (212)

color toners Chemical solutions that change the metallic silver of a print to a color other than its normal gray. (269)

compaction Underdevelopment that allows film to respond to longer ranges of light. (207)

completion development The development of an emulsion to its maximum density, such as paper development. (194)

composition The relationships between various objects in a picture. (144)

condenser enlargers Enlargers that use lenses to control the light before passing the light through the negative. (198)

consistency The harmony of parts to one another or the whole. An important concept in the presentation of photographs. (268)

contact dermatitis A skin condition that can be caused by processing chemicals used in photography. (89)

contact sheets Single sheets of paper printed to display a group of negatives. Also known as proof sheets. (119)

continuous lighting Light that remains on and visible. (172)

contrast The amount of difference in tones within a photograph. (56)

contrast filter A filter that changes the contrast of the negative by absorbing complementary color portions of the light entering the camera. (179)

contrast index The slope of the straight-line portion of a characteristic curve. Also known as gamma. (205)

contrast range The series of tones or values present in the scene. (212)

convergence The visual effect of parallel lines coming together at a distance. (242)

dark cloth A cloth used to help focus a view camera. (231)

darkroom A room with either no light or light that is safe for photographic processing. (102)

dark slide The part of a sheet film holder that can be removed to allow exposure of the film. (233)

daylight tanks Tanks that hold reels of film, with a light trap built in to permit the introduction of chemicals for processing the film. (89)

densitometer A tool used to measure the density of negatives or prints. (204)

depth of field The distances in front of and behind the plane of sharp focus that will appear in focus in the final picture. (44)

design elements The building blocks of composition. (151)

Deutsches Industrie Norm (DIN) A European film speed standard. (55)

diaphragm The mechanical device that adjusts the size of the lens opening. (37)

diffuse light Light coming from a large area that creates soft, open shadows. (164)

diffusion enlargers Enlargers that use mixing chambers, translucent material, or large light sources to control the light before passing the light through the negative. (198)

DIN *See Deutsches Industrie Norm.*

Dmax The highest usable density of an emulsion. Set by ANSI as 0.90 of maximum black. (205)

Dmin The lowest usable density of an emulsion. Set by ANSI as $B \times F \times 0.04$. (205)

dodging A method for lightening areas of the print selectively. (124)

dry mounting Methods of adhering photographs to mounting boards without liquid adhesives. The most common dry mounting technique is using heat-activated tissues. (135)

duotone An offset printing process used to reprint black-and-white photographs by completing two printing passes, one for the higher values and a second for dark tones or black. Two related processes are tritone (three tones) and quadratone (four tones). This book is printed using the duotone process. (281)

dye couplers Chemicals that will attach to developing silvers and change the color of a black-and-white photograph. (271)

dyes Chemicals that change the overall color of a black-and-white print with the most effect on the paper base. (271)

dynamic balance A balance within a picture that creates apparent motion. (147)

effective speed The speed used for film in nonnormal situations. (212)

electromagnetic waves spectrum Related energy sources that include visible light. (163)

electronic flash Lighting equipment using inert gases to produce short-duration, discontinuous light. (176)

emulsion The light-sensitive coating of film, whose two main components are gelatin and halides of silver. (58)

enlarger A tool that allows prints to be made larger than the size of the negatives. (104)

equivalent exposures A series of f-stops and shutter speeds that equal the same exposure, sometimes referred to as reciprocity exposures. (79)

expansion Overdevelopment that allows film to respond correctly to short ranges of light. (207)

exposure The action of light on the film that creates the latent image. (65)

exposure index (EI) A number used in a metering system to reflect a sensitivity either tested or selected by the photographer. (208)

factory-loaded film holders Paper holders loaded with sheet film and designed to be used in instant film holders. (236)

fiber-based paper A printing material that has a gelatin-supported emulsion on a paper base. (108)

field cameras View cameras made of light materials to allow for easier use outside the studio. (227)

film Light-sensitive material on a flexible base. (53)

film hangers Metal frames used to process sheet film. (247)

film support The film material that supports the emulsion. Also known as film base. (62)

filter dodging A printing technique that is used with multicontrast paper and changes the contrast in a localized area of the print. (190)

filter factor A number used to calculate the effect of the filter on exposure. (186)

fixer A solution that removes undeveloped silver halides from the emulsion, making the image permanent. (94)

flashing A printing technique that exposes paper below its exposure threshold in order to reduce print contrast. (192)

floodlight The simplest continuous light with exposed bulbs. (172)

f-numbers The numbers used to define f-stops. These numbers are derived from the formula F = Lens Focal Length ÷ Lens Opening Diameter. (38)

focal length The distance from the center of the lens to the film when the lens is focused at infinity. (34)

focal plane shutter A curtain or shutter mechanism directly in front of the film. (16)

fog Density in the emulsion caused by extraneous light. *See also* **chemical fog.** (121)

format (1) The size of the camera. (2) A presentation choice that leads to consistency. (269)

Fresnel-designed lenses Lenses made of a series of concentric rings that even out light, making it more controllable. (173)

front standard The front support of a view camera that holds the lens board. (224)

f-stops Measures of the size of the lens opening. (37)

gelatin The material used to contain the silver halides in the emulsion. (60)

geometric center The point where diagonals from the corners of a picture cross. (145)

graded papers Printing papers with a set contrast range from 0 to 5 in whole number increments. (114)

grain focusers Tools used as focus aids in enlarging to gain maximum sharpness in prints. (106)

graininess The apparent amount of grain structure of a negative. (56)

grain magnifiers *See* **grain focusers.**

gray card A card that has an 18 percent reflective surface and is used for substitution metering or as a known value in film testing. (76)

ground glass The part of a view camera used for focusing. (224)

guide numbers Numbers indicating the power of a flash relative to the film speed (ISO) in use. The formula to calculate a guide number is Guide Number = F-Stop Used × Flash-to-Subject Distance. (178)

halation The softening of highlights caused by the reflection of bright light from the subject within the film. (62)

halftone A printing process that uses dots to reproduce the tonal range of photographs. (281)

hardening fixer A fixing solution that has been prepared to make the emulsion more durable. (94)

hard papers Graded papers that are designed to print negatives with short ranges. These papers are numbered 4, 5, and 6. (114)

haze Several conditions that affect the light that falls on the subject. The two major types are high-cloud haze and high-humidity haze. (169)

heliograph Sun writing The first name used to describe the product of the photographic process. (163)

hot lights Slang for *continuous lighting equipment.* (172)

hot shoe A device on a camera that holds and activates the flash. (176)

hyperfocal distance The nearest point that will be in focus when the lens is focused at infinity. (48)

hyperfocal focusing The maximum depth of field, achieved by shifting focus to the hyperfocal distance. (48)

hypo-clearing solutions Solutions used to assist the washing of film. A hypo-clearing solution will combine with the fixer to make a compound that readily washes out. The result is a shorter washing time. (96)

hypo eliminators Solutions used to assist the washing of film that shorten the washing time. Another term for *hypo-clearing solution.* (96)

image magnification The size of the subject on the film relative to its actual size. (45)

incident light Light that falls on the surfaces of the subject. (71)

incident-light meters Tools that measure the light that falls on the subject. (71)

indicator stop bath An acetic acid solution with an added chemical that tells when the solution has lost its effectiveness. (93)

instant film holders Containers designed to use either sheet or pack instant film with various cameras. (235)

intensity ranges The series of light values that a film can record. (164)

interaction A perceptual process that involves mental processing to interpret what was in front of the camera. (156)

interference filters Filters that change the effect of the light on the film by disturbing the passage of the light into the camera. (184)

International Standards Organization (ISO) The most widely used rating for film speed. (55)

interposition The placement of one object in front of another. This is an indication of depth. (150)

inverse square law The principle that light from a specular source falls off at the rate equal to the inverse square of the distance from the source to the subject. (43, 167)

ISO *See International Standards Organization (ISO).*

juxtaposition The placing of objects within a picture that allows comparison. (150)

large-format probe A TTL meter system for view cameras that measures light directly off the ground glass. (71)

latent image The image formed by the action of light on the film that cannot be seen until the film is processed. (54)

latitude The film's ability to function in various exposure or development situations. (56)

law of reciprocity The principle that a reciprocal relationship exists between f-stops and shutter speeds based on the 2:1 ratio. *See also* **equivalent exposures.** (81)

leaf shutter A shutter made up of moving leaves located within the lens. Also called a between-the-lens shutter. (16)

lens board The part of a view camera used to hold the lens on the front standard. (224)

lens speed The rating of the amount of light that the lens will let into the camera. (41)

light The energy source used to produce most photographs. (163)

light meter An instrument that measures the amount of light reflecting from or falling on the subject. *See also* **incident-light meter; reflected-light meter.** (70)

line A design element created by a graphic pattern in the scene or by the edges of objects in the picture. (152)

linear perspective The way parallel lines appear to converge as they recede from the point of view. (148)

log exposure range The amount of light affecting exposure of the emulsion. (205)

maximum aperture The largest opening of a lens. (47)

maximum black The highest measured density in negatives or prints. (204)

metallic enrichment toners Toners used to deepen the tones in the print with only a slight coloration change. The most common of these are selenium and gold toners. (271)

metallic silver The result of developing the exposed silver halides that form the negative. (86)

middle gray In black-and-white photography, a tone that reflects 18 percent of all light from the surface. Also the value of zone V. *See also* **gray card.** (68)

motion In composition, the apparent motion created in the frame by various parts of the picture. (145)

motion parallax The apparent motion created by movement of the camera while the focus is fixed on a point within the spatial depth of the scene. (150)

motion perspective The apparent motion created by movement of the camera while the focus is fixed on a point at infinity. (150)

mounting board A rigid material used to present photographs. (132)

multicontrast paper A printing paper designed to have varying contrast ranges. (114)

N development *See normal development.*

negative The result of processing the exposed film; shows the image in reversed tones. (54)

negative space The space created by the ground between or next to the figure or subject. (151)

neutral-density filters Filters designed to reduce light entering the camera in all spectral areas. (179)

N− development A zone system notation for underdevelopment, or compaction. (259)

normal development The standard development for tested film used in the zone system. (259)

normal lenses Lenses designed to give a view that is approximately the same as normal visual perception. (34)

N+ development A zone system notation for overdevelopment, or expansion. (259)

optical centering A method for placing pictures on mounting boards. (133)

overmatting A mounting method that uses a window cut into a mounting board that is then placed over the picture. (139)

paper safes Lighttight containers used to hold quantities of paper for enlarging. (106)

parallax error An error that occurs at close distances when using cameras with two lenses, one for focusing and another for exposure. (12)

parallel planes position The standard, or zero, position of a view camera that creates parallel alignment between the front and rear standards. (240)

pebble grains One type of grain used in the production of films. Often called conventional grain. (60)

perspective The relationship of objects in space. (50, 148)

pH Parts hydrogen. A measure of acidity. The lower the number, the stronger the acidity, with pH 7 neutral. (93)

Photoflo A registered product of the Eastman Kodak Company that has become synonymous with wetting agents. (97)

photofloods Lightbulbs that are similar to household lightbulbs. (172)

photovoltaic meters Light meters that convert the light energy directly to electric voltage and measure that voltage. (70)

plane of sharp focus The plane in front of the camera that the lens will record as sharp on the film with the camera aperture wide open. (32)

polarizing filters Filters used to reduce the effect of glare on exposure. These filters are made of either very fine parallel lines or concentric lines. (184)

portfolio A group of photographs displayed as one visual presentation. (279)

positive space The space defined by the figure or subject. (151)

presoak The liquid used to wet the film prior to the introduction of developer so that the developer will work evenly. (91)

press cameras Large-format cameras that fold, often can be focused without using the ground glass, and can be handheld. (227)

previsualization Deciding what the print will look like before exposing the film. (218, 132)

printing easels Devices that hold paper flat during enlarging. (105)

programmed exposures Functions that are found on some modern cameras and use the light measurement of the TTL to set the proper exposure. (70)

proofing frames Devices that hold negatives against the paper to make contact prints. (106)

proof prints The first enlargements that enable the photographer to make judgments about printing controls that will be needed for the final print. Also known as work prints. (123)

pull The underdevelopment of film to reduce the effective speed. (216)

push The overdevelopment of film to increase the effective speed. (215)

push factor The amount of overdevelopment required for an increase in speed. (216)

quality An expectation of consistency for presentation. (269)

quartz-halogens Continuous lights that use quartz crystal glass and a halogen gas to extend bulb life. (172)

rag board A museum-quality mounting board made of 100 percent cotton fiber. (132)

range A measurement of the amount of density in emulsions of brightness in scenes. (207)

rangefinder focusing system A system that uses a split view to focus by triangulation. (10)

reaction A perceptual process that uses the photographic image to elicit a response in the viewer that may go beyond what was in the photo. (156)

rear standard The rear support of a view camera that holds the ground glass. (224)

rebate edge The area around the sprocket holes and the edges of film that received no exposure and thus consists of base plus fog. (121)

reciprocity failure The failure of the law of reciprocity at very long (over 1-second) or extremely short (under 1/1,000-second) exposures. (81)

redevelopment toners Toners used to replace the metallic silver of a print by a bleaching and redevelopment process. Sepia toner is the most common of these toners. (271)

reflected light Light that reflects from the surfaces of the subject. (71)

reflected-light meter A device that measures the light that reflects from the subject. (71)

replenisher A chemical used to replace oxidized developer to restore the original strength prior to reuse. (92)

replication A perceptual process that presents a simple interpretation of what was in front of the camera. (154)

resin-coated (RC) paper A printing material that has the emulsion and support between layers of plastic. (108)

resolving power A film's ability to record fine detail. (56)

reticulation The wrinkling of the film's emulsion caused by large temperature differences between steps in the developing process. (92)

rise-fall Vertical movements of the front or rear standard that change the area of composition on a view camera.

safelight A colored light that is used in the darkroom and will not expose emulsions. (102)

SBR *See **subject brightness range (SBR)**.*

Scheimpflug principle The principle used to maximize focus with the swings or tilts or both swings and tilts of a view camera. (241)

selective focus A technique for isolating a subject by limiting the depth of field to just that of the subject. (50)

sensitizing dyes Dyes used to make black-and-white films record electromagnetic radiation outside the normal range of the film. (60)

sensitometer A laboratory tool used to expose film for sensitometry. (204)

sensitometry The scientific technique used to determine the effects of exposure and development on emulsions. (202)

shape A design element that deals with the perimeter of an object. (151)

sheet film holder A device designed to hold film flat and to be placed into the view camera. (233)

shift A horizontal movement of the front or rear standard that changes the area of composition on a view camera. (239)

shoulder The top part of the characteristic curve of film and paper that represents the most dense parts of the emulsion. (206)

silicon diode meters Resistance-based light meters. (70)

silver halides Ions of silver and one of the halogens within the emulsion that are sensitive to light. (58)

single-lens reflex camera A camera that uses the same lens for focusing and exposure by employing a 45-degree-angle mirror placed behind the lens. (13)

sodium thiosulfate A chemical used to fix the emulsion. (94)

softbox Lighting equipment that creates diffuse light. (174)

soft papers Graded papers designed to handle long-range negatives. These papers are numbered 0 and 1. (114)

space A design element that defines the partitioning and divisions of the picture's frame. (152)

special effects filters Filters used to interfere with the light entering the camera and produce visual effects not found in the scene. (186)

specular light Light that appears to be from a small source that creates sharp, crisp shadows. (164)

speed test A method for finding the effective speed of film in relation to camera, metering, and development. (208)

split developers Two different types of developer solutions used in one procedure to control contrast. (196)

spotlights Lights that use lenses or mirrors or both to focus or collimate light. (172)

spot meters Meters that measure light from a small area of the subject. (71)

spotting Retouching prints or negatives with dyes to eliminate small defects. (128)

static balance Balance within a picture that has no apparent motion. (145)

step tablets Tools used to expose paper or film for sensitometry. (204)

stock solutions Solutions that either were mixed from liquid or dry chemicals or purchased in liquid form and are stored until used to prepare working-strength chemistry. (84)

stop bath A chemical that neutralizes the action of the developer to allow for accurate development time. (93)

straight-line portion The part of the characteristic curve that approximates a straight line. (207)

studio view cameras Cameras that have maximum movement controls and are used primarily in the studio. (227)

subbing The adhesive that holds the emulsion to the film support. (62)

subject brightness range (SBR) The amount of light that affects exposure of the emulsion. (205)

substitution metering A system that uses measured reflective light from a known reflectance material to set the exposure. (76)

sunny day rule The exposure rule that states that on a normal sunny day, f/16 at a shutter speed of 1/ISO will result in the correct exposure on any film. (66)

swing A rotation of a view camera standard about a vertical axis that changes focus or distortion. (239)

symbols Tangible objects used to represent an idea, give meaning, or replace another object. (159)

symmetrical balance A balance structure in a picture that is approximately the same on either side of the visual center. (147)

tabular grains Tabletlike grains used in the construction of some newer films. (60)

telephoto effect The visual compression of space caused by telephoto lenses. (50)

telephoto lenses Lenses designed to give a view that is narrower than normal visual perception. (34)

textural gradient A type of perspective that shows depth in a scene as the texture of the background loses detail. (148)

texture A design element that creates an apparent roughness or smoothness to objects in the photograph. (152)

threshold of exposure The minimum light level required to create a latent image. (192)

through-the-lens (TTL) meter A type of light meter that measures the light coming through the camera's lens. (70)

tilt A rotation of a view camera standard about a horizontal axis that changes focus or distortion. (239)

toe The lower part of the characteristic curve that represents the least dense parts of the emulsion. (206)

tone The tonal or value range of a picture. (269)

toning A technique that changes the color or contrast or both color and contrast of an emulsion. (194)

top coat A dressing applied to the surface of the emulsion for protection and to allow retouching. (62)

tripod A device used to support a camera. (25)

TTL meter *See* **through-the-lens (TTL) meter.**

twin-lens reflex camera A type of camera that uses a focusing lens whose image is reflected by a mirror onto a ground glass that is above the separate exposing lens. (23)

tungsten filaments Small wires in continuous-lighting equipment that glow as electricity is passed through them. (172)

2:1 ratio The primary concept of photographic exposure. The 2:1 ratio can be seen in film speed, f-stops, shutter speeds, guide numbers, and zones. (55)

value A design element that defines the variation of tones within the picture. (152)

view camera A camera designed to use a ground glass for viewing and focusing and then displace the ground glass with the film for the exposure. View cameras

generally are capable of movements on front or rear standards or both, and are usually used with a tripod. (See chapter 12.) (224)

viewfinder camera A camera that uses a viewer to frame the picture but has no interlocked focusing. (8)

viewing distance How far a picture should be viewed from. This is approximately the length of the picture's diagonal. (266)

visual center A point in the picture frame that appears to be the center. This point is slightly above the geometric center. (145)

visual weight The apparent weight and effect of objects in a picture. (148)

volume A design element that creates an illusion within the photograph that an object is three-dimensional. (152)

washing agent A solution used to make the washing of film more effective. (96)

water bath development A split development technique using a tray of water and a tray of developer, generally employed to print extremely high-contrast negatives. (197)

wetting agent A solution that removes surface tension on wet film and allows the film to dry without water spots. (97)

wide-angle distortion The distortion of objects within space by using a wide-angle lens. (50)

wide-angle lenses Lenses designed to give a view that is wider than normal visual perception. (34)

working solutions Solutions prepared to be used in processing the film or paper, generally made from stock solutions and water. (84)

zone A tone within the scene, negative, or print that is one stop, using the 2:1 ratio, from the next tone. (218)

zone placement A method for choosing the way any given tone within the scene will be represented in the print. (218)

zone ruler A tool used to establish tonal values available in the scene. (218, 13-4)

zone system An exposure development system that adjusts tones and the contrast range to meet the desires of the photographer. (219, chapter 13)